*

ANATOMY For the Artist

THE DYNAMICS OF THE HUMAN FORM

ANATOMY For the Artist

THE DYNAMICS OF THE HUMAN FORM

Drawings by Tom Flint Consultant Editor Peter Stanyer MA Royal College of Art

ARCTURUS

This edition produced for Indigo Books, 468 King St W, Suite 500 Toronto Ontario M5V 1L8

All rights reserved. No part of this publication may be reproduced, stored in a retrieval system, or transmitted, in any form or by any means, electronic, mechanical, photocopying, recording or otherwise, without written permission in accordance with the provisions of the Copyright Act 1956 (as amended). Any person or persons who do any unauthorized act in relation to this publication may be liable to criminal prosecution and civil claims for damages.

© Arcturus Publishing Limited/Tom Flint, 2002

ISBN 1-84193-073-3

Typography by Chris Smith Cover design by Alex Ingr

Printed and bound in China

CONTENTS

Introduction	7
The Skeleton	9
The Muscles	39
The Skin	73
Proportion	87
Posture	105
Fundamental Form	155
Working Drawings	185

INTRODUCTION

The human body has long inspired artists and representations of it can be found in many of the greatest works of art. Such works could not have been produced without meticulous study and observation. Nowadays figure drawing is in danger of being regarded as an outmoded means of artistic expression. The demise of life drawing in our art institutions is sad, because the disciplines it teaches underpin most of our visual language and these have often been productively transferred to other areas of art and design.

As artists we use visual information to convey our innermost thoughts and ideas. The human form and condition has been used continuously by artists down through the ages to convey a wealth of such information. How to communicate this information to the viewer is one of the most difficult challenges any artist can face.

Good figure drawing demands both acute observational skills and a thorough knowledge and understanding of what is there. As much as the artist's eye must see, his brain must know. This book aims to help this process by presenting anatomical information in a way that artists can relate to, by gradually building a picture of the body instead of relying on anatomical terms for description. *Anatomy for the Artist* offers a purely visual presentation of what is there.

We begin our understanding of the body by studying the skeleton, followed by the musculature, and through these show the basic framework. The body's outer layer, the skin, enables us to express particular characteristics of the human condition. The elements of the body are shown in the same sequence in each section, beginning with the head, moving down to the thorax and abdominal area, the pelvis, and then to the limbs, arms and hands first, and finally the legs and feet.

With the body now built up from the inside, we investigate proportion, posture and fundamental form. Each of these essential techniques reinforces and supports the others in describing the human form and its underlying anatomy. They are the artist's means of accurately rendering the structures of the body in various poses and making a visual impact on the viewer.

We end with a series of freely expressive working drawings. These bring together what has been learnt and show how vital is the handling of proportion and fundamental form to a successful outcome in figure drawing.

The human body is one of the most complex structures on the planet and offers unlimited possibilities for artistic exploration and renewal. We hope you will use the knowledge gained from studying these illustrations to develop your own creative ideas.

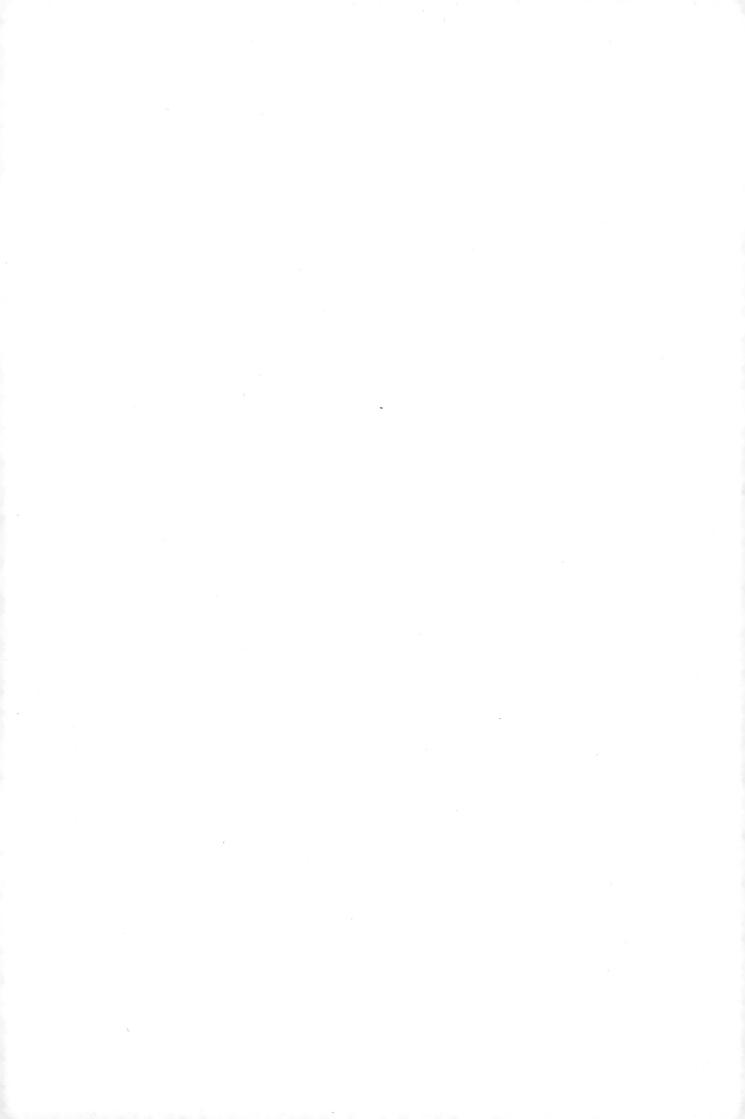

THE SKELETON

The skeleton is a naturally beautiful, faultlessly designed phenomenon, and yet because it is often associated with death and fear, most people perceive it as ugly. Artists view it with a different eye. For them it is a means of expressing what is known about the human form in general and an individual subject in particular.

When we look at the nude body we see only a fraction of the skeleton – where, for example; parts of it protrude from under muscle and push against the skin. The rest of it we know imprecisely, as a framework and structure for our organs and limbs. It is important for us, as artists, to gain an intrinsic appreciation and knowledge of this framework and how it functions.

In the past the skeleton was mainly studied by artists through the medium of drawing. Their observations and research revealed to later generations of artists the role the skeleton plays in our visual understanding of the human form.

In this part of the book we take you through the skeleton from top to bottom to give you a basic visual record of how the various parts of the skeleton relate and interact.

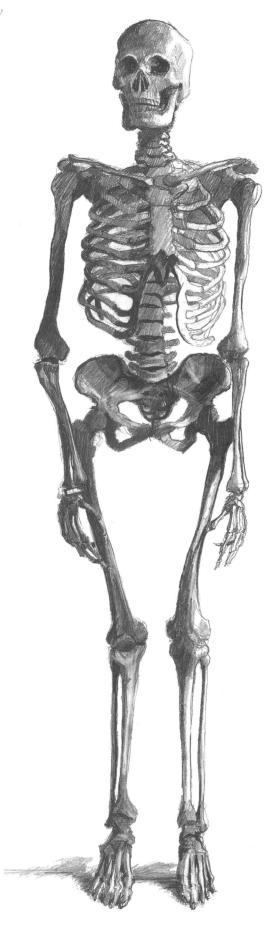

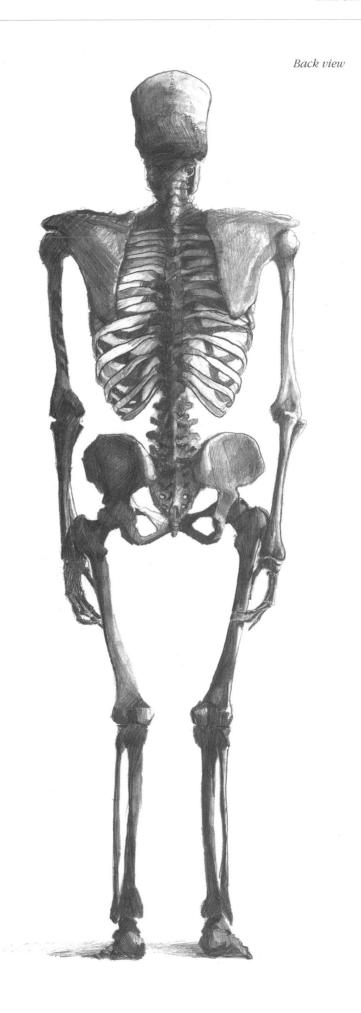

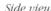

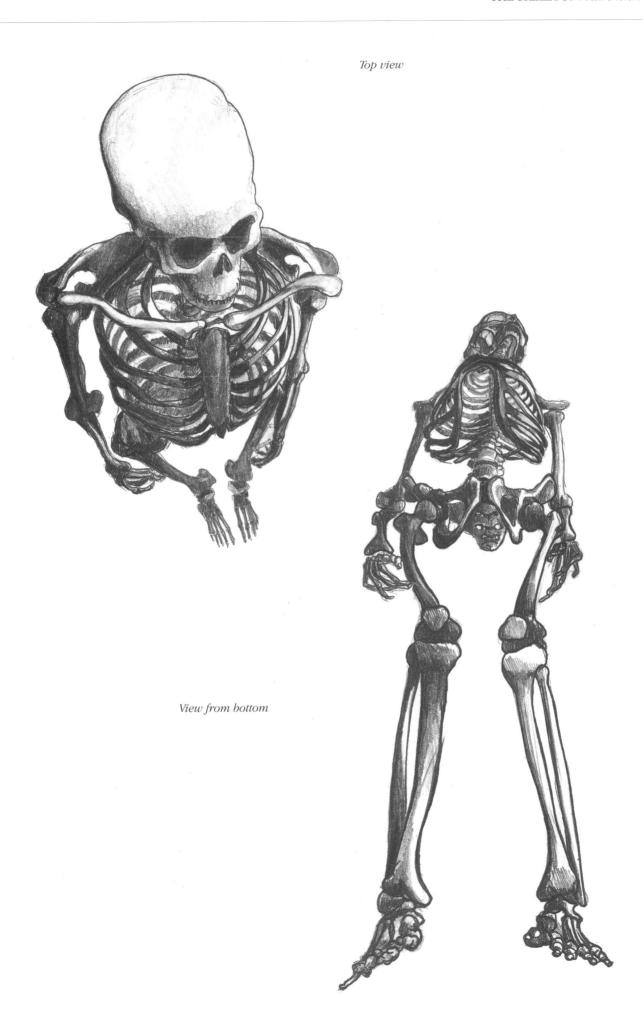

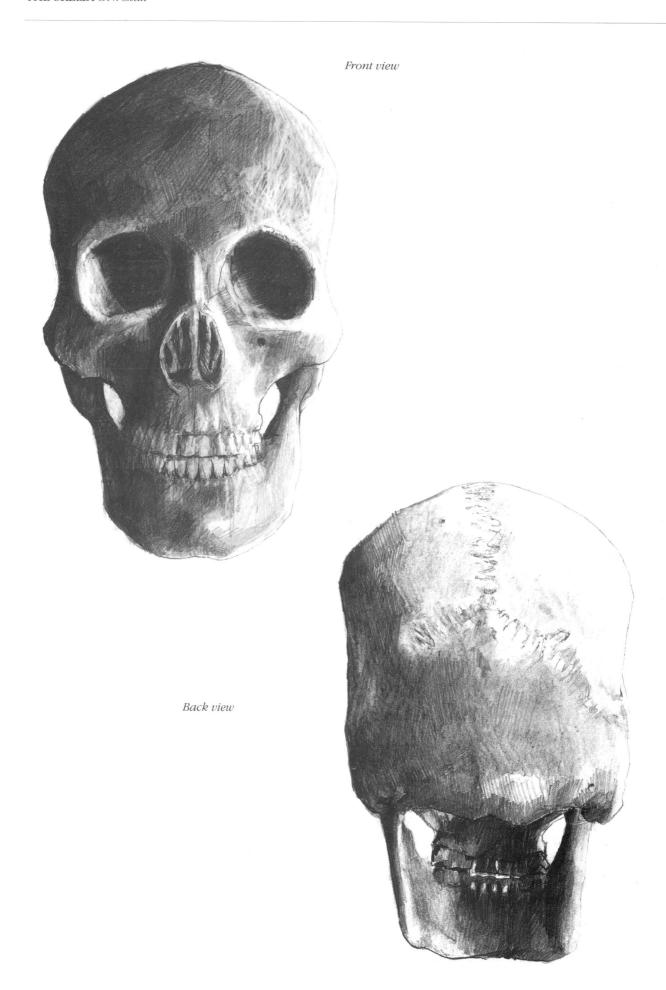

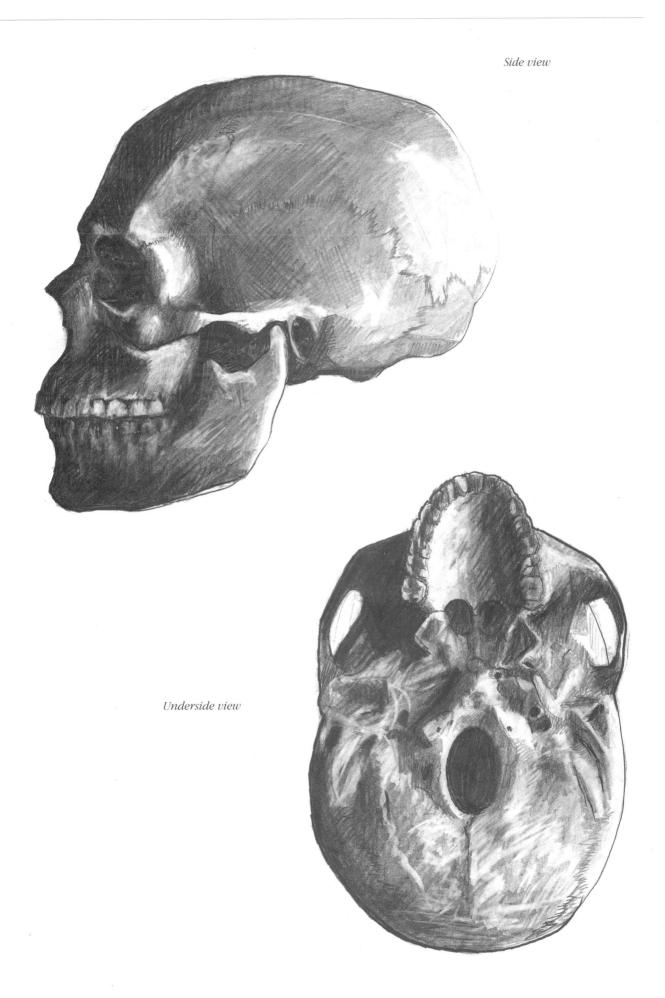

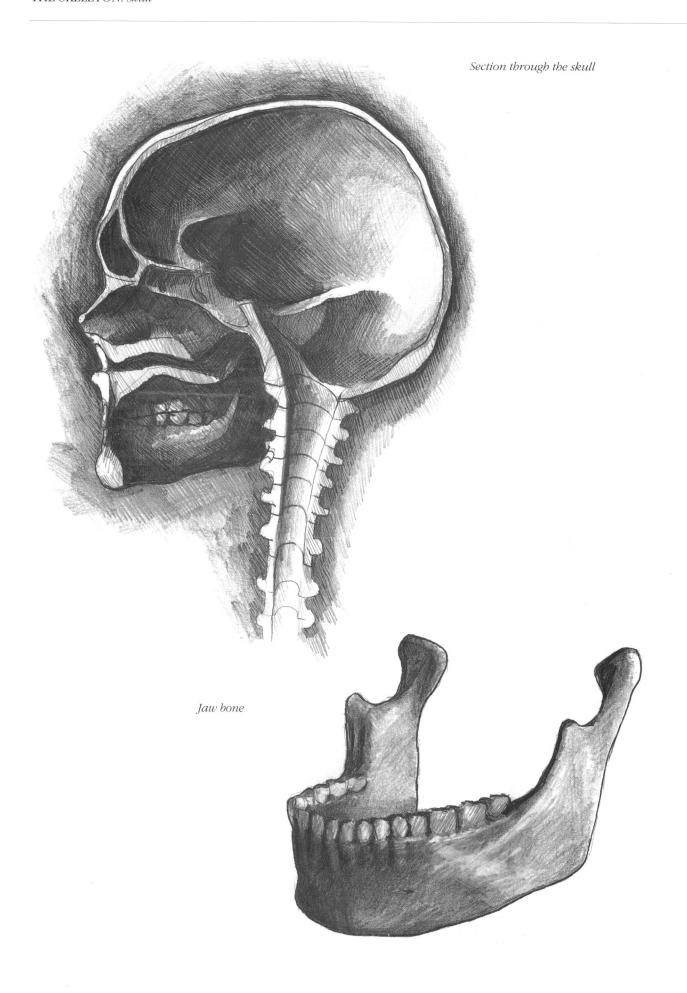

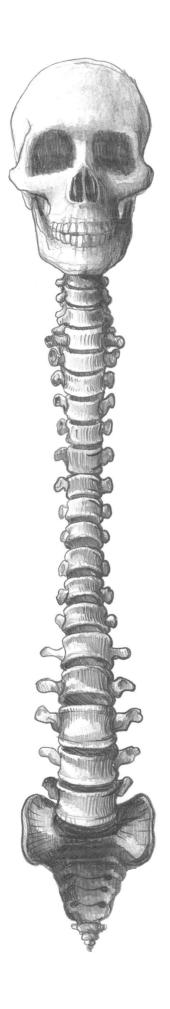

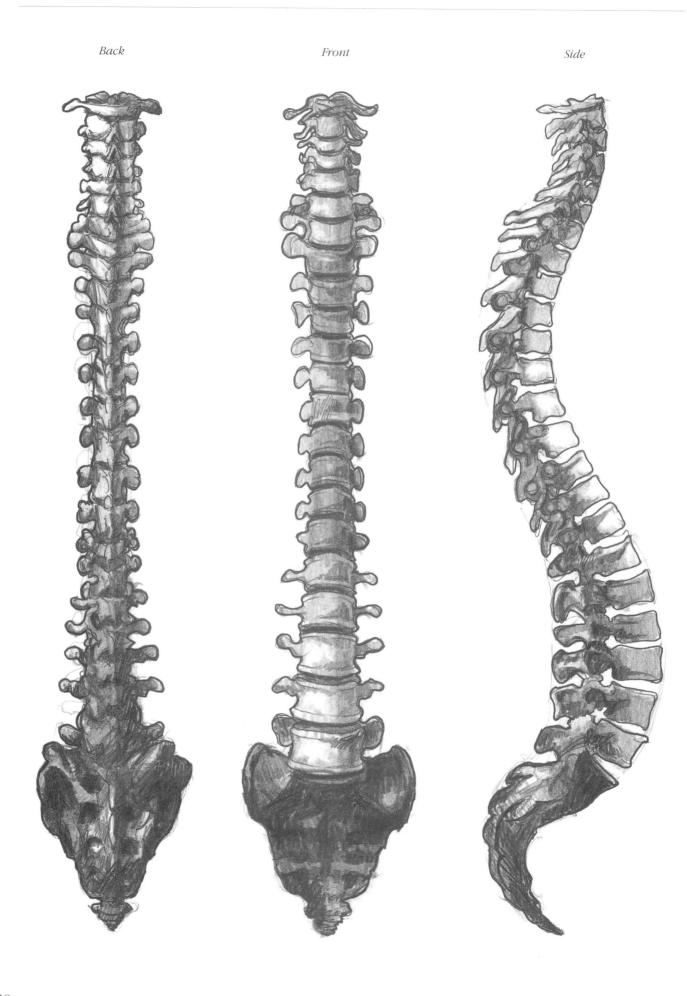

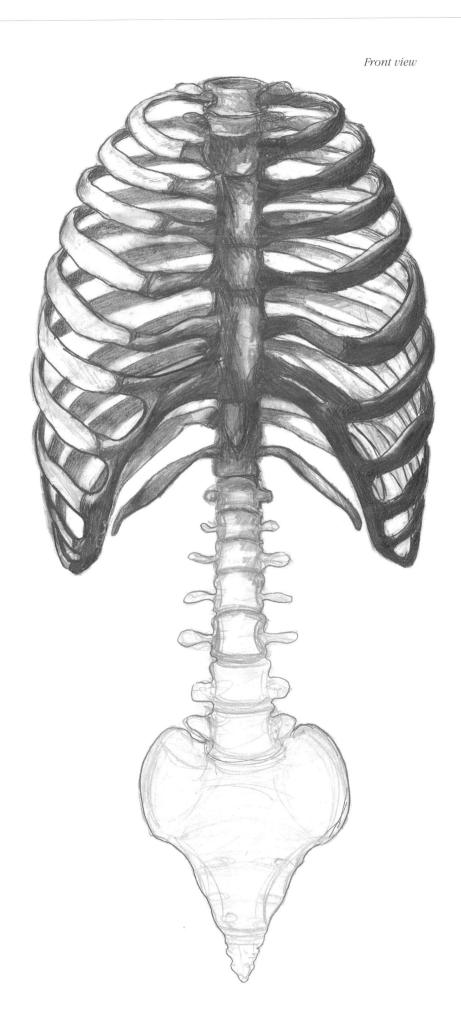

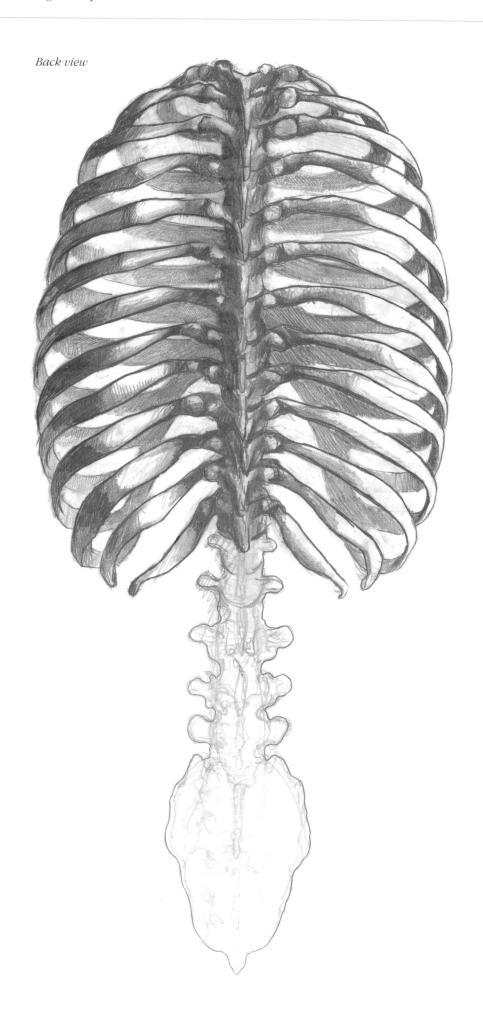

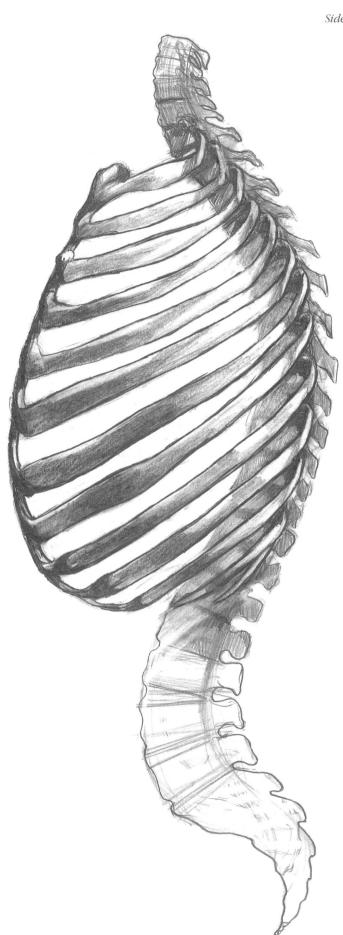

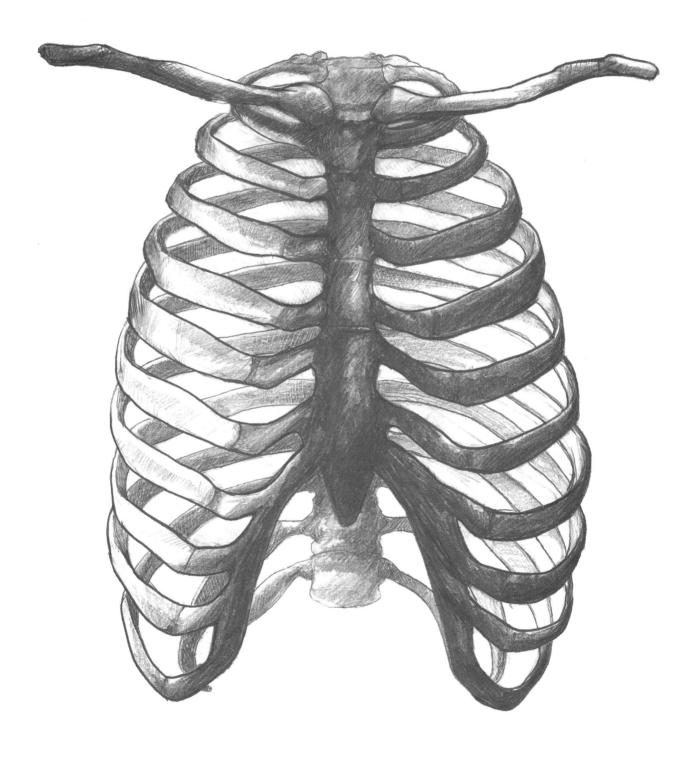

Back view (with spine)

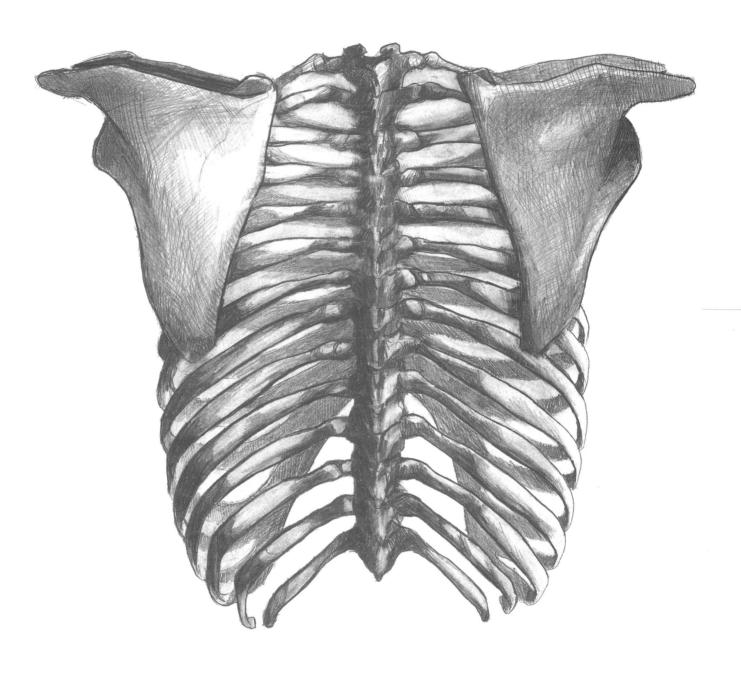

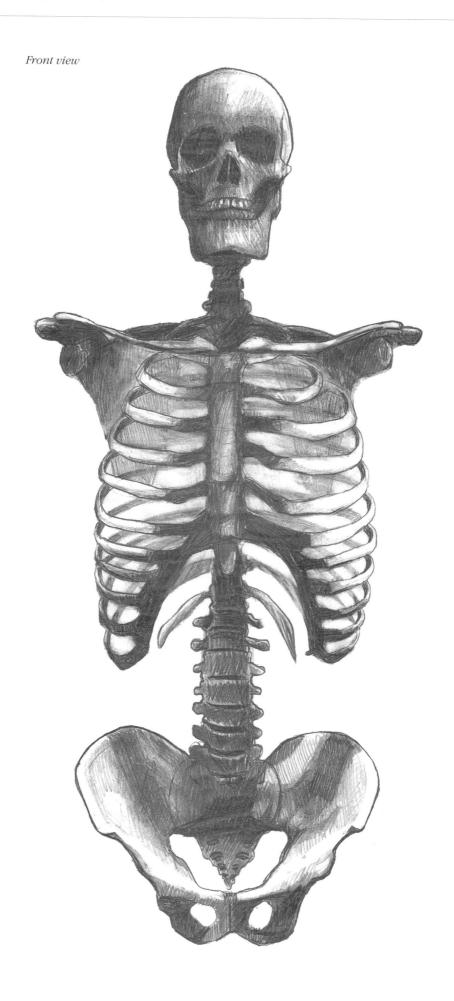

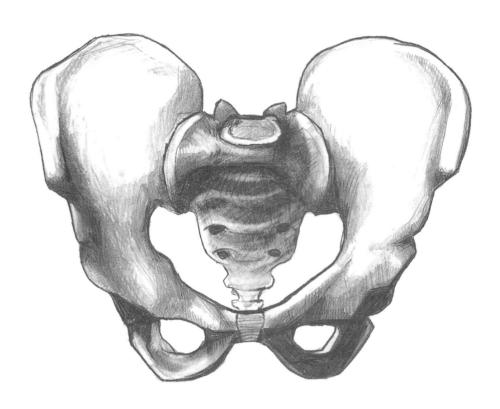

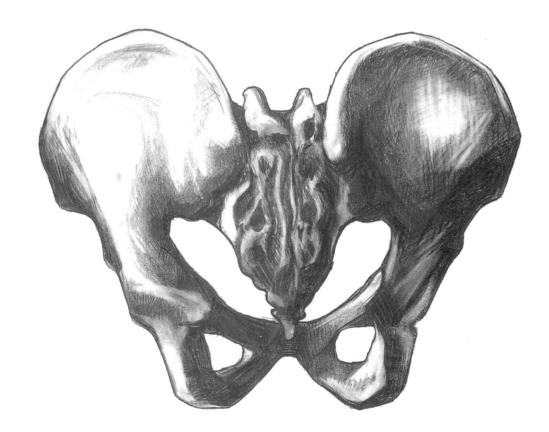

Back view

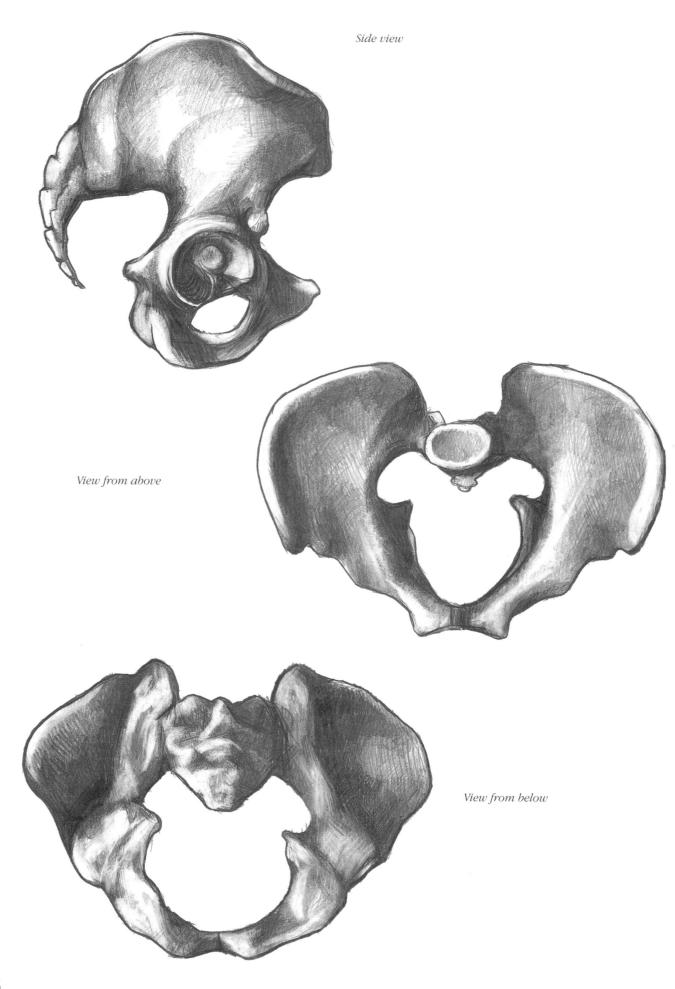

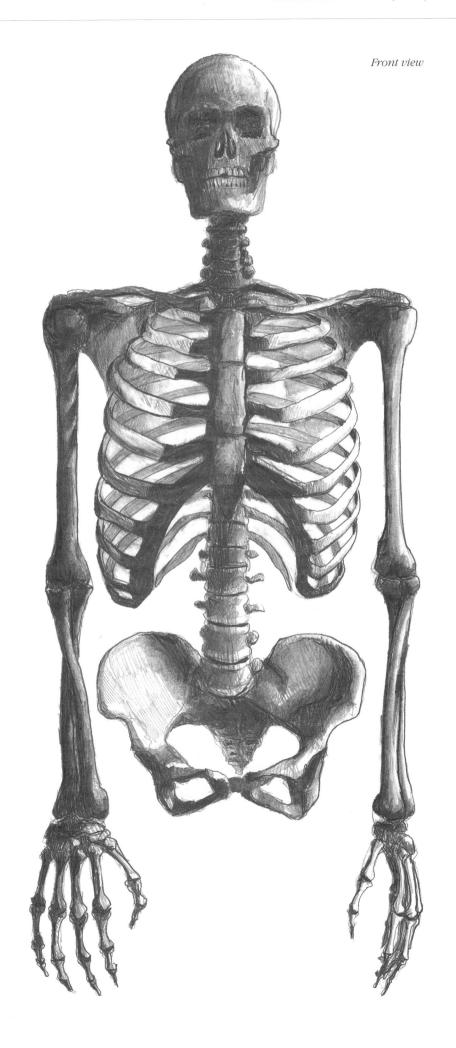

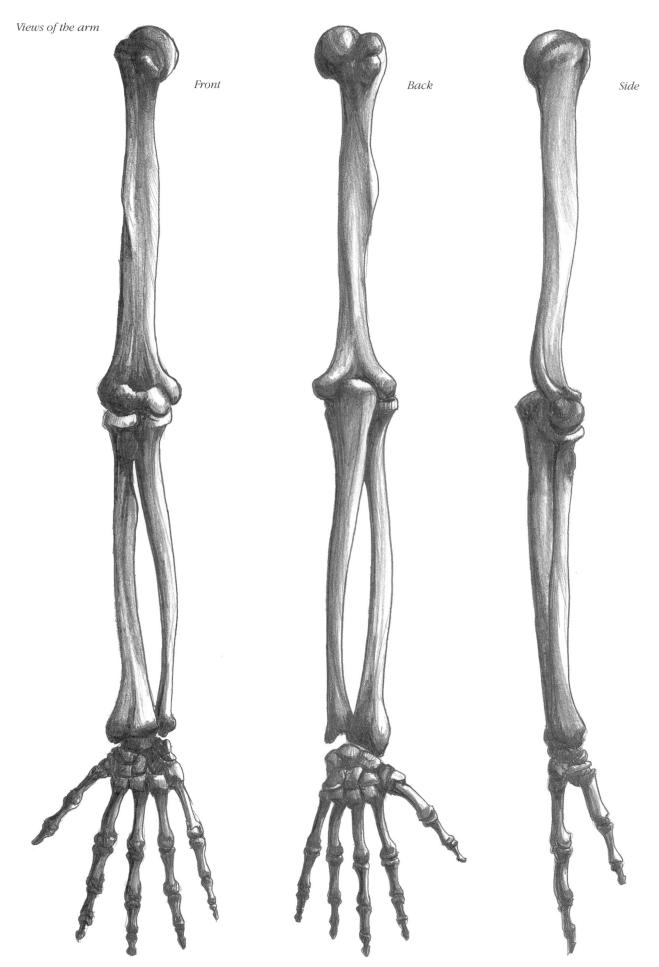

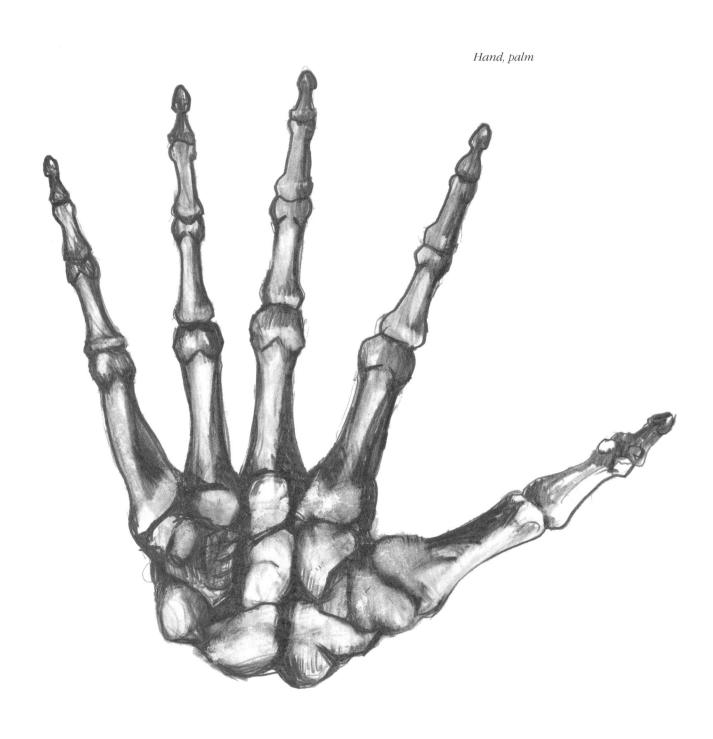

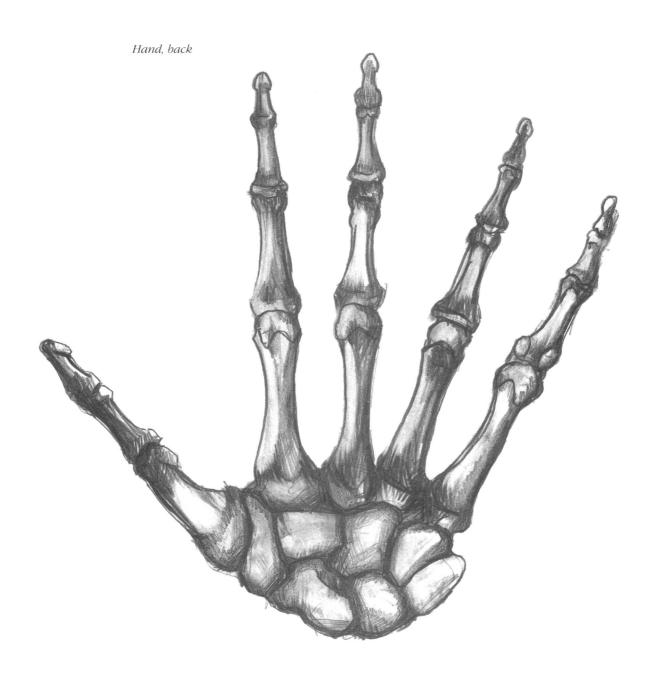

The hand from different angles

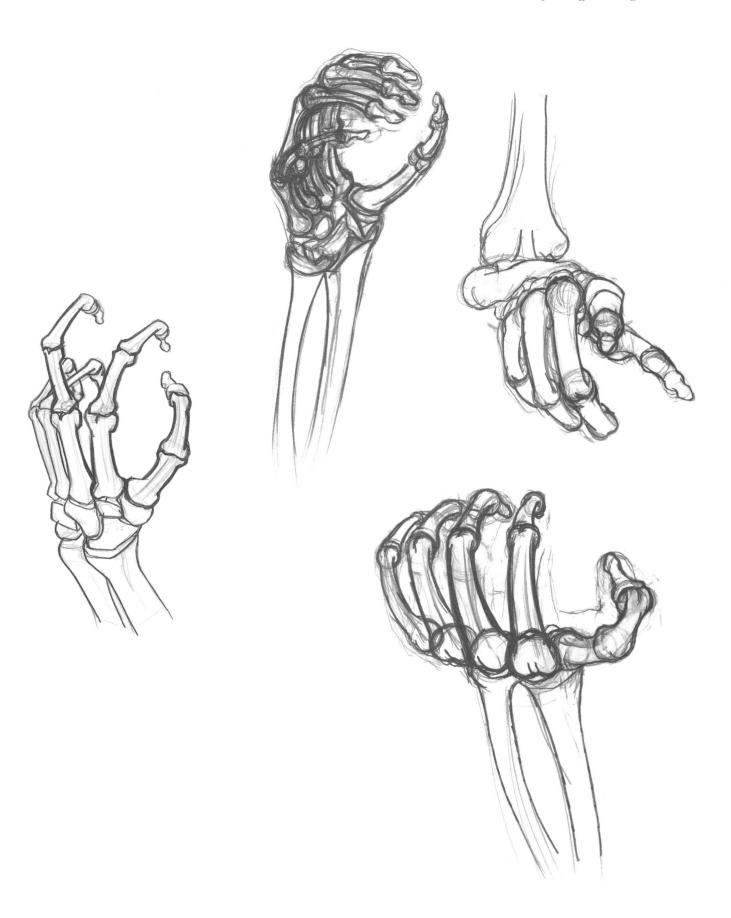

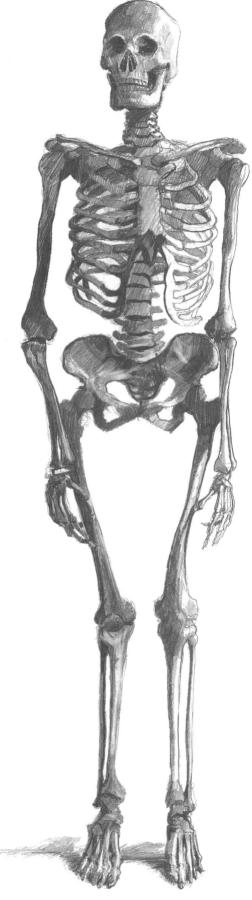

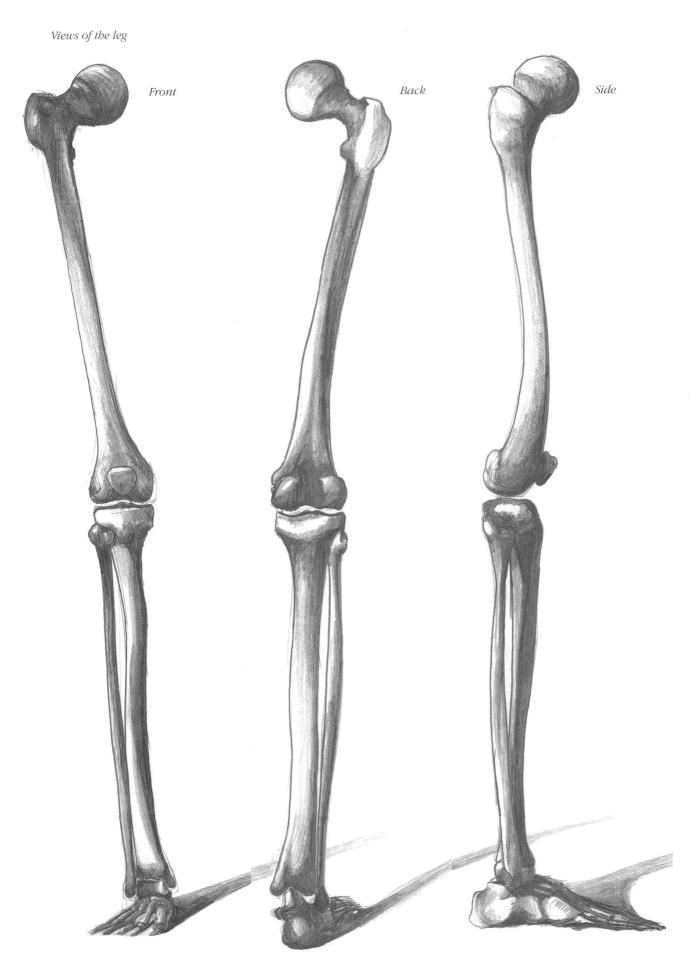

 $Foot\, from\ above$

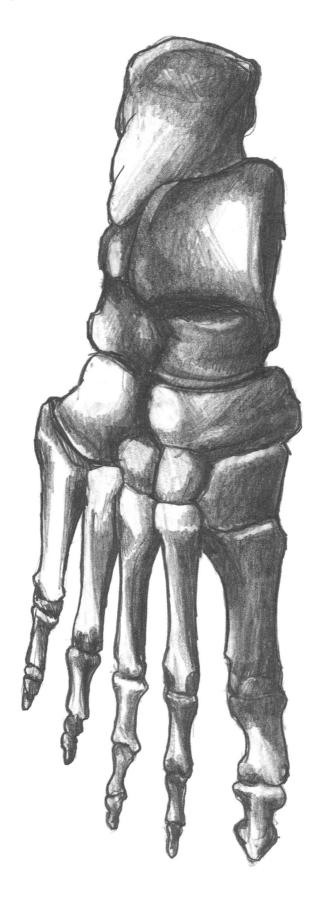

Foot from below ·

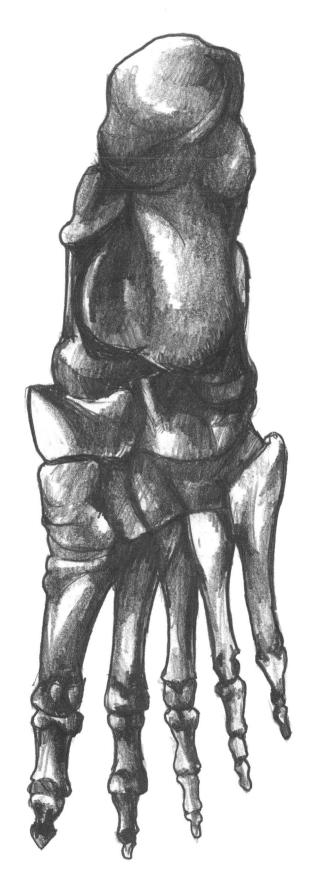

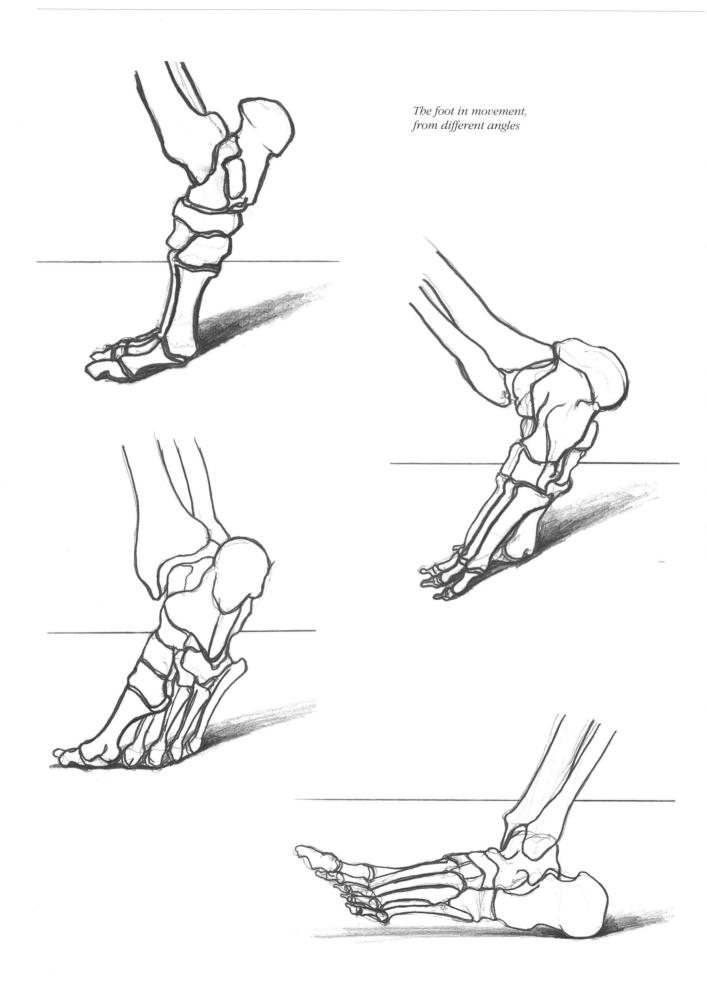

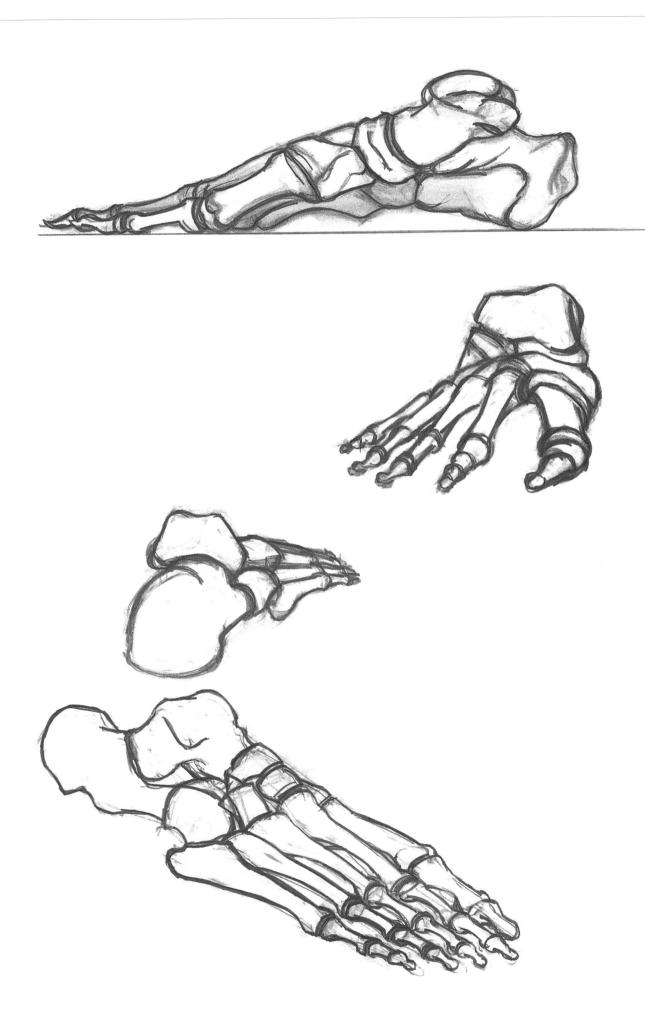

THE MUSCLES

Muscles are an amazing design of nature, expanding or contracting in response to nerve impulses or messages they receive from the central nervous system. The function of the muscles is to stabilize the body as well as enable it to move and maintain its posture. There are three types of muscle: skeletal, smooth and cardiac. The most important of these for artists is skeletal muscle.

Skeletal muscles are attached to the bones by rough fibrous cords called tendons. When the muscle contracts the tendon pulls the bone, causing it to move. Many muscles are grouped in opposing pairs, so that when one muscle contracts the other expands or releases. This action is most evident in the movement of our arms and legs, and can be likened to the hydraulics system used in machinery.

There are two types of skeletal muscle, one lying just under the surface of the skin – so called superficial muscles – and the other, layered beneath the superficial muscle, called deep muscle. The superficial muscles, together with the bones, show the underlying form of the body. Their study is essential for the artist. We shall look at them in detail in this section.

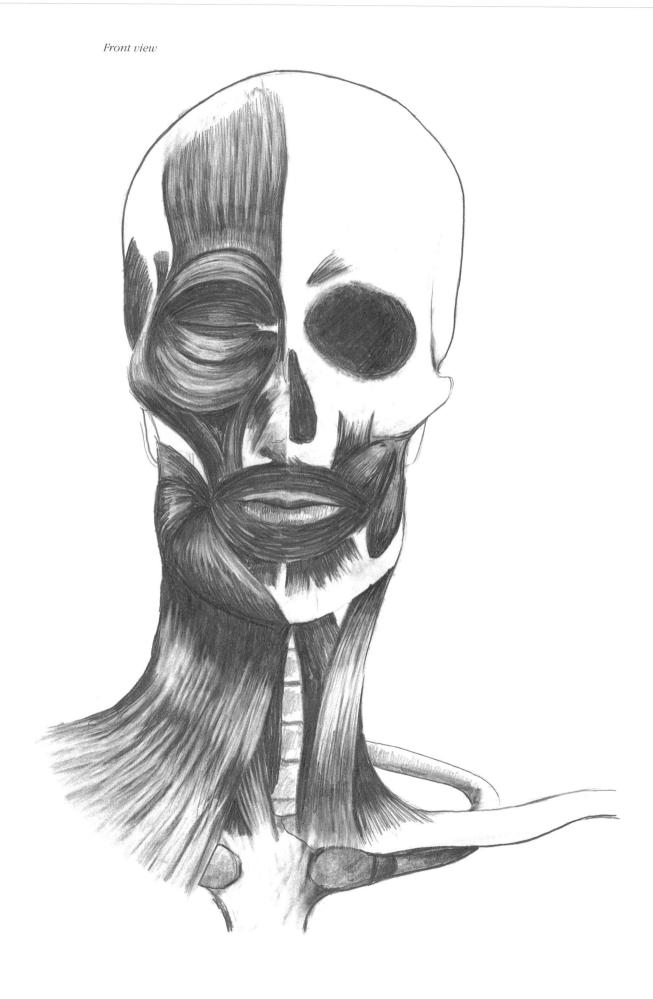

Side view

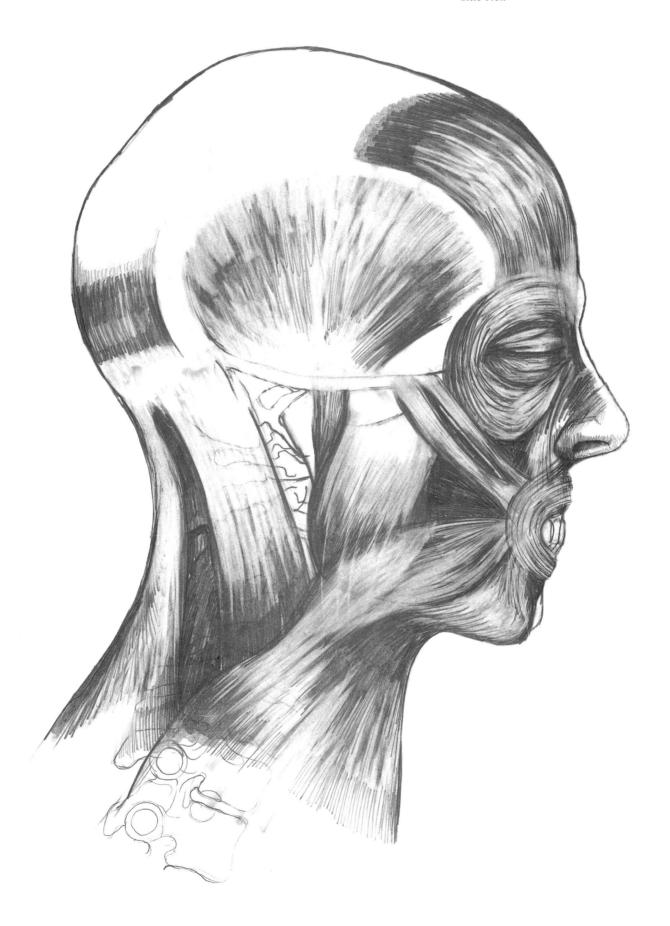

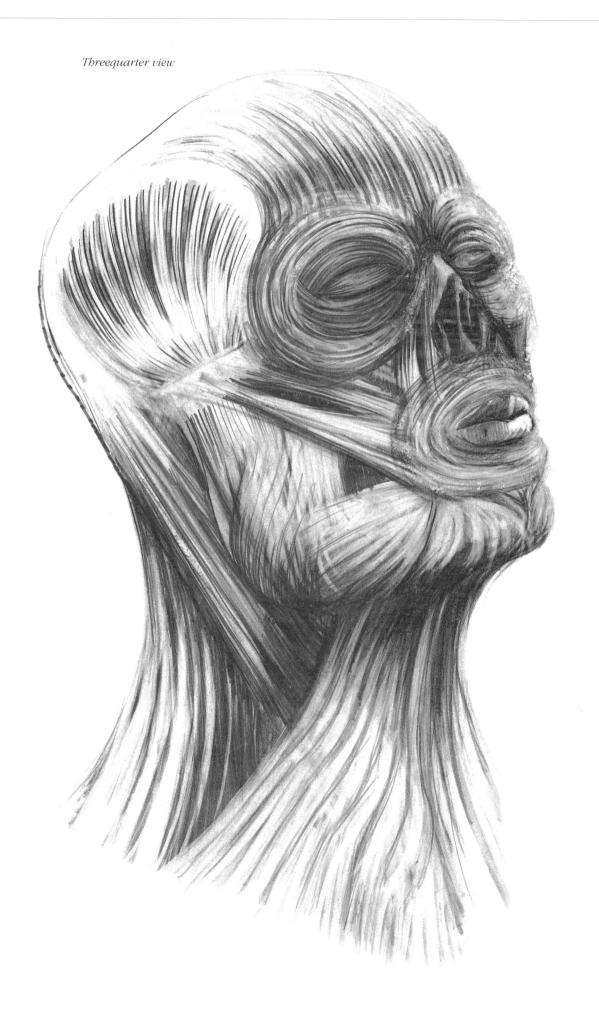

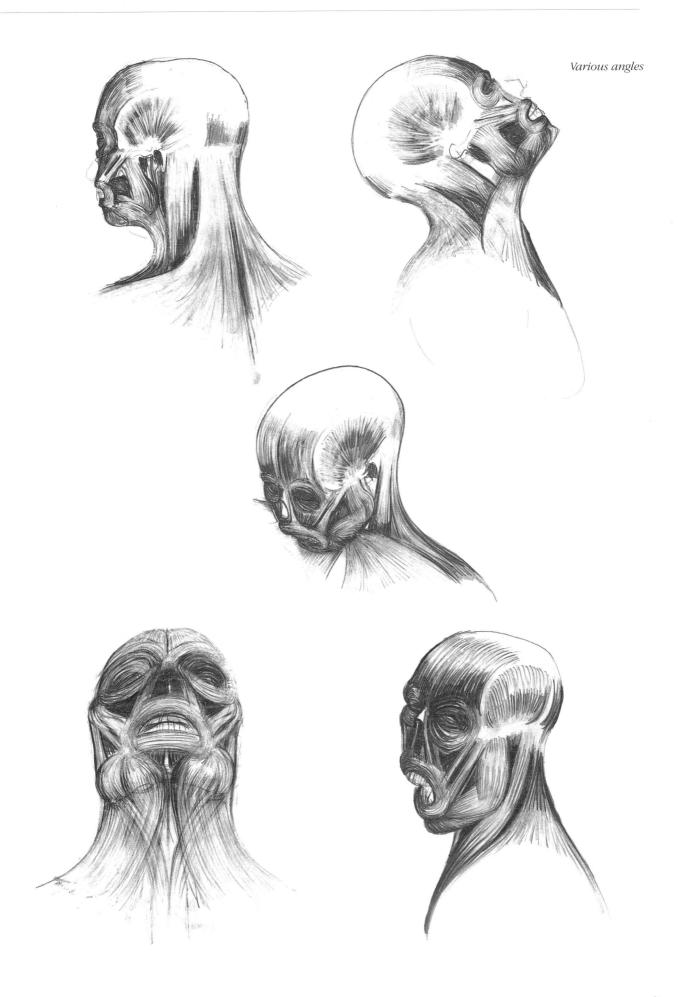

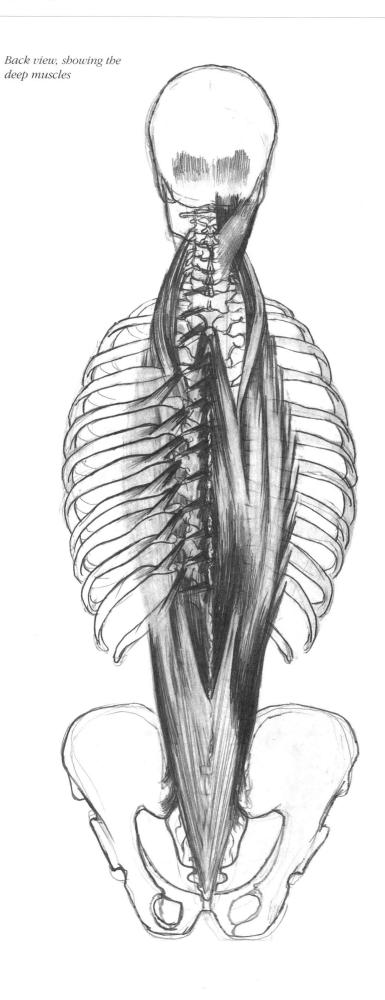

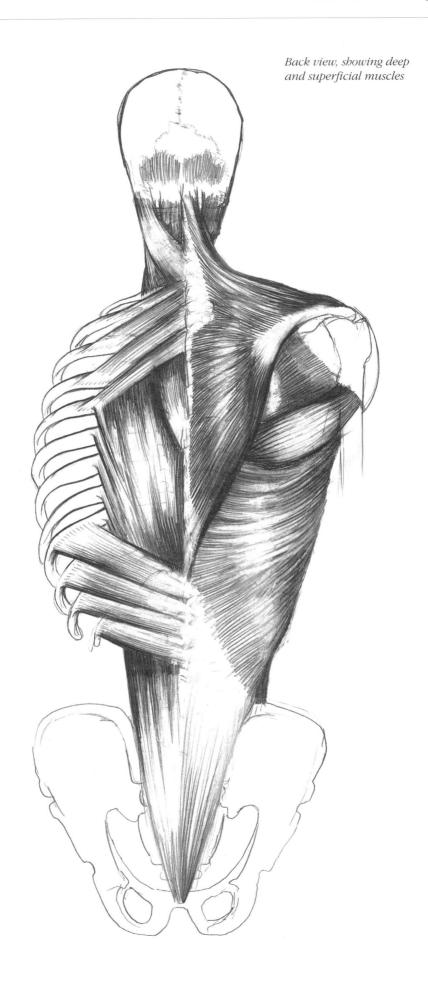

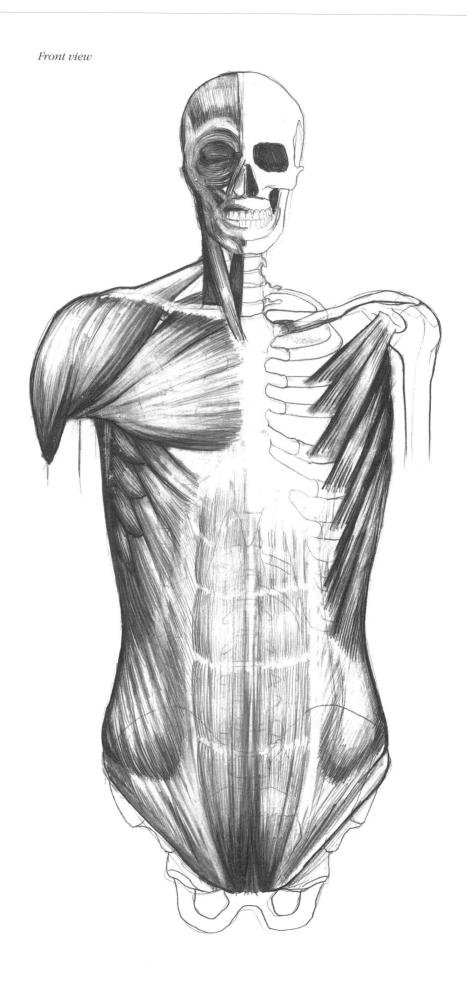

Side view

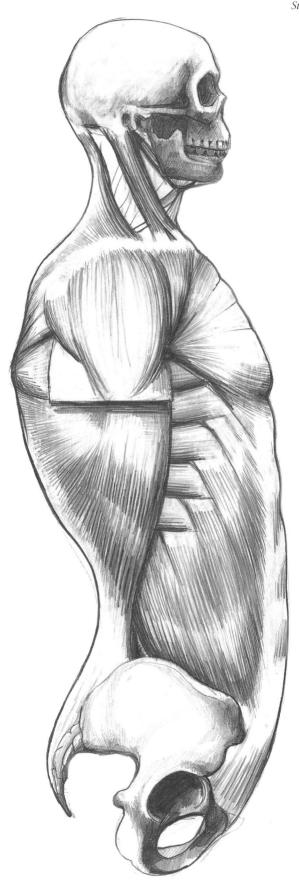

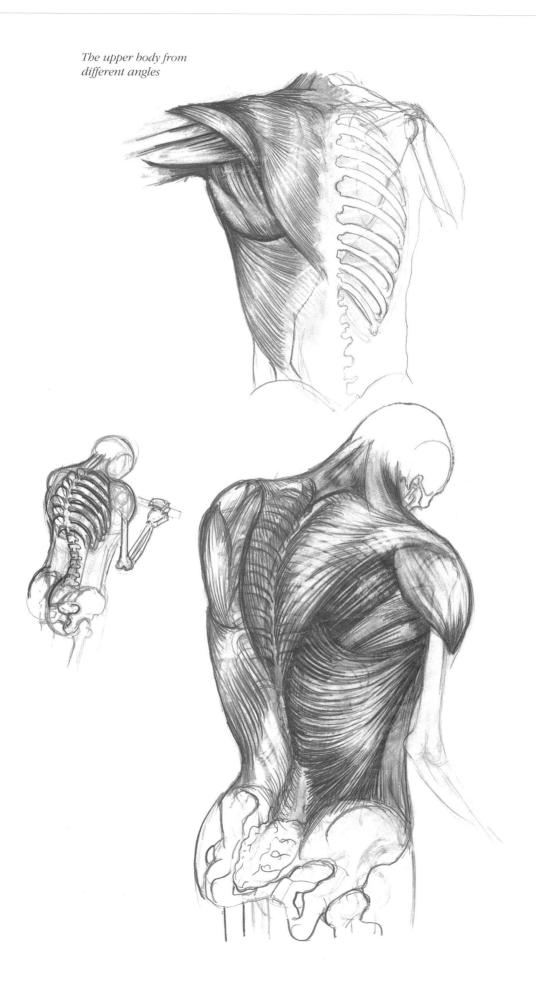

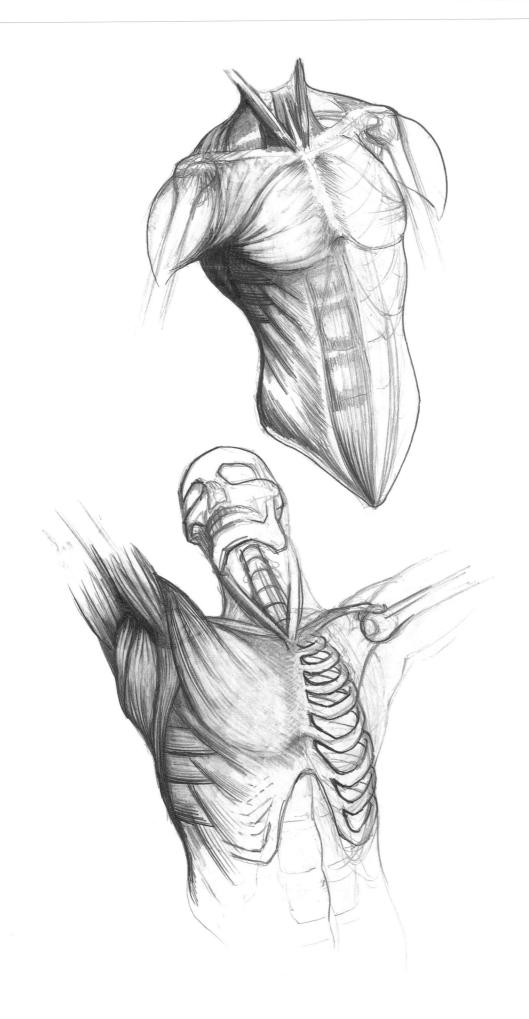

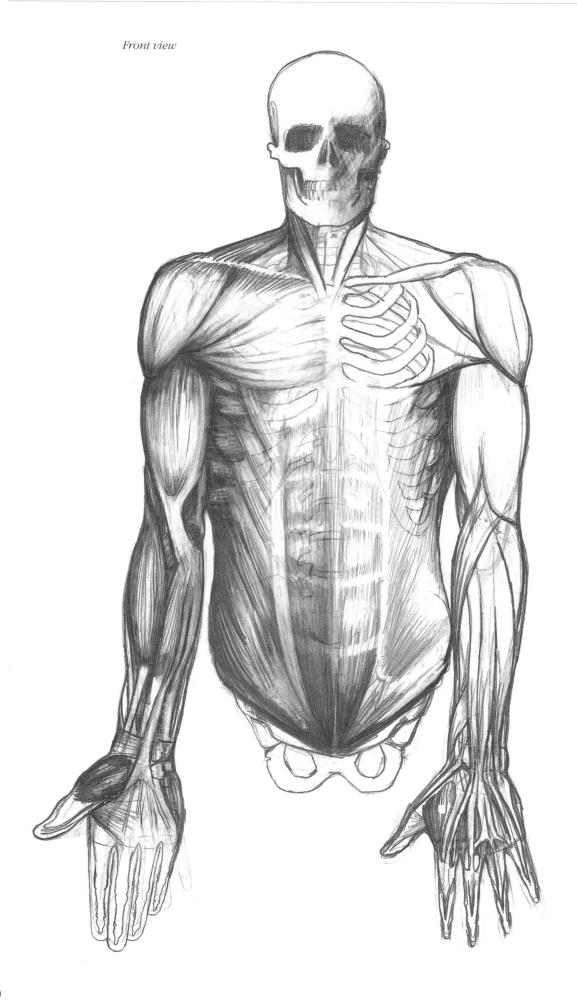

Side view

Arm muscles, side view

Arm muscles, flexed

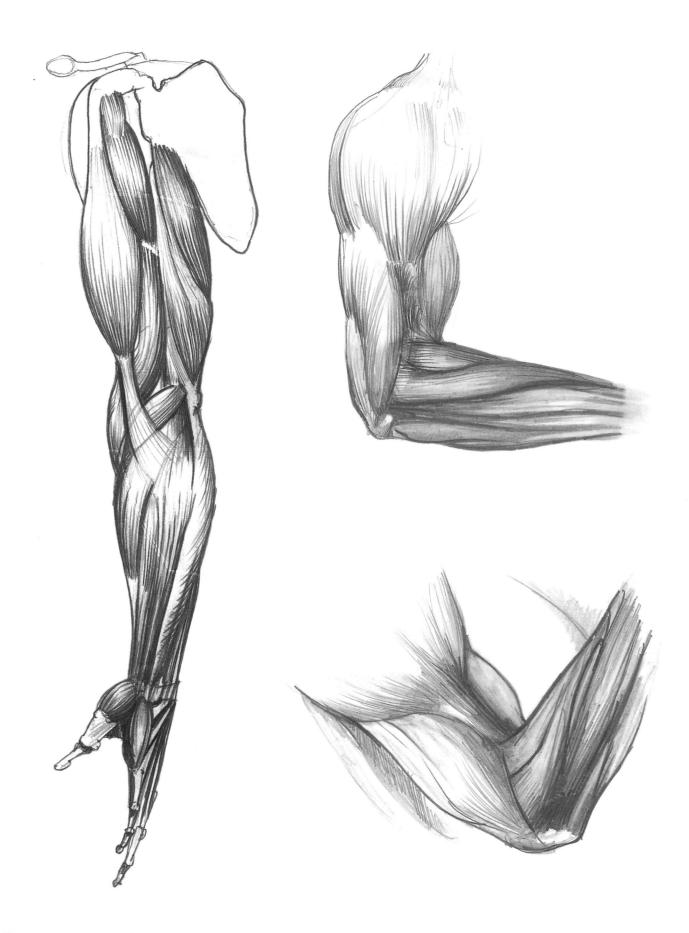

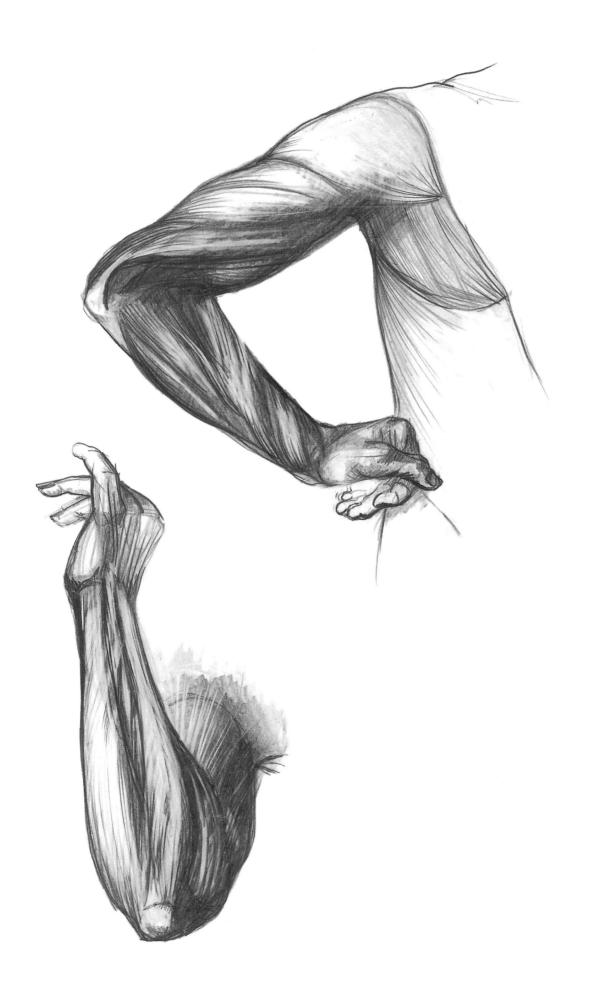

Hand, back

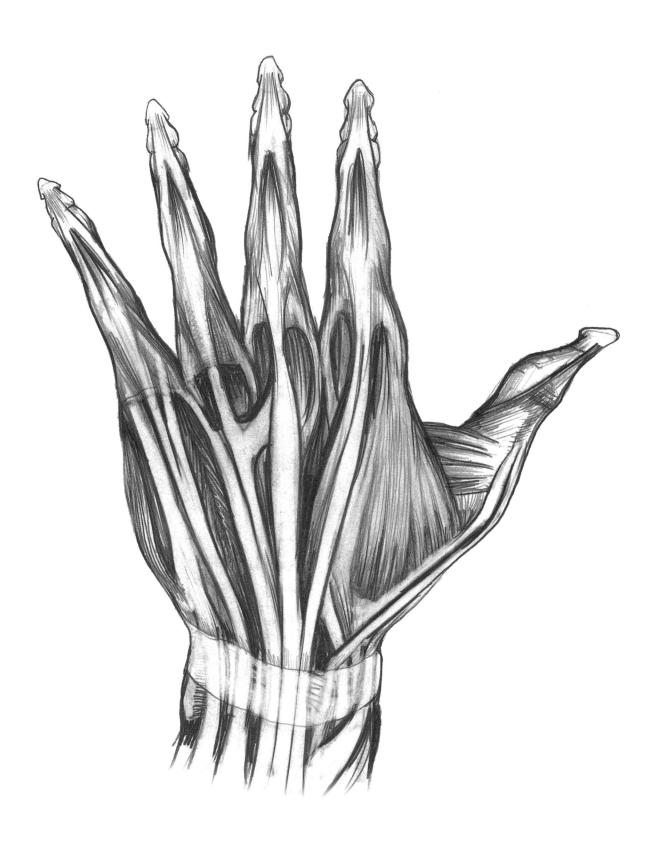

Hand, palm

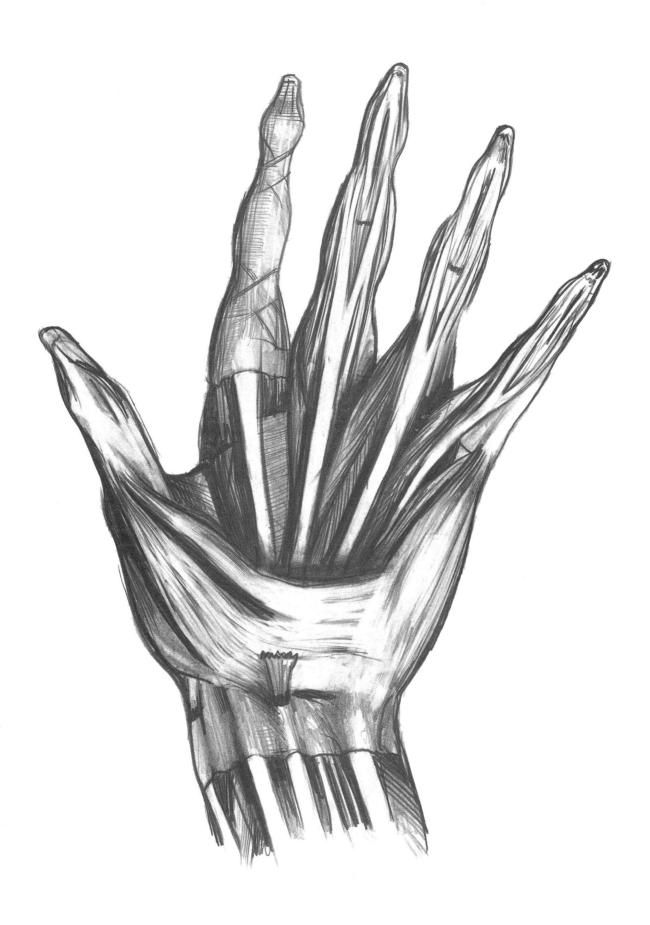

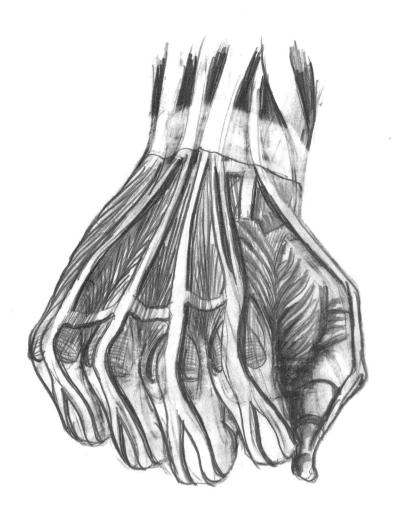

The hand from different angles

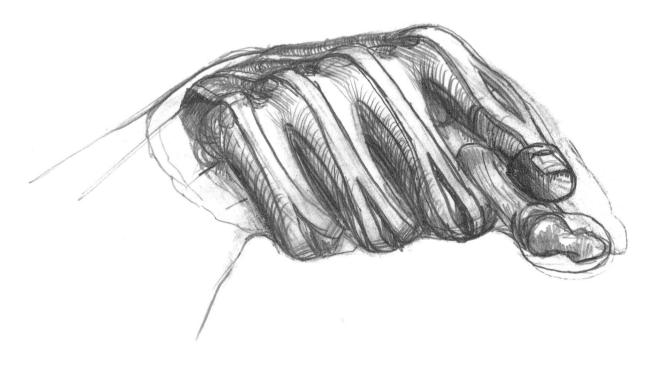

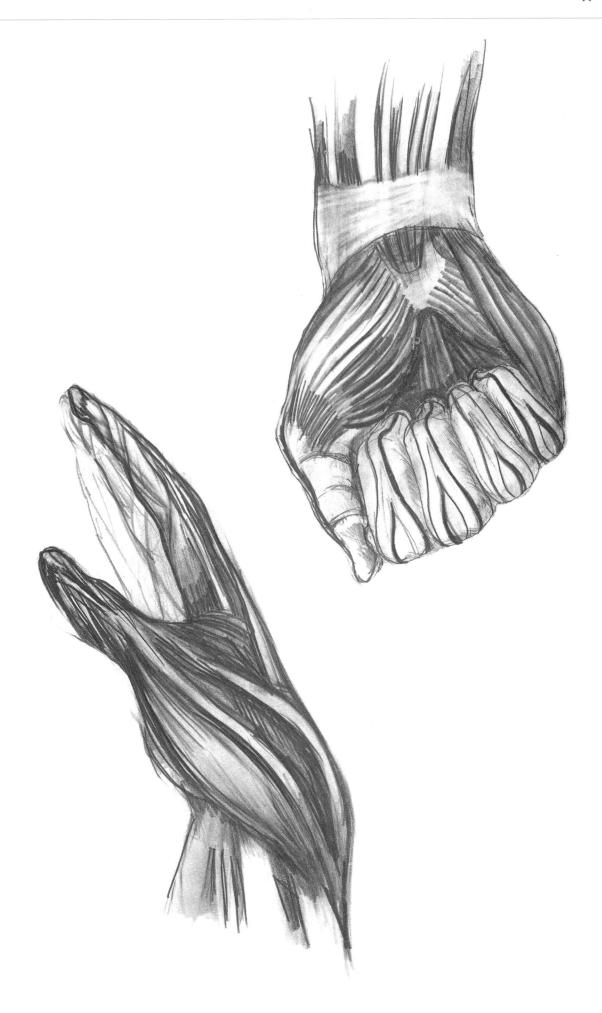

Leg bending, foresbortened

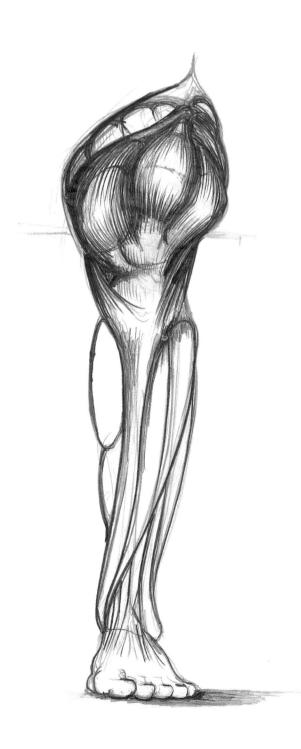

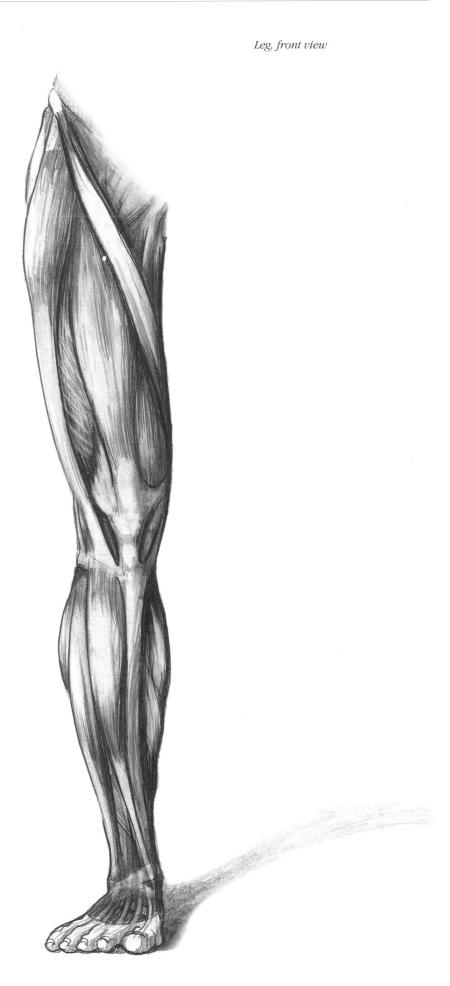

Leg, back view

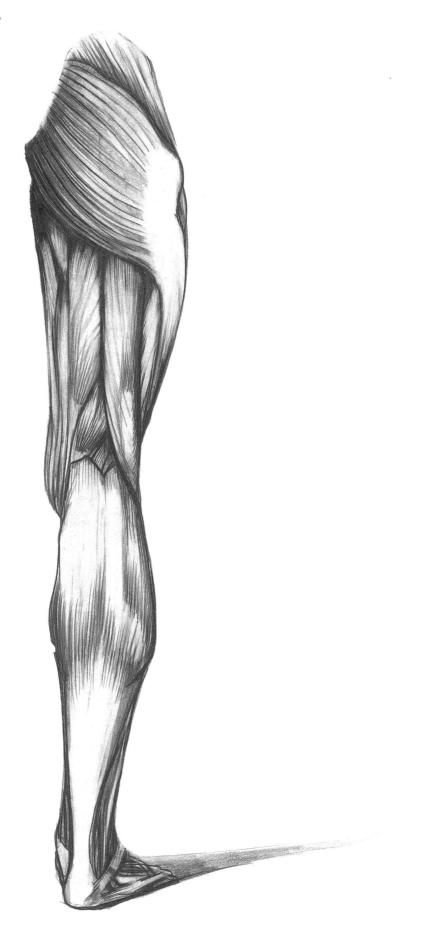

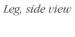

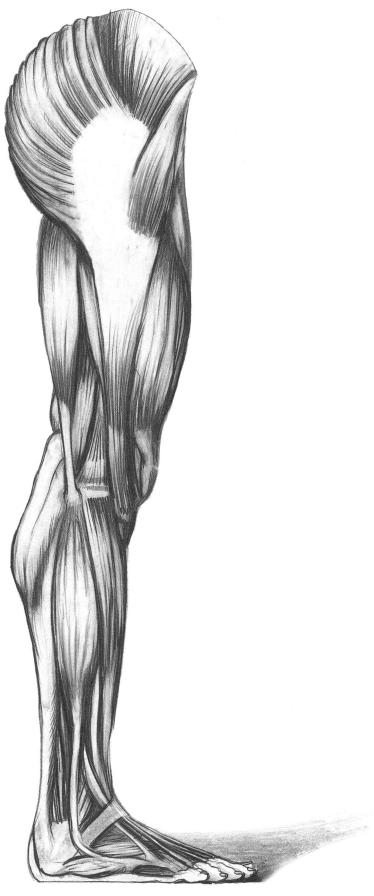

Leg, side view, straight and bent

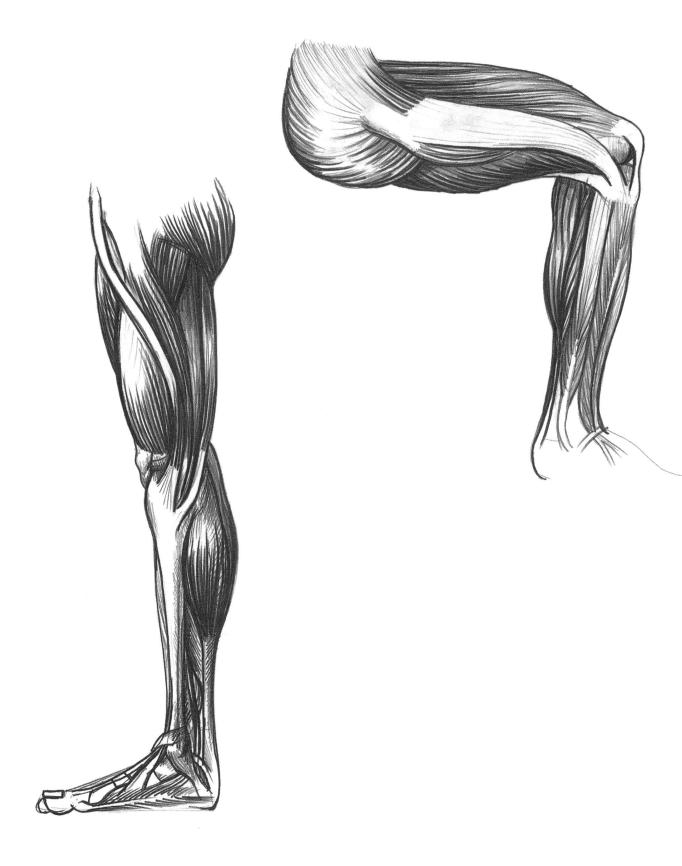

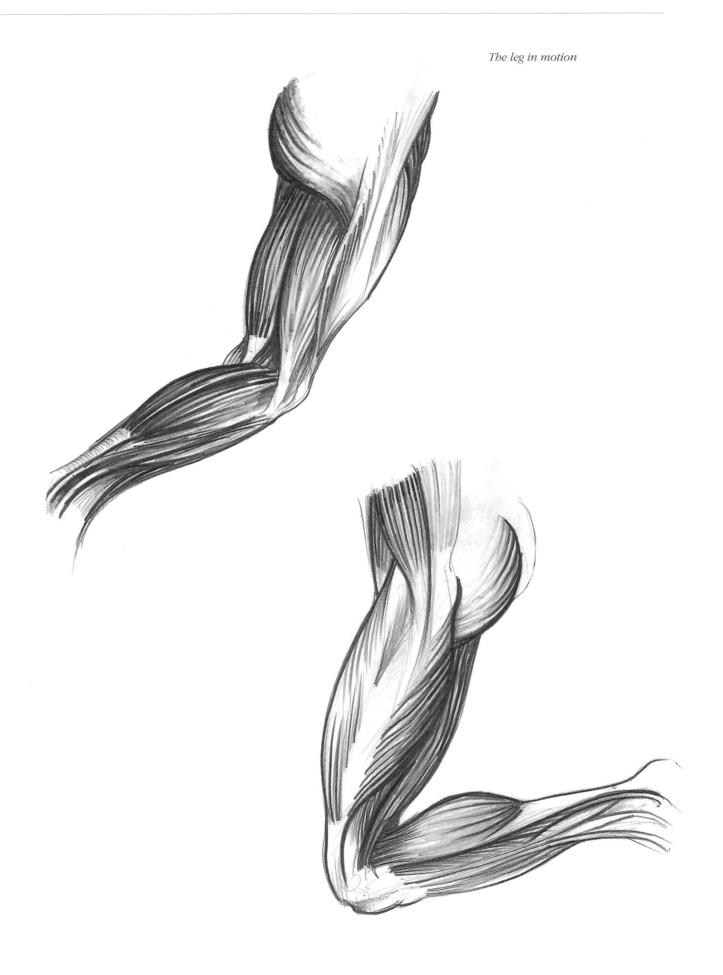

Foot, view from above

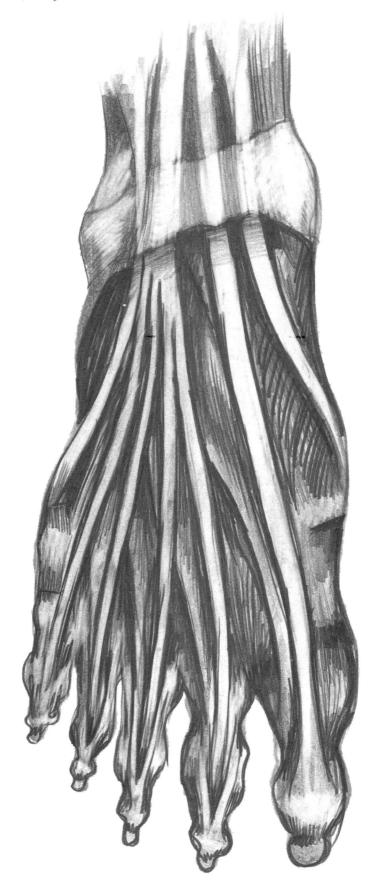

Sole of foot

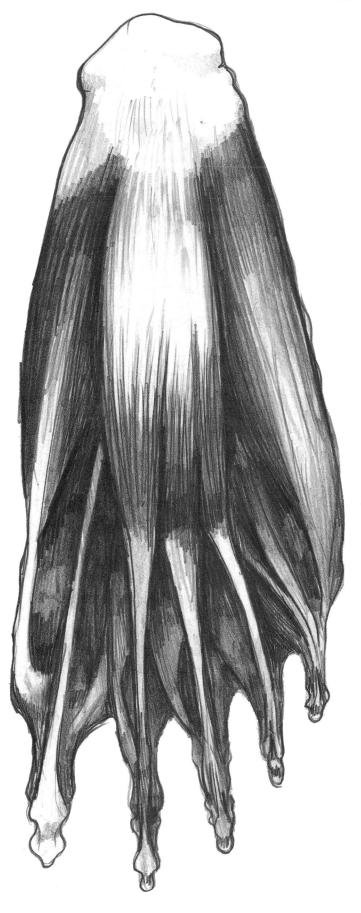

The foot in motion

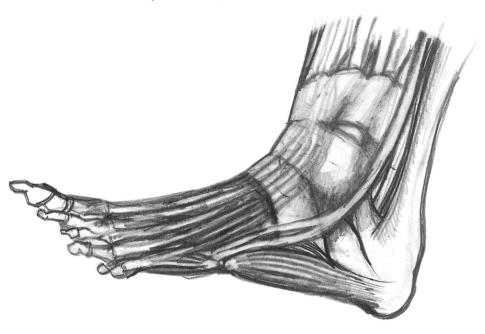

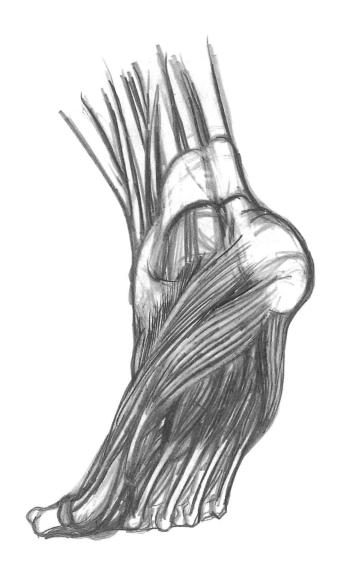

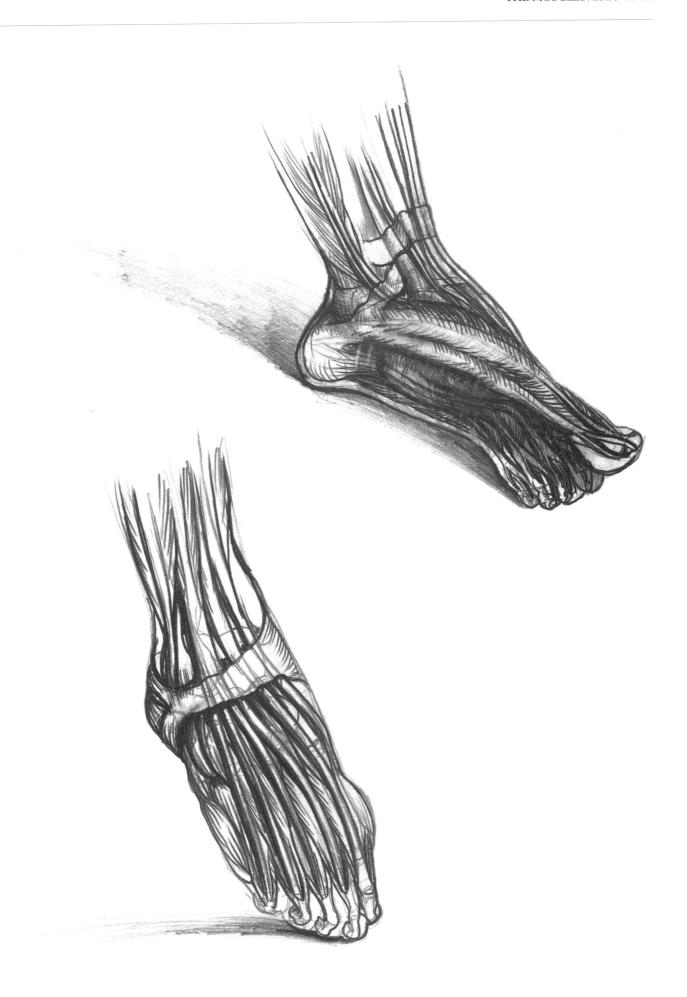

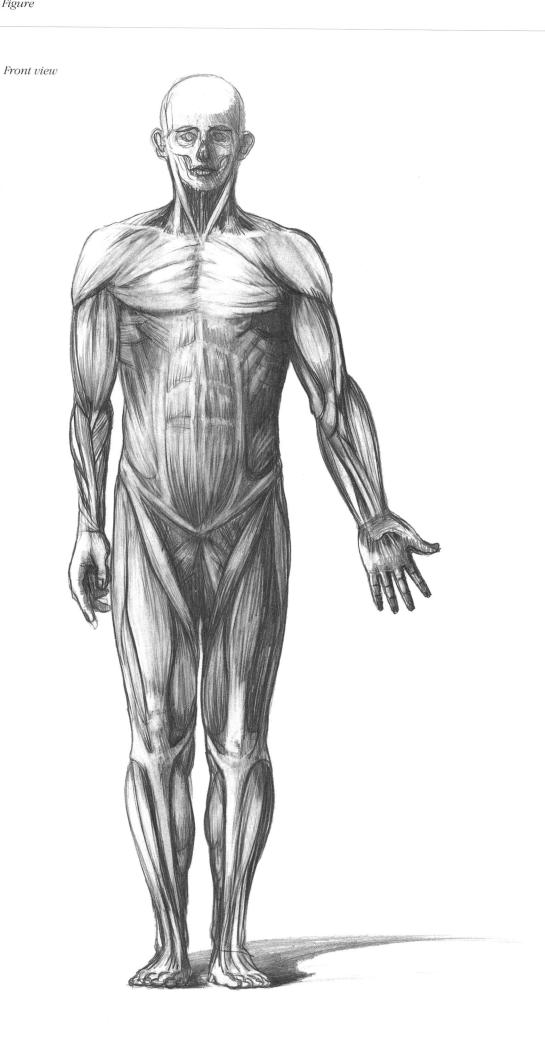

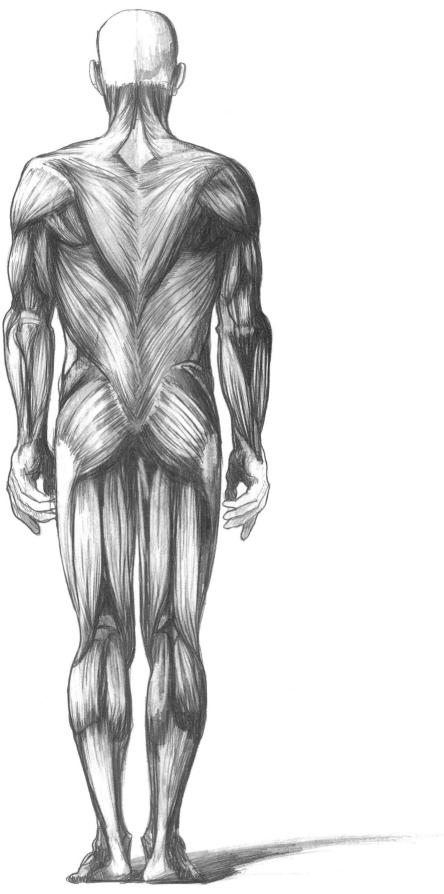

Side view

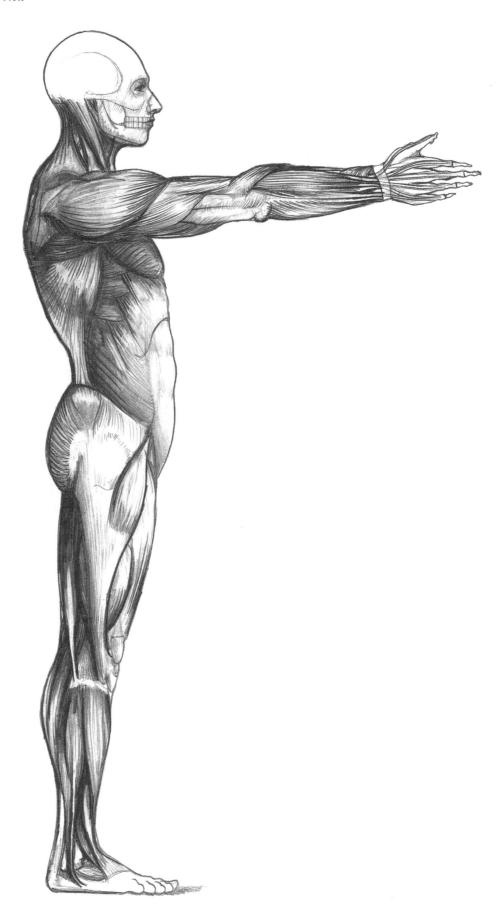

Prone position

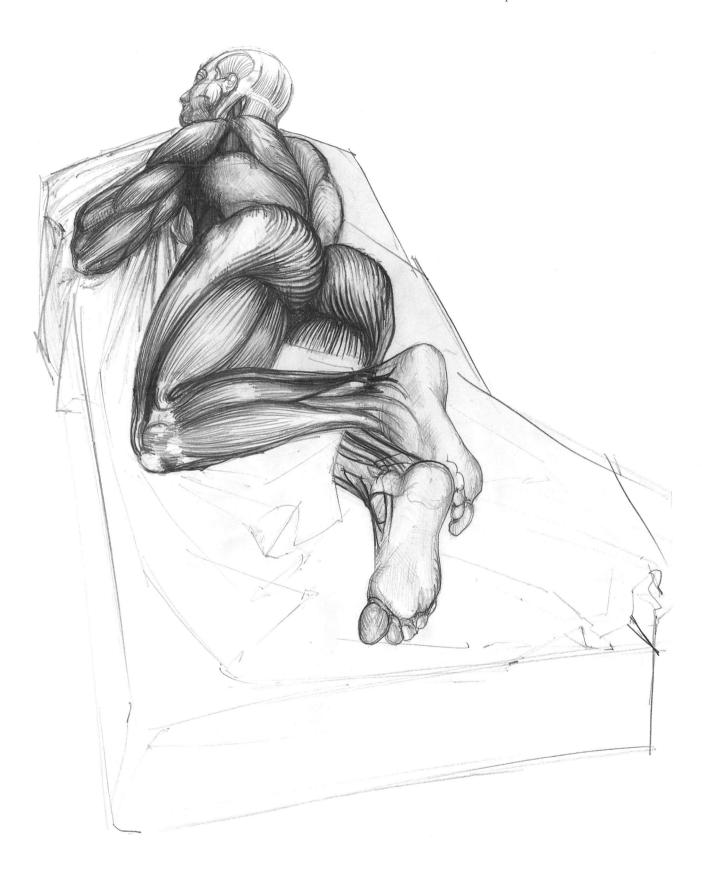

THE SKIN

Throughout the history of art the special attributes of the skin have been used by artists to express their observations of the human form. Portraits by Dürer, Rembrandt and Ingres – to name but three masters – reveal a fascination for the skin. Their handling of it is so expert and informed by understanding that we viewers feel the truth and 'realness' of what we are looking at. When we have this feeling, a work ceases being a mere portrait and becomes art.

How much of the structure of the superficial muscle appears through the skin will vary from subject to subject. In a heavily built or rotund person the skin stretches loosely over the body, whereas in someone who is leaner the skin fits around the underlying form more tightly. Similarly, the texture and look of the skin change with age, state of health and the position of the body.

In the following series of drawings you will find examples of these differences and variations.

Old age

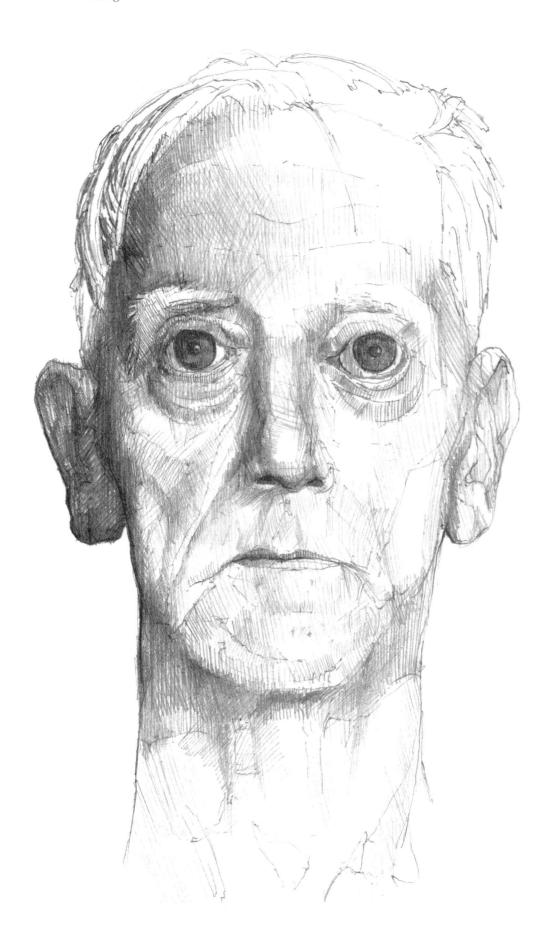

Middle age

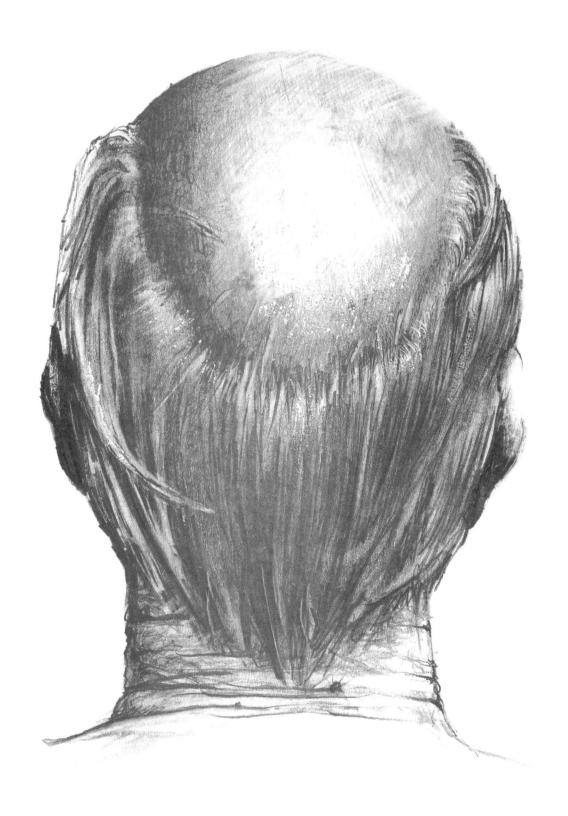

Youth

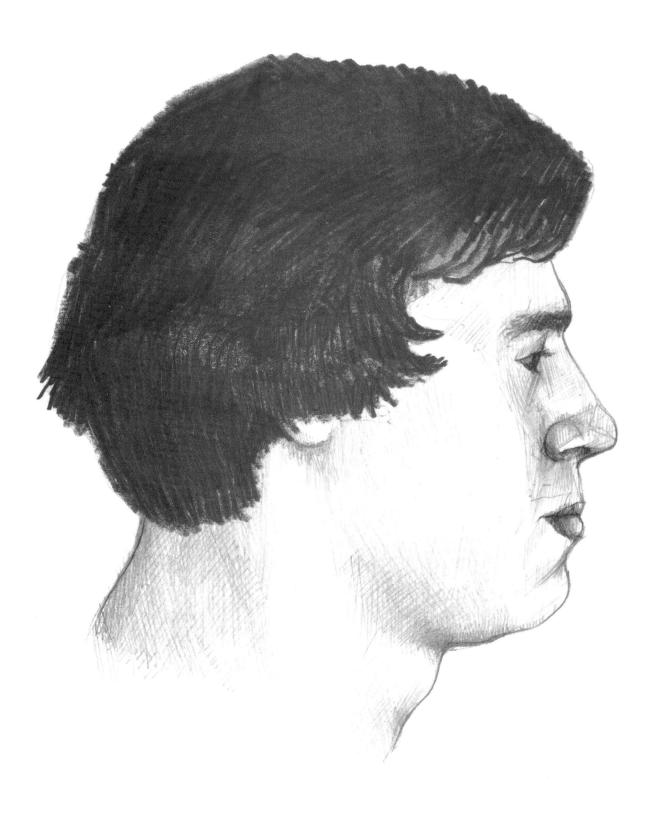

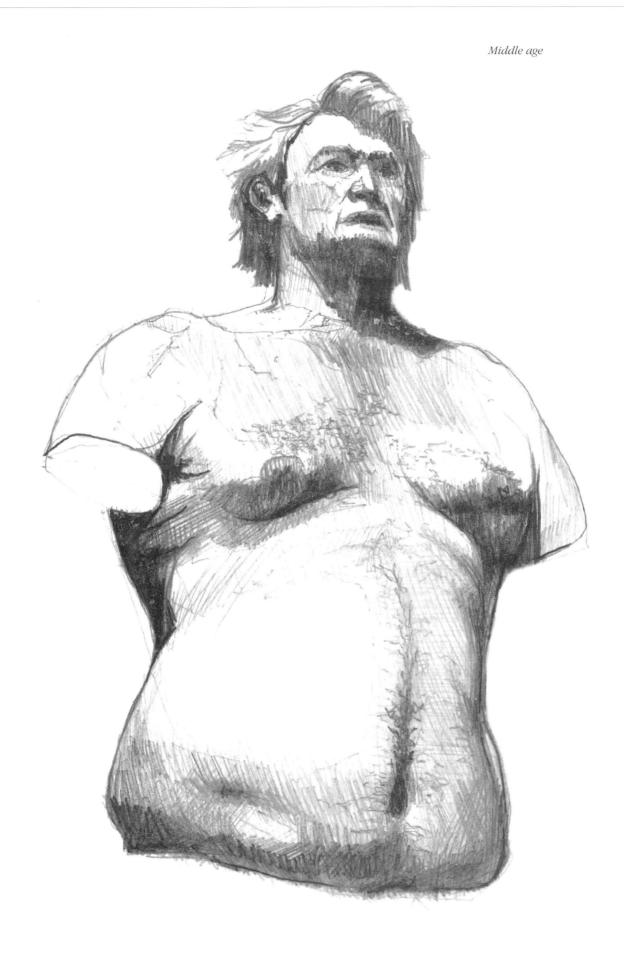

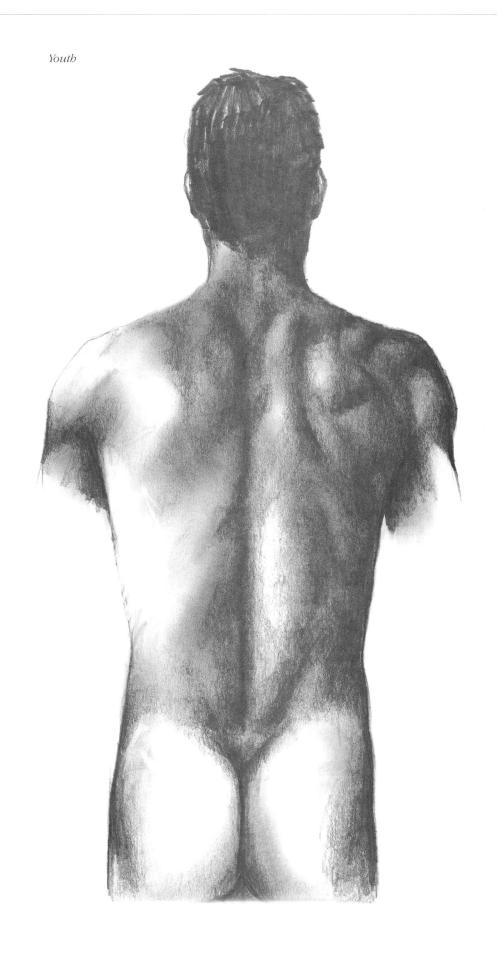

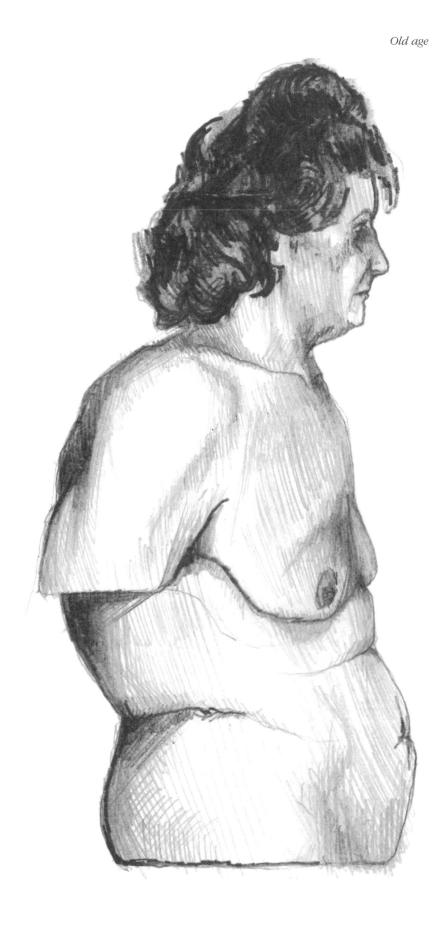

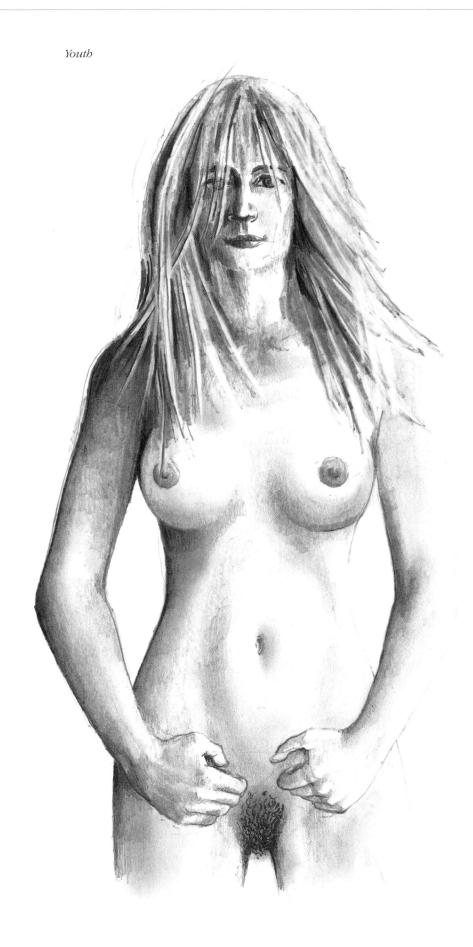

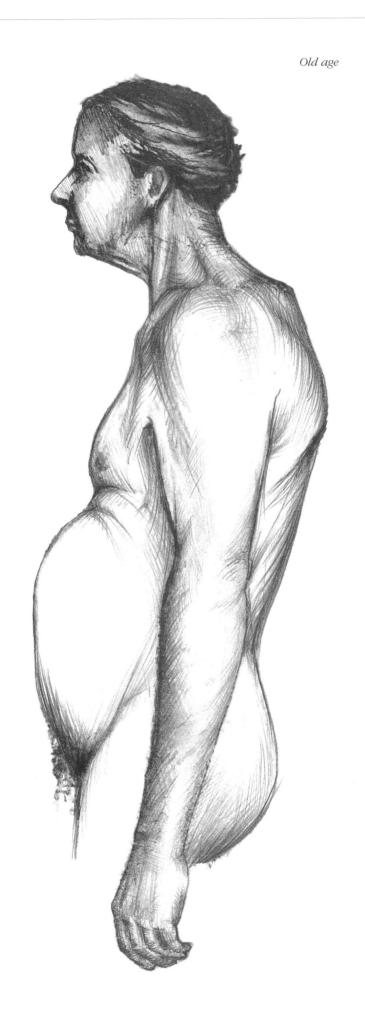

Middle age

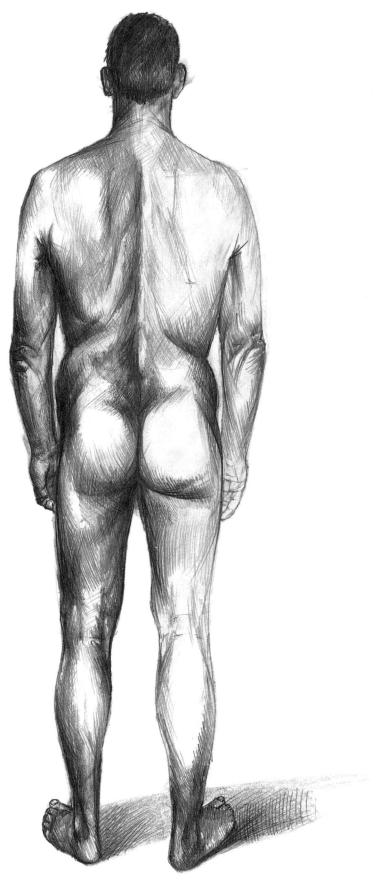

Old age

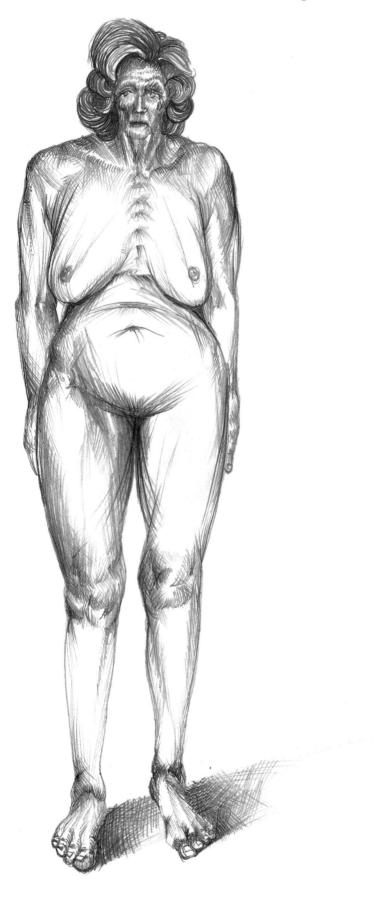

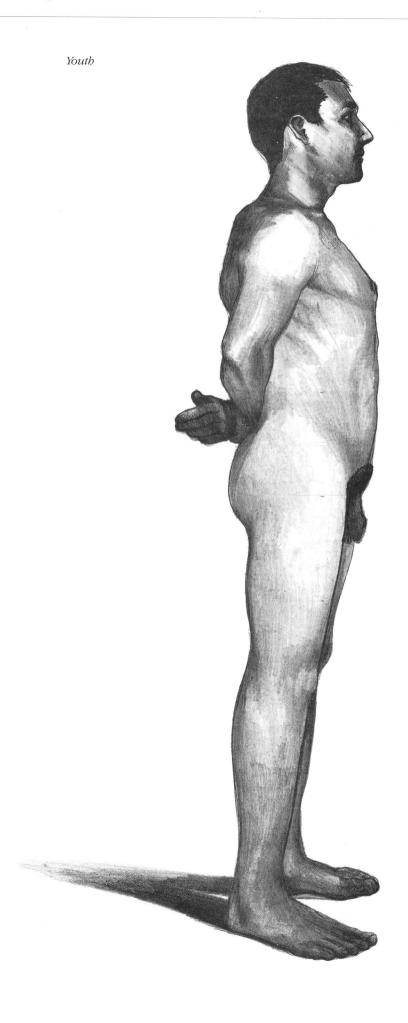

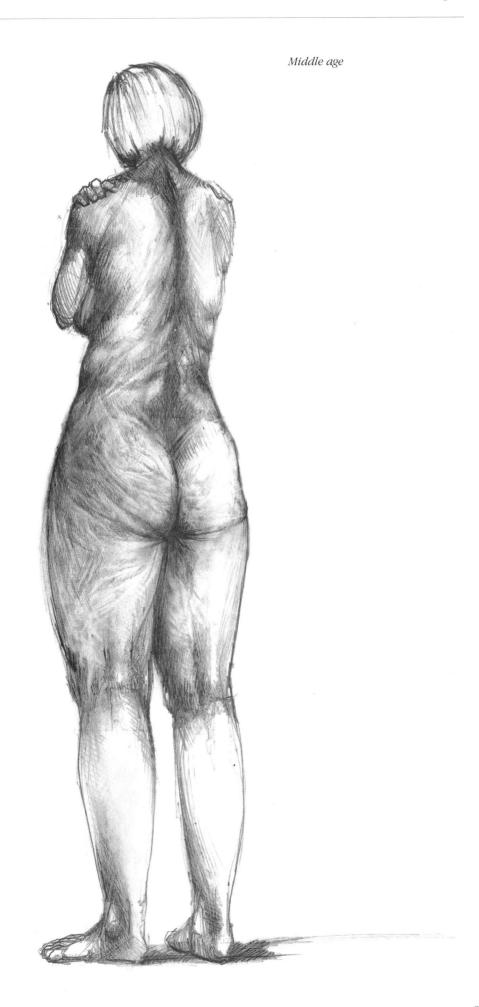

PROPORTION

Proportion, and how it relates to human anatomy, has been studied by Western artists since time immemorial. Although here we are presenting proportion as a means of giving an accurate classical measurement to the human figure, it is worth remembering that it can also be used non-realistically, to make a symbolic statement.

The basic key to proportion is assessing the size of one part of the body in relation to the rest. Artists like Leonardo and Dürer observed that the human body could be divided up, or measured, by using the head as the unit of measurement. As you will see from the series of drawings shown in this section, the height of the head – measured from its top to the bottom of the chin – goes into the height of the body eight times.

This system of measurement only works when the model is standing straight, either facing us to the front, side or back. However, if the model is sitting, lying, bending or in any other position, we must use a system that helps us create the illusion of the form and proportion of the figure moving back through space on the flat picture plane. We can do this by using the same unit of measurement in a grid system across the drawing. Using this proportional unit, the artist is able to work out the exact size of certain anatomical features in relation to others. Measuring in this way will give you a very clear knowledge of anatomical proportions within the human body.

The proportions shown in this section are of average-size males and females. Proportions can, of course, vary between individuals, and the artist has to take this into account when studying a subject.

Front view

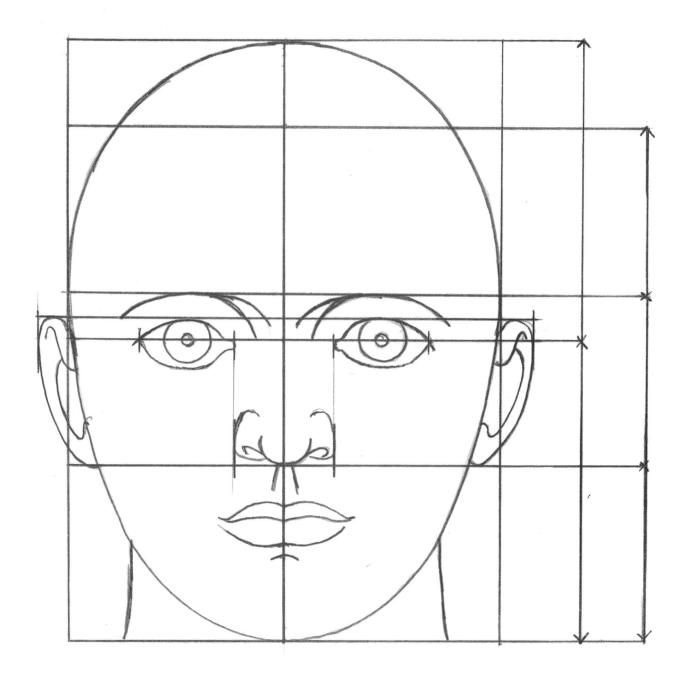

Side view

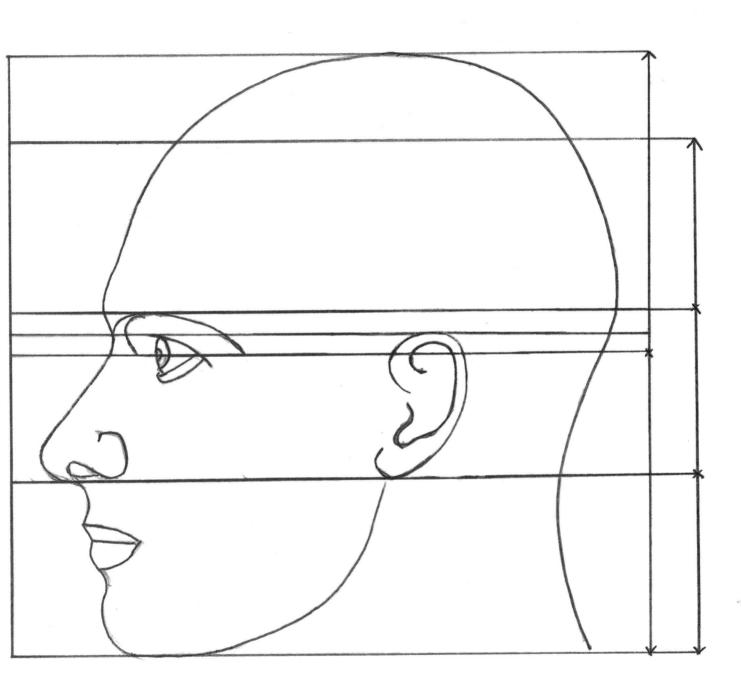

Front view

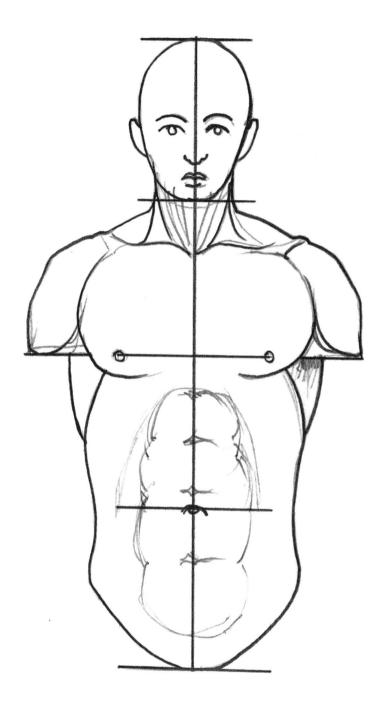

Side view

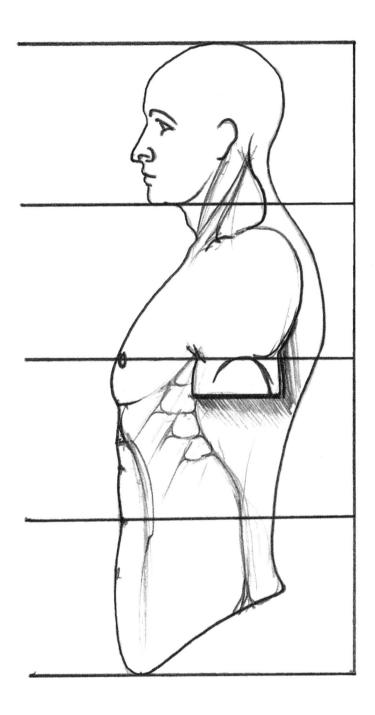

Front view

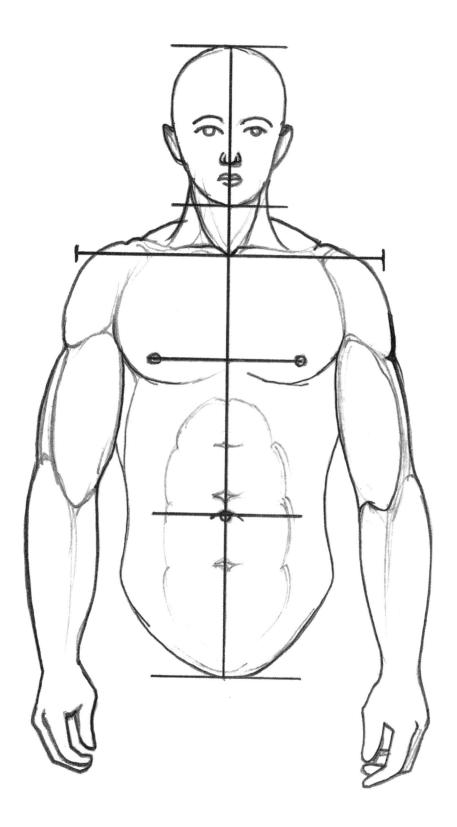

Side view

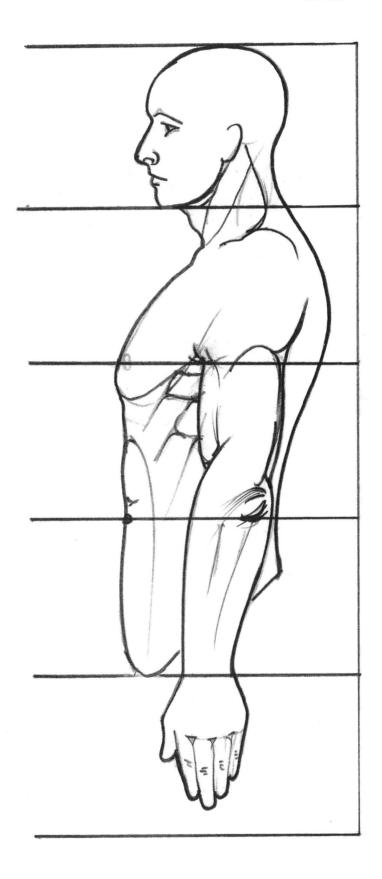

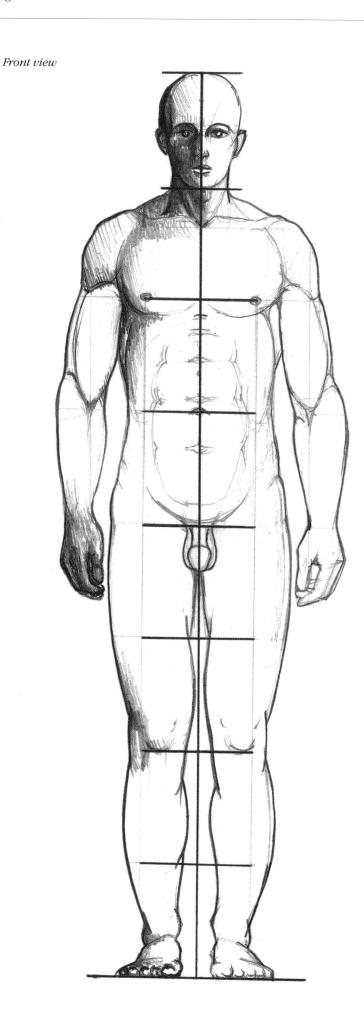

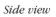

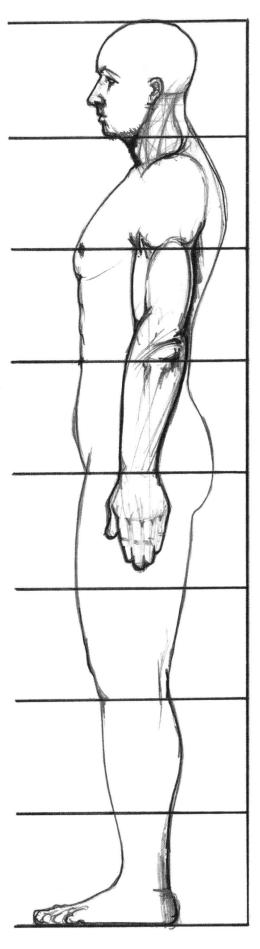

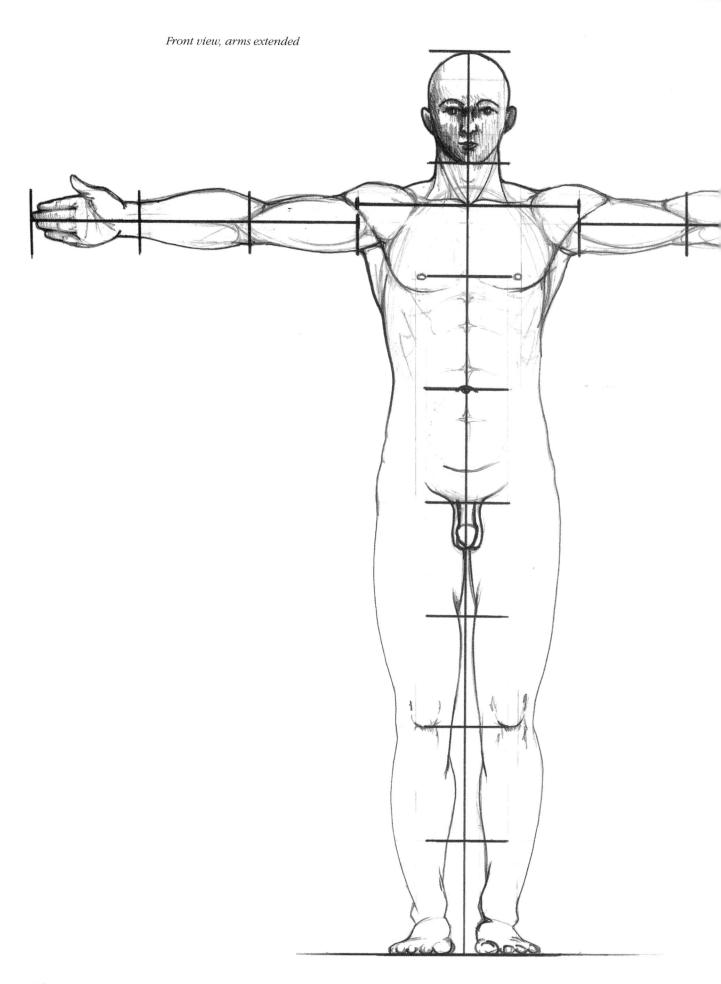

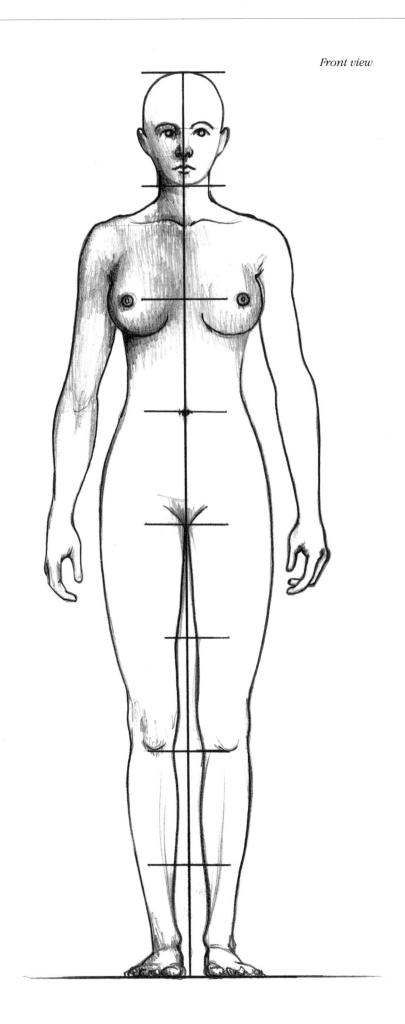

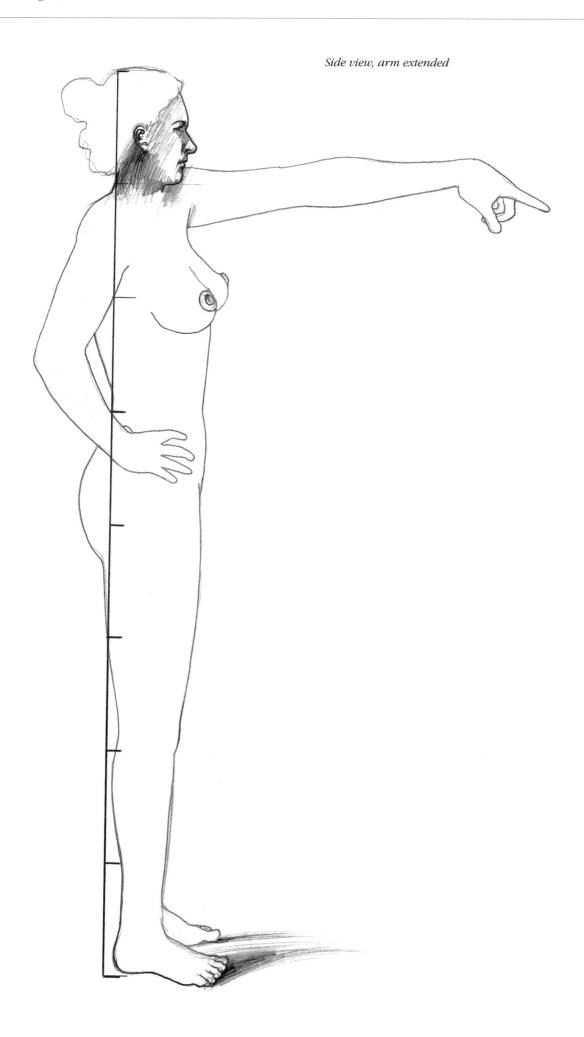

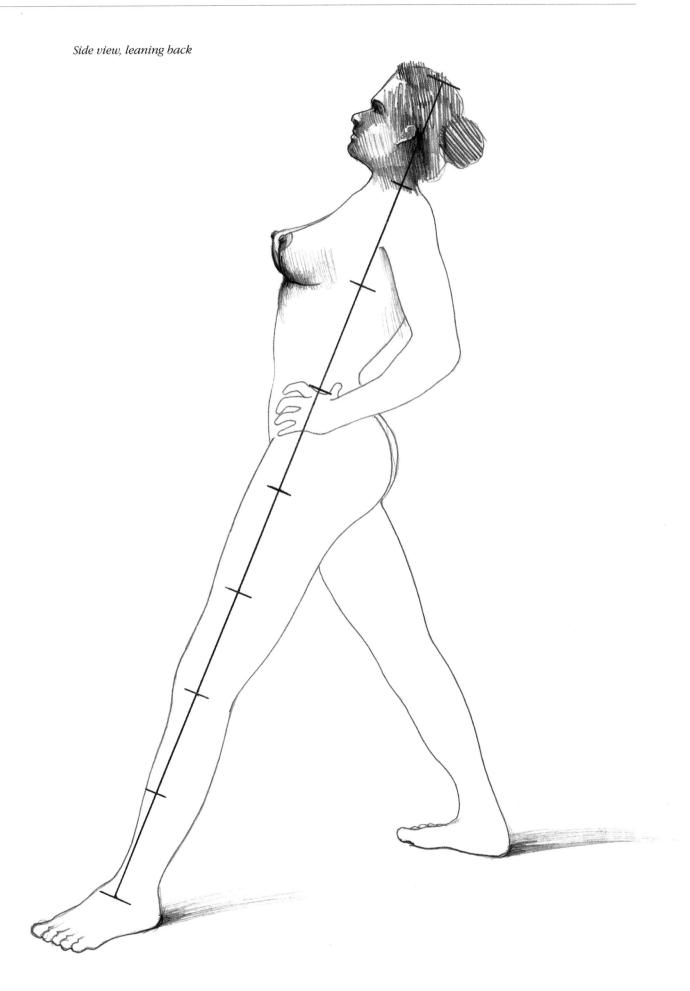

Side view, arms behind

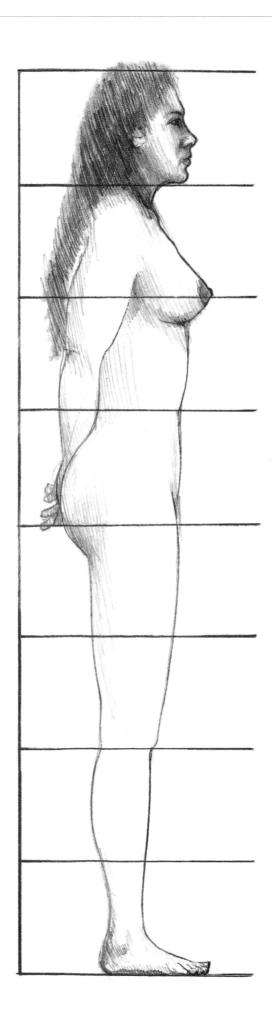

Side view, bending and stretching

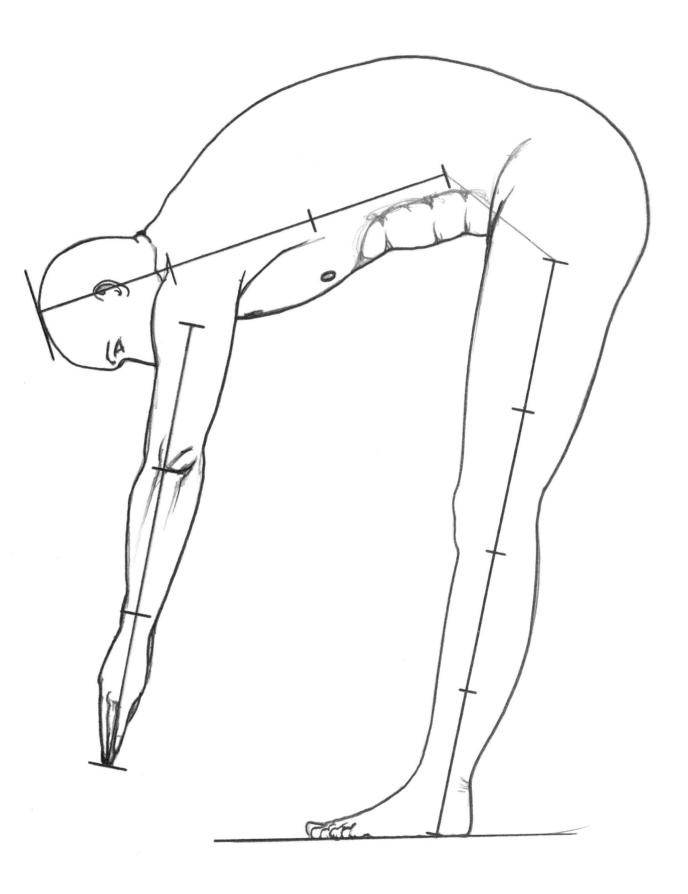

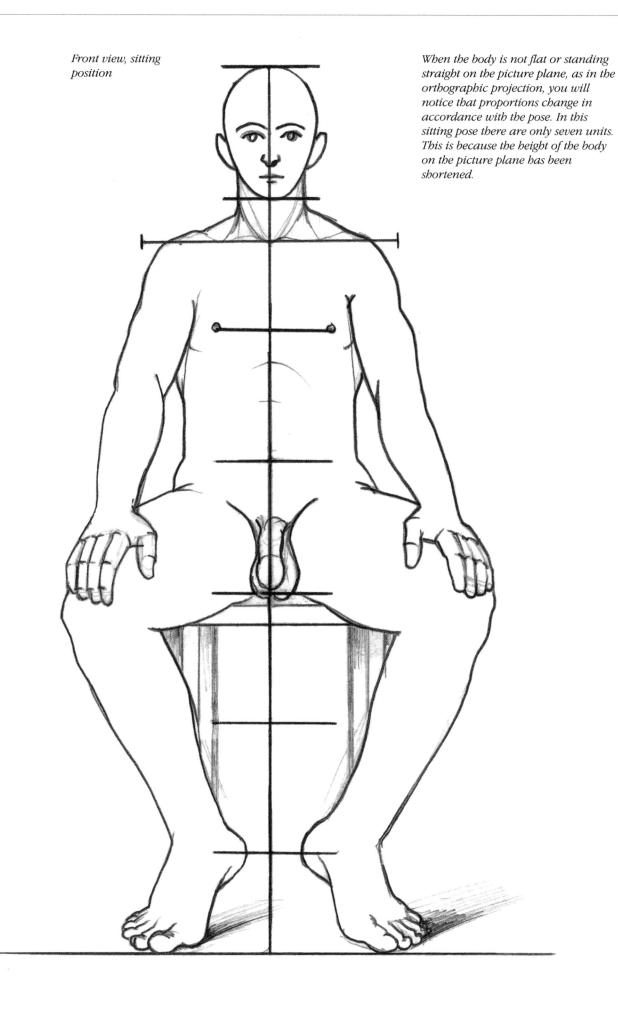

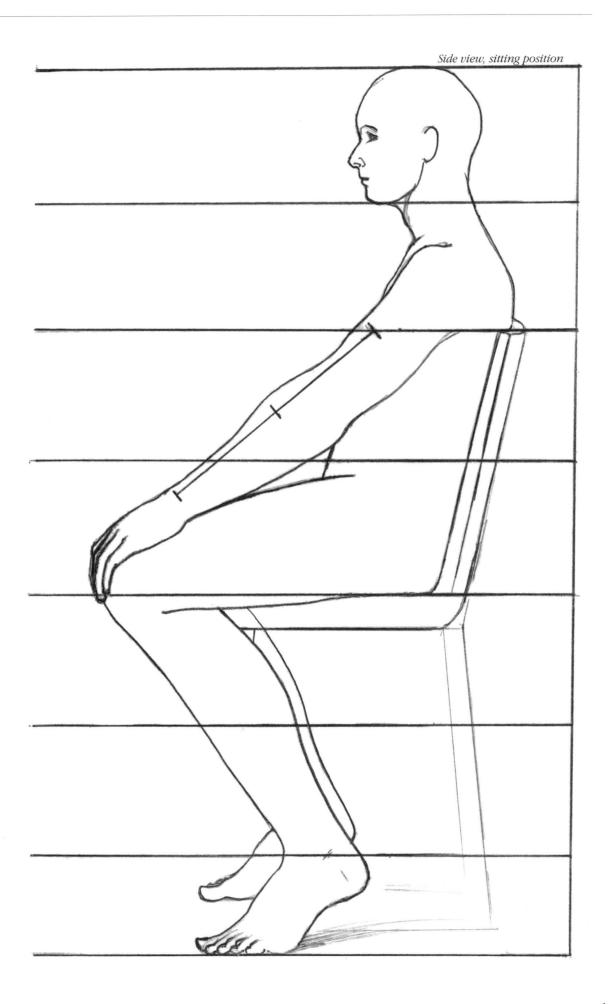

POSTURE

Posture is the way we hold ourselves. It is controlled by the muscles, which in turn are programmed by the impulses they receive from the brain. Like the skin, posture can tell much about a subject. When we talk of 'body language', we mean the communication of fundamental information about an individual at a particular moment.

Posture can be used to express and symbolize any number of attitudes and attributes: generosity or meanness, hope or despair, bravery or cowardice; the list is endless. Before setting up a pose the artist must have a clear idea of what he wants to communicate or express. The position the model is then placed in must reflect the nature of the drawing. Rodin's *Thinker* and Michelangelo's *David* are famous examples of artists using posture and gesture to give conscious meaning to their work. In the *David*, for example, we read the virtues of nobility, leadership, youth and compassion. Goya's *The Nude Maja* embodies passion and eroticism.

Thinking through your ideas before you pose a model and start drawing will enable you to approach it with a purpose and dynamic direction that will translate into expressive communication, qualities that are integral to any worthwhile work of art.

Front view

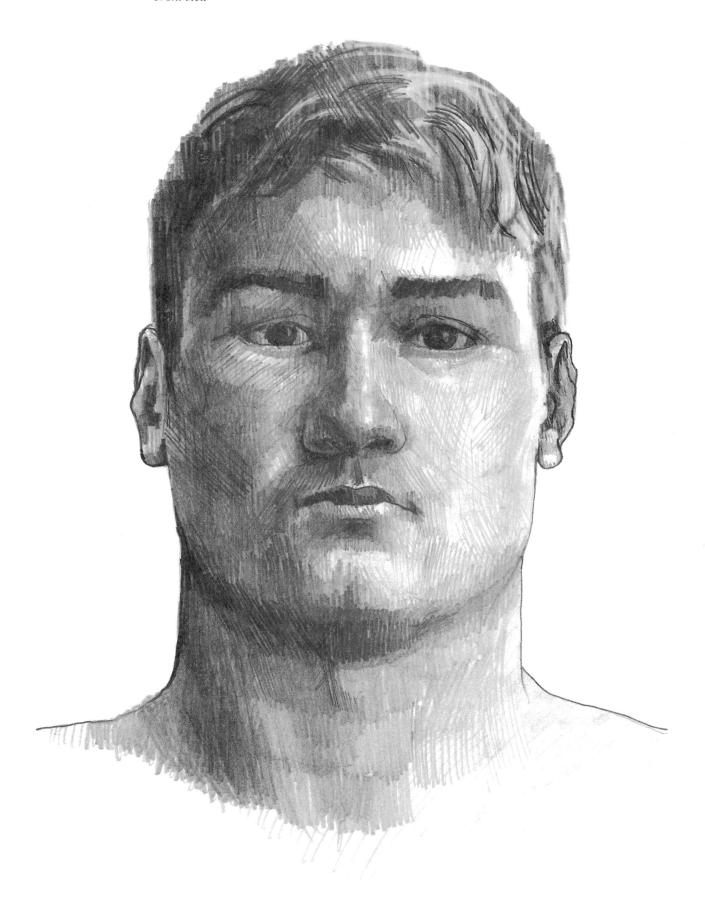

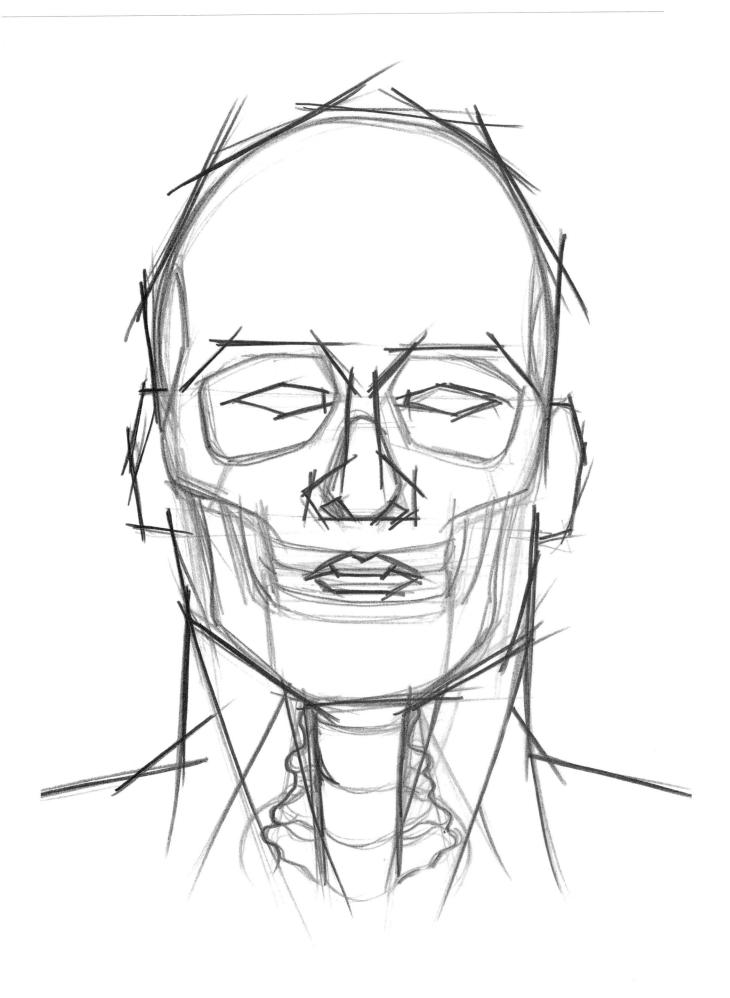

Front view, angled

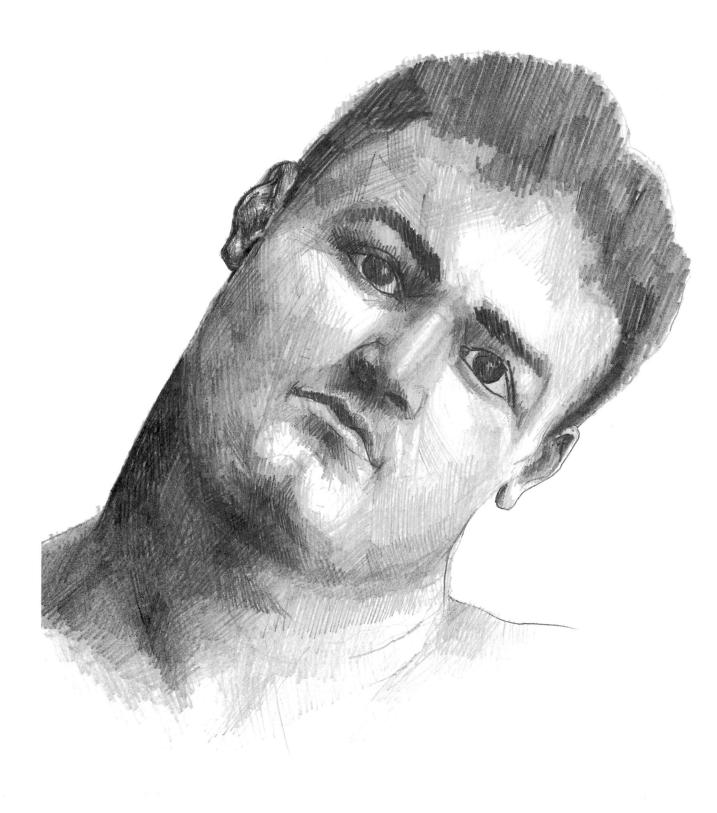

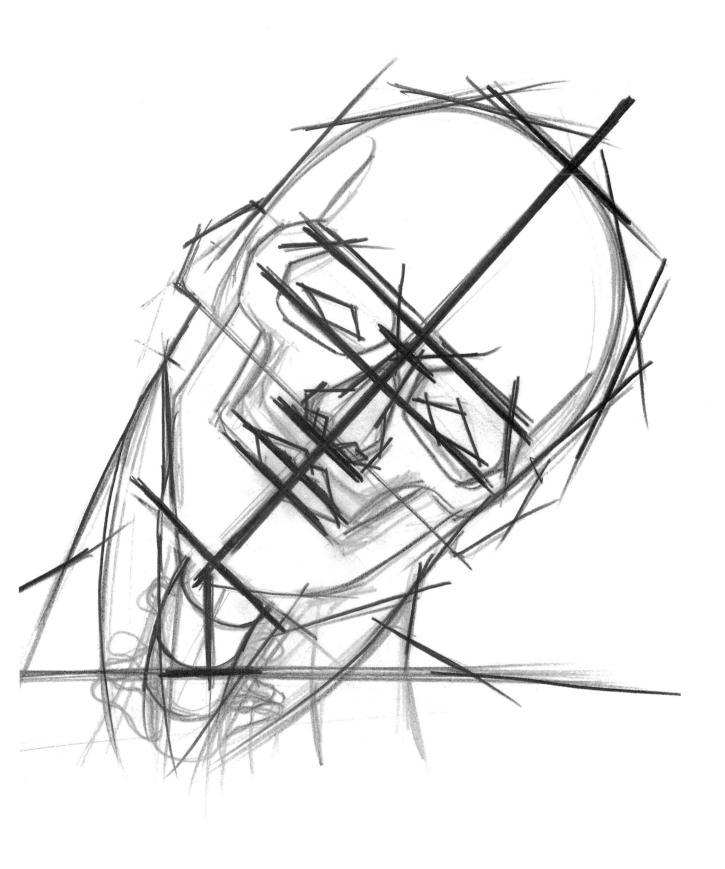

View from below

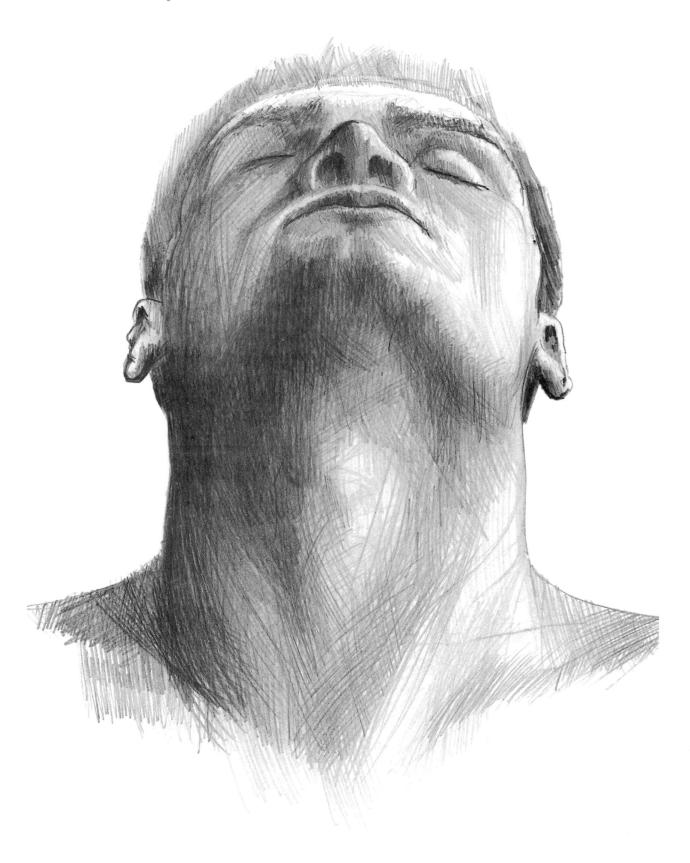

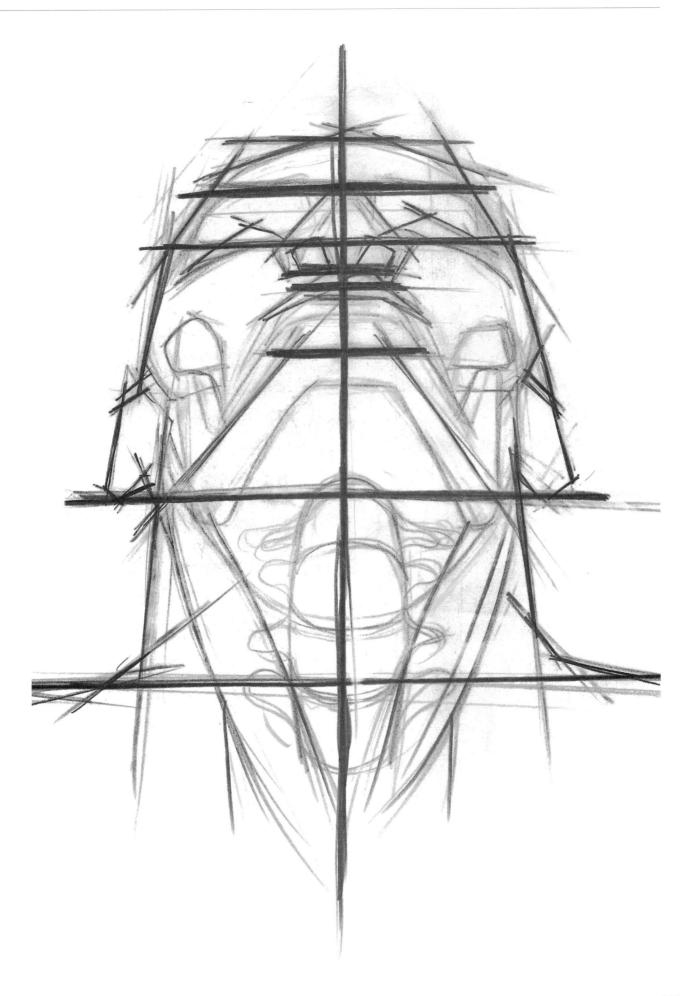

Threequarter view

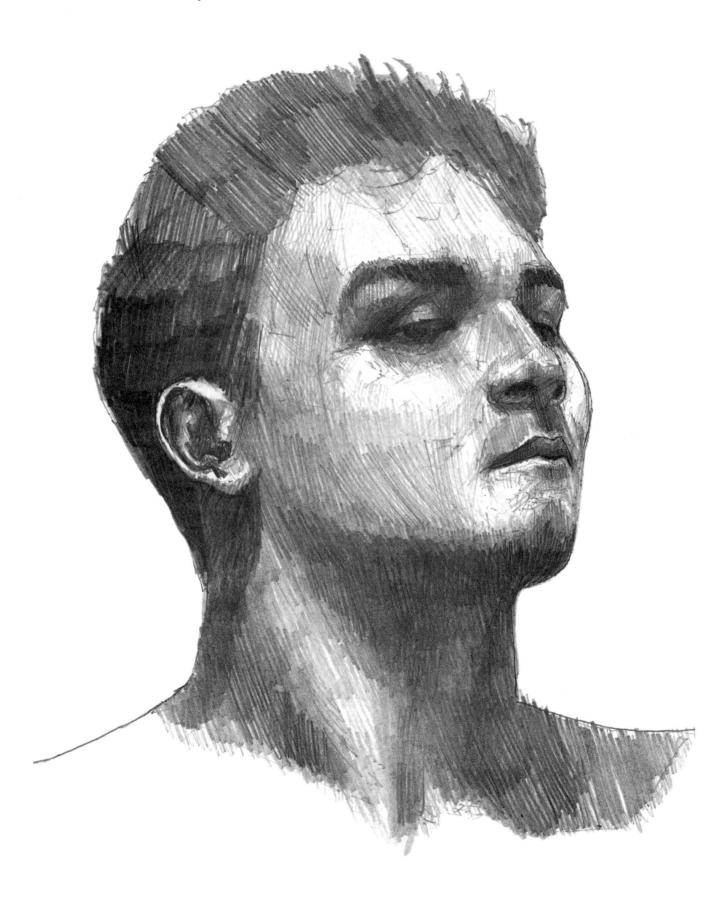

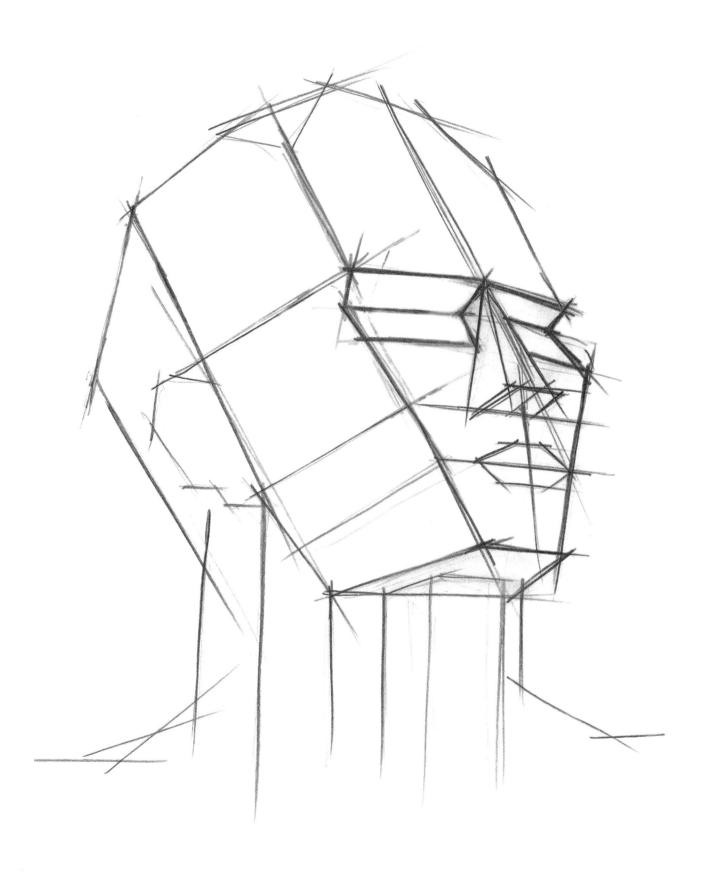

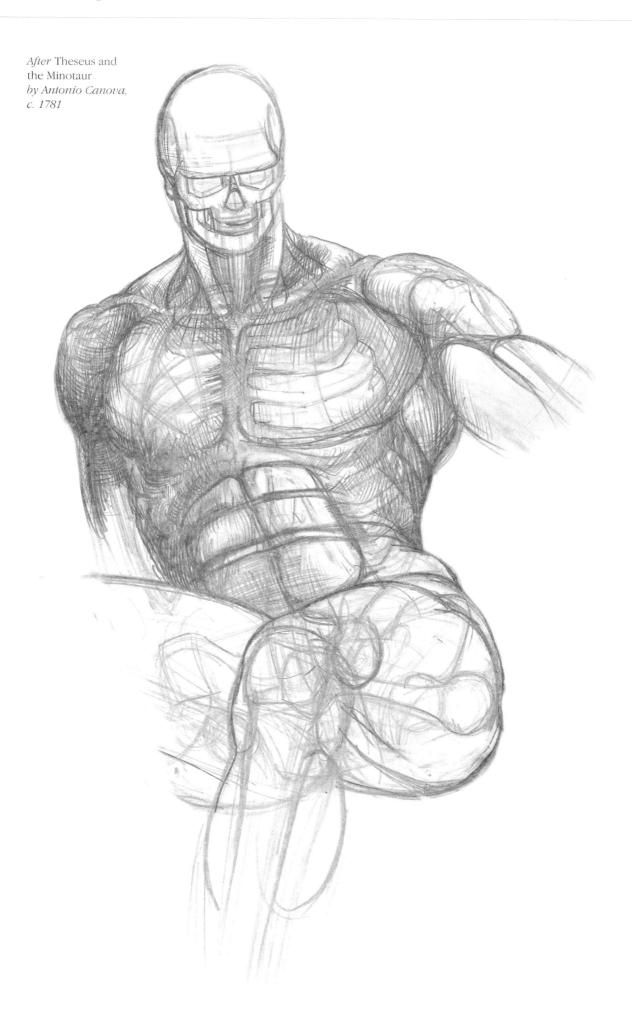

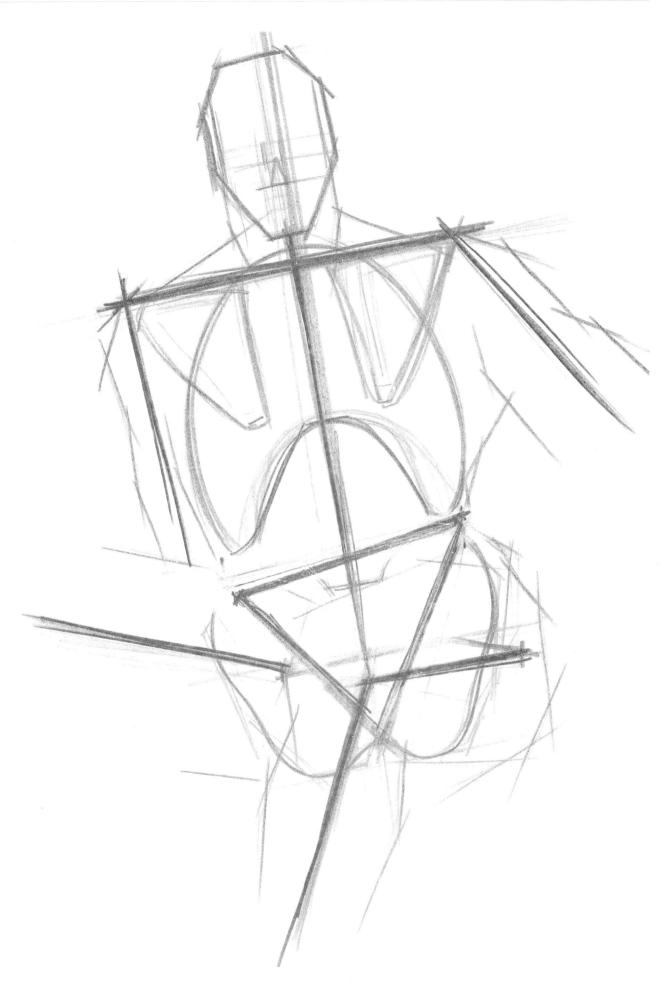

After A Male Torso by Giovanni Bologna, c. 1575–88

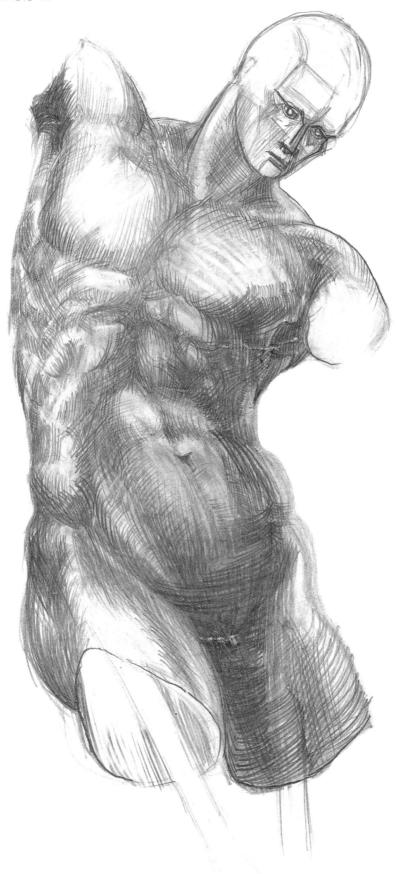

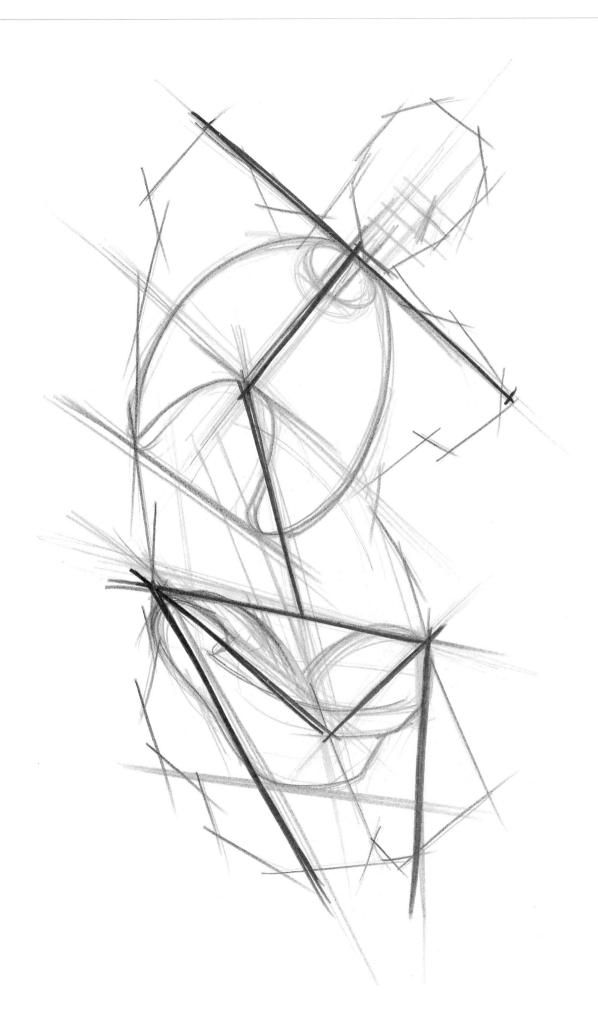

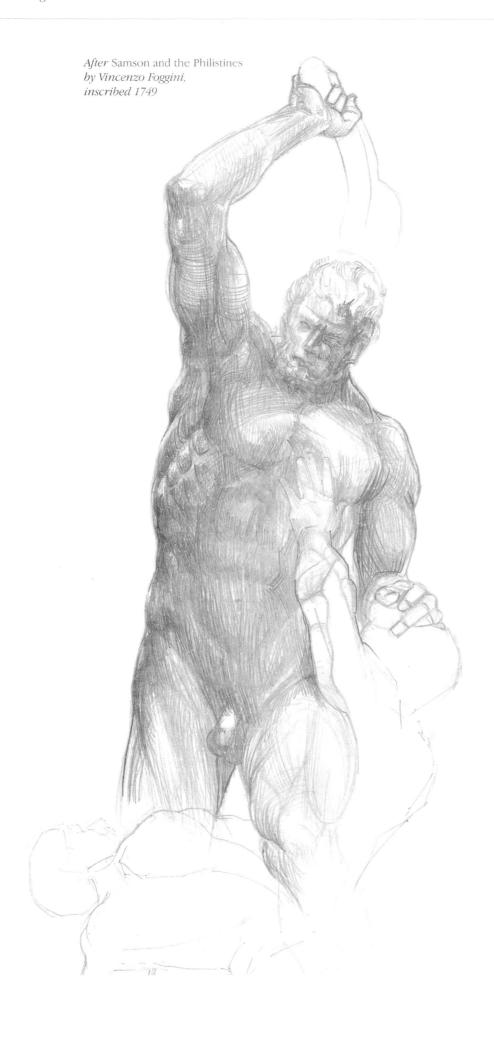

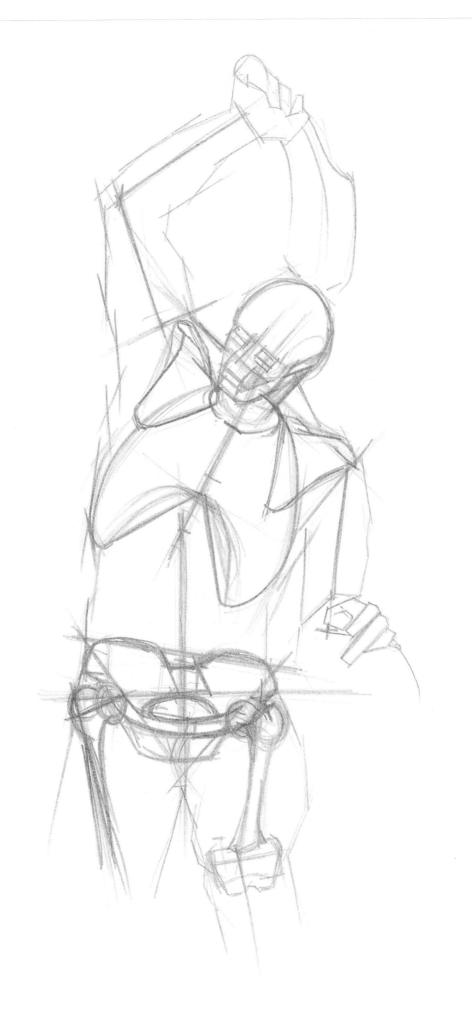

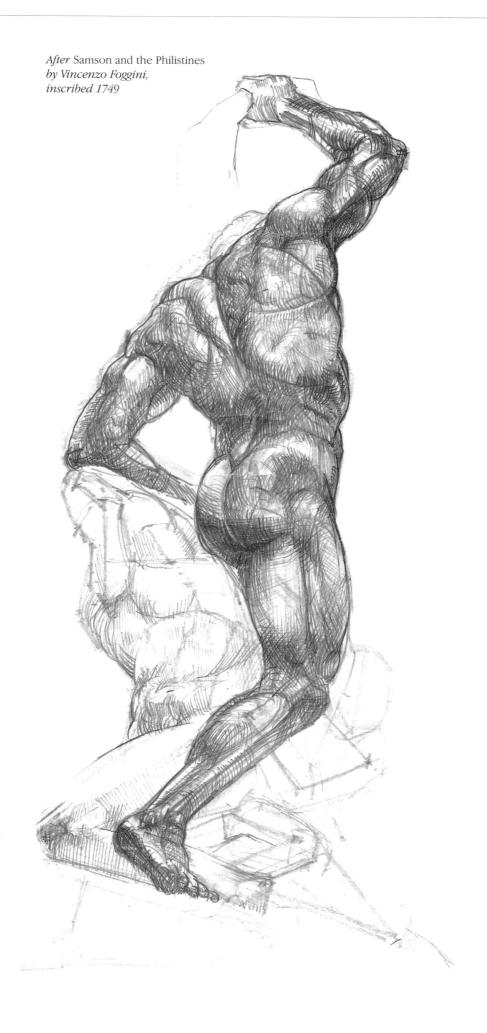

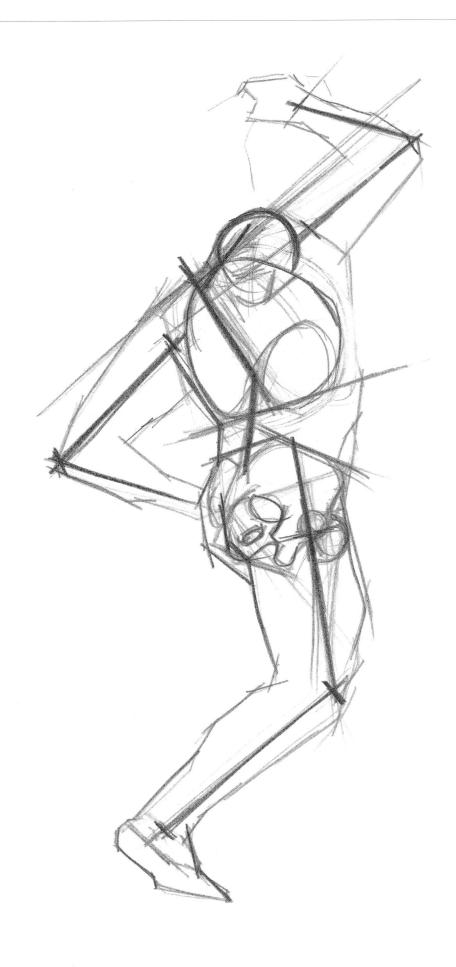

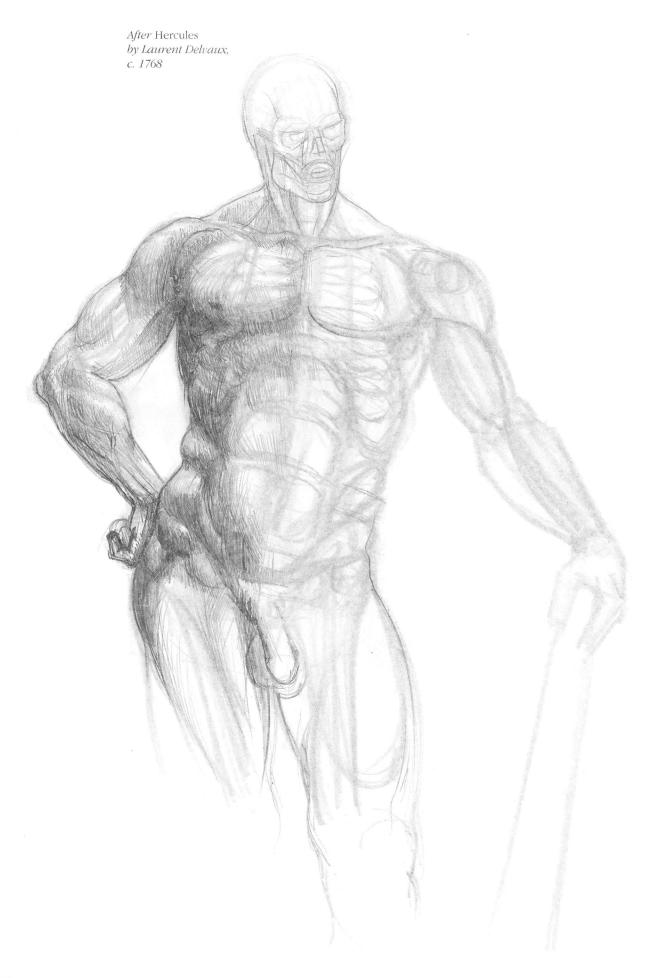

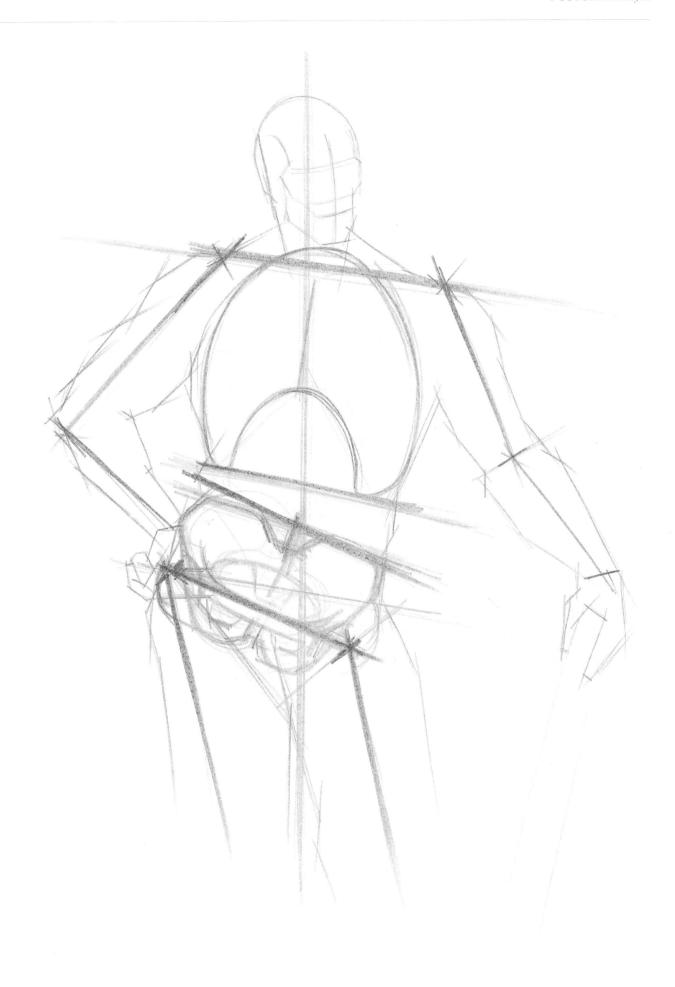

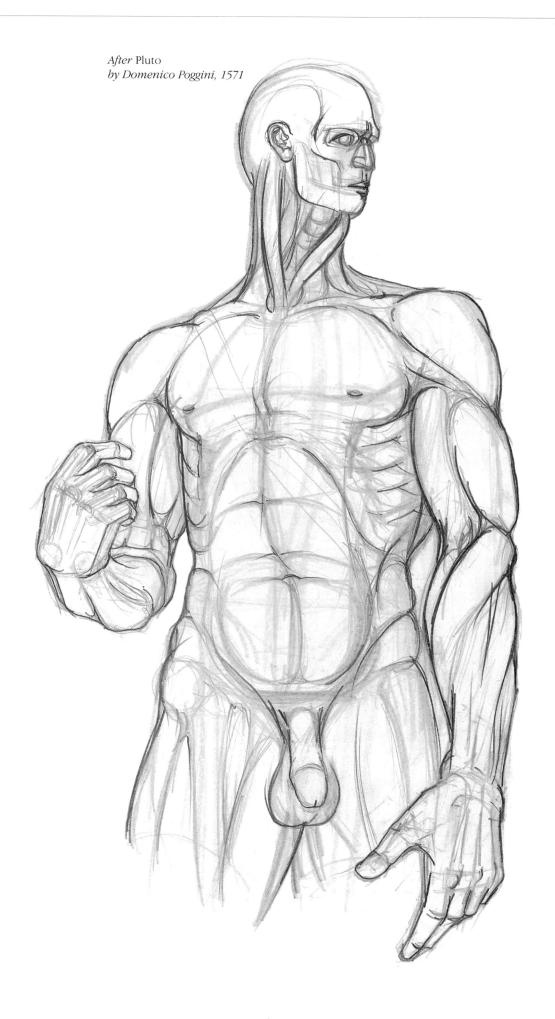

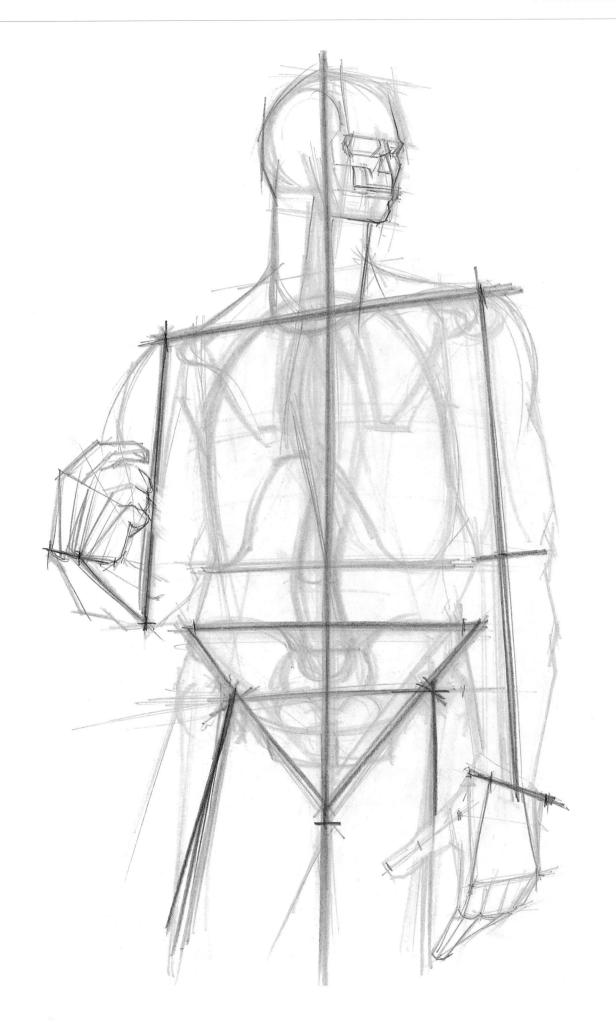

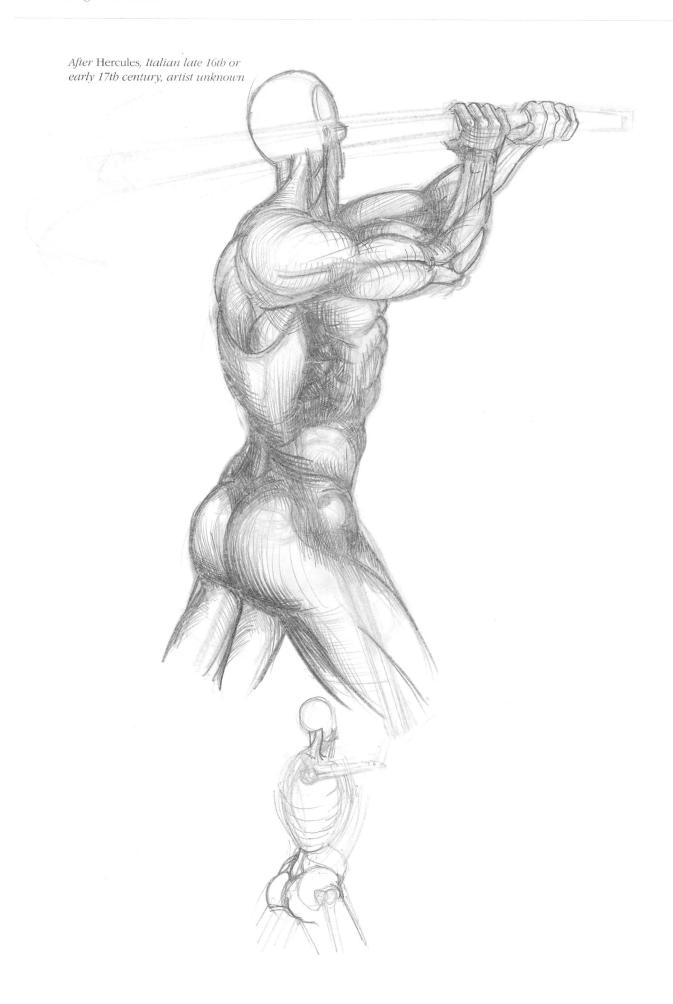

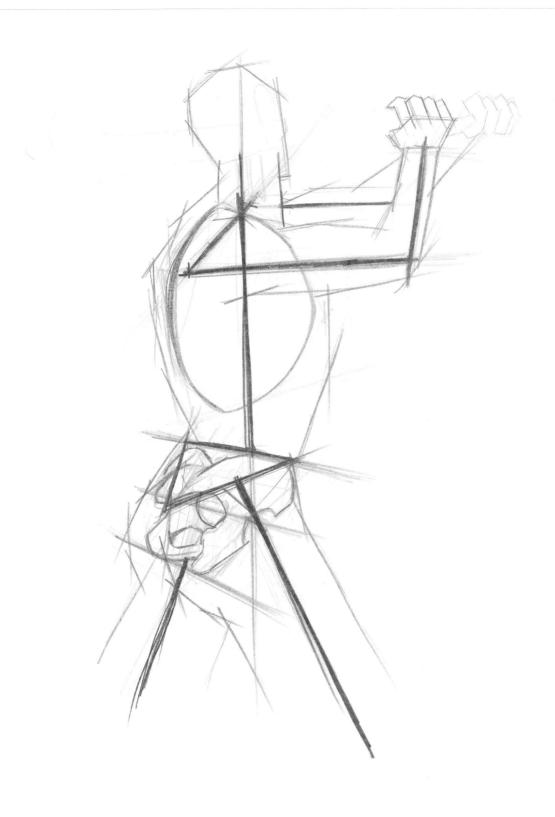

After Woman Reclining and Writing (Geometry and Astrology), attributed to Giovanni Bologna, c. 1565–70

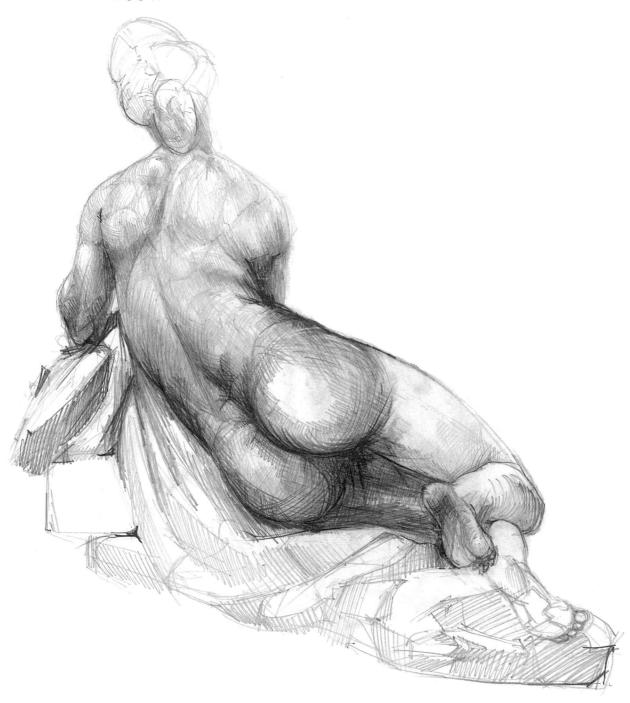

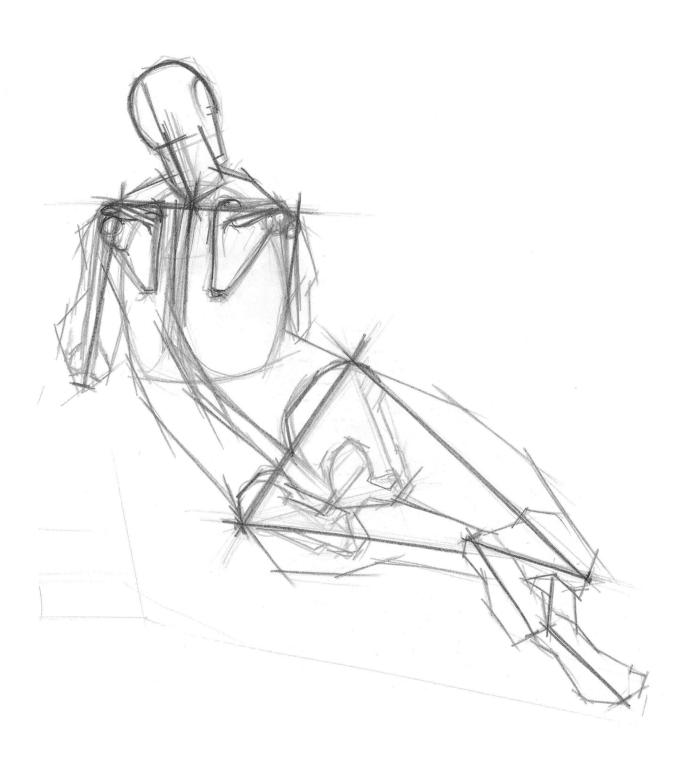

After Eve Listening to the Voice by Edward Hodges Baily, 1842

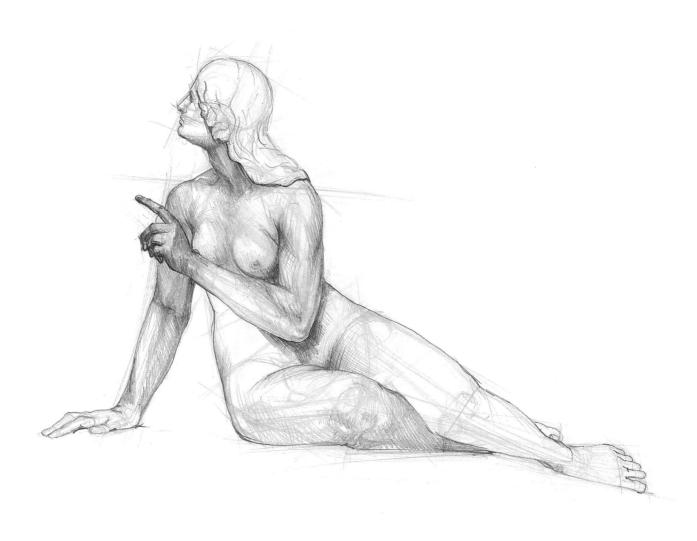

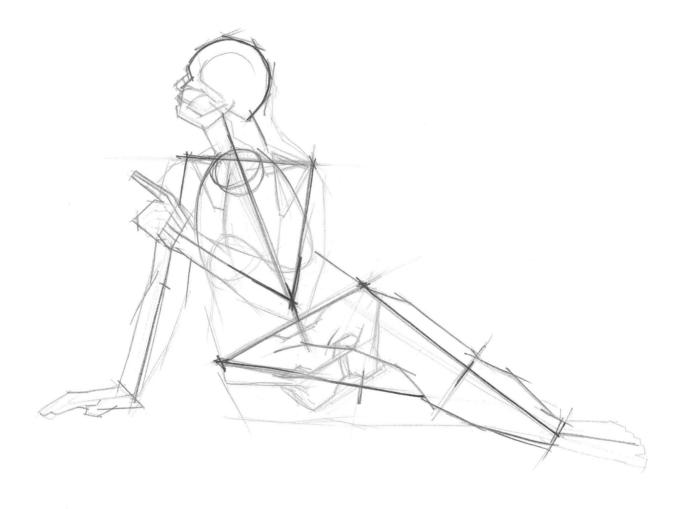

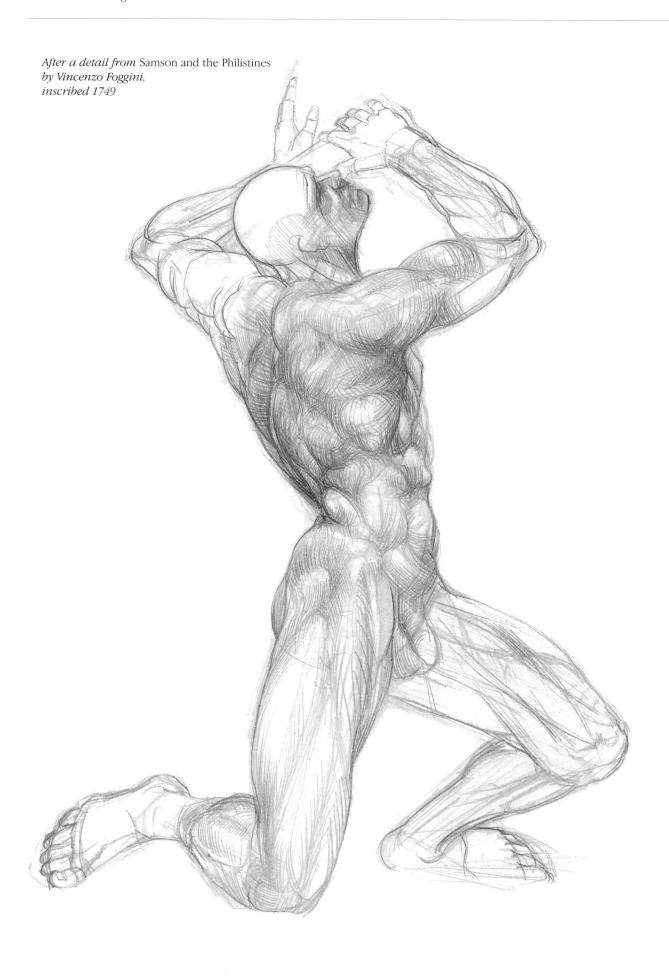

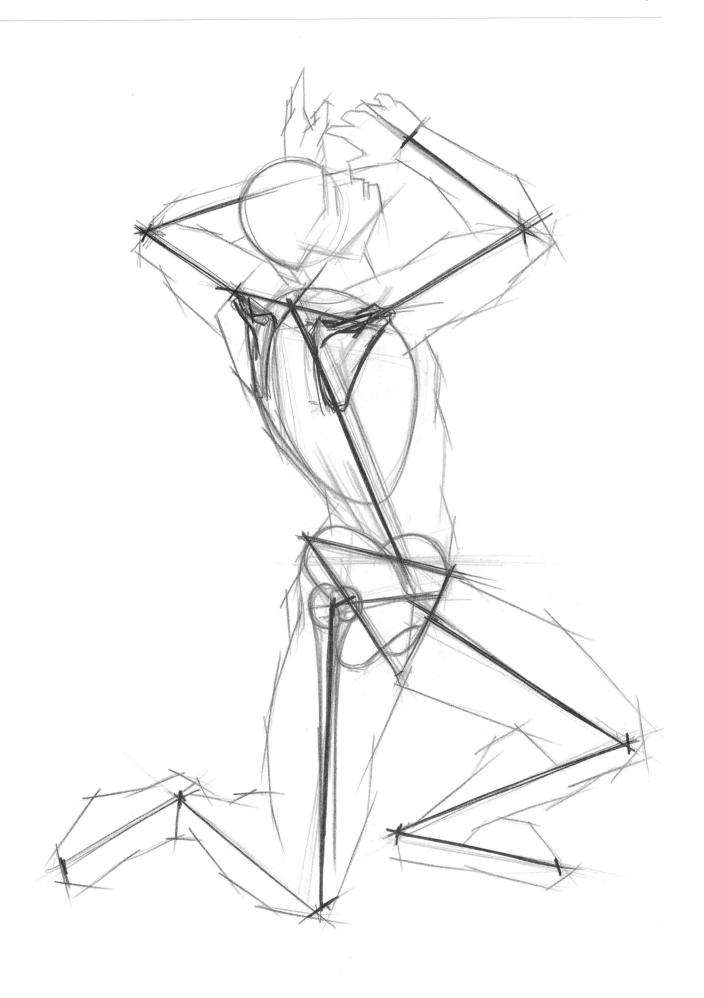

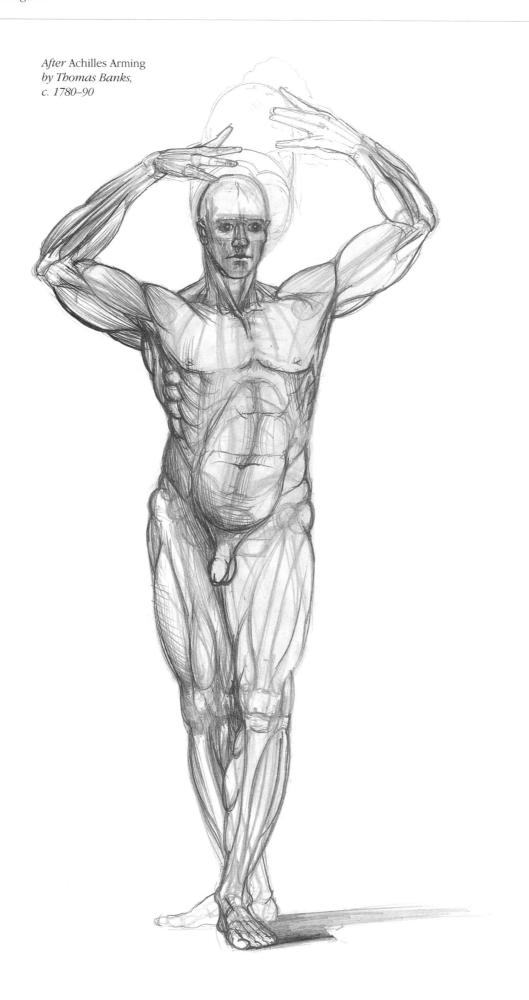

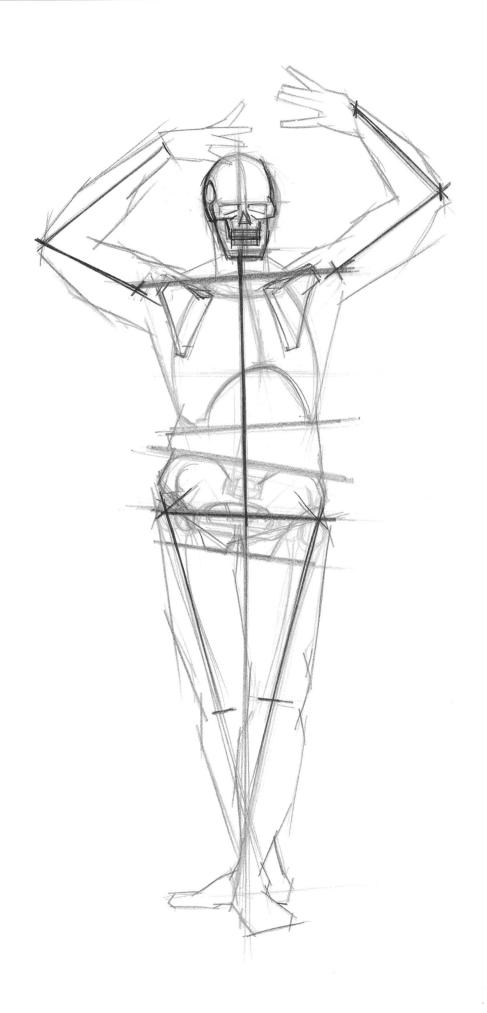

After A Left Hand, known as Michelangelo's Hand, c. 1580

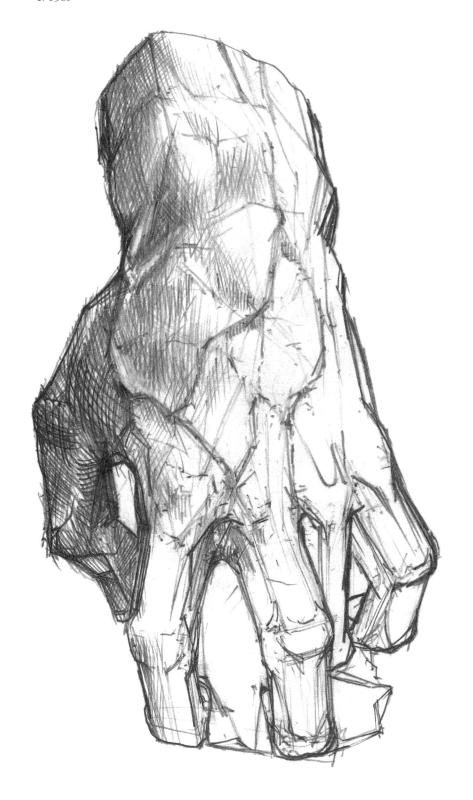

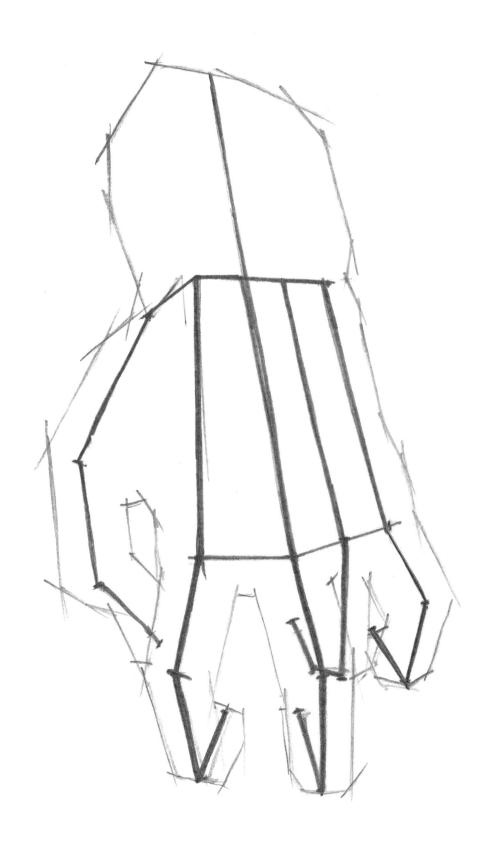

After the hand of Michelangelo's David sculpture, 1501–4

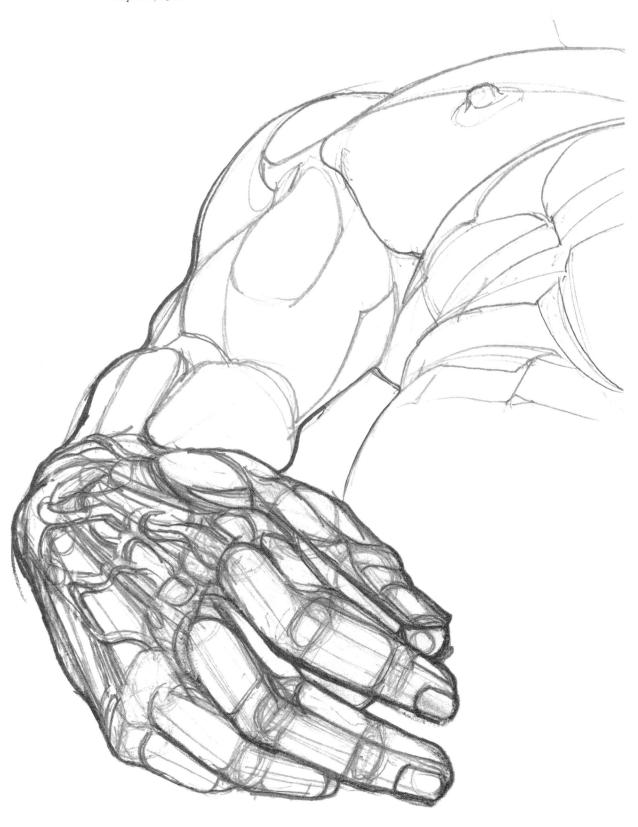

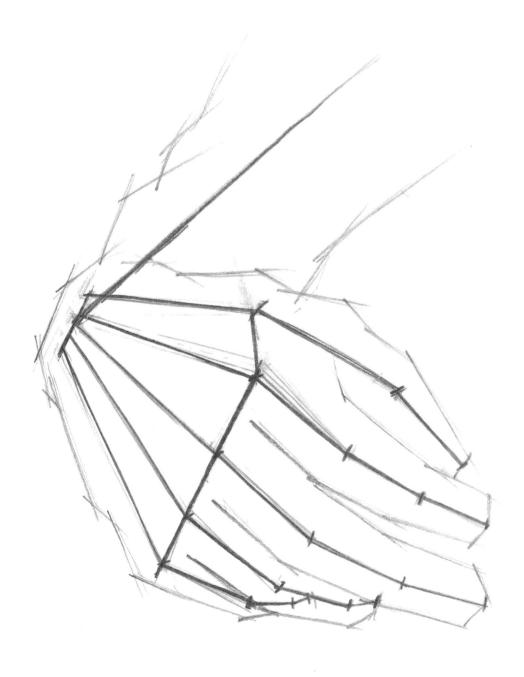

After a detail from Samson and the Philistines by Vincenzo Foggini, inscribed 1749

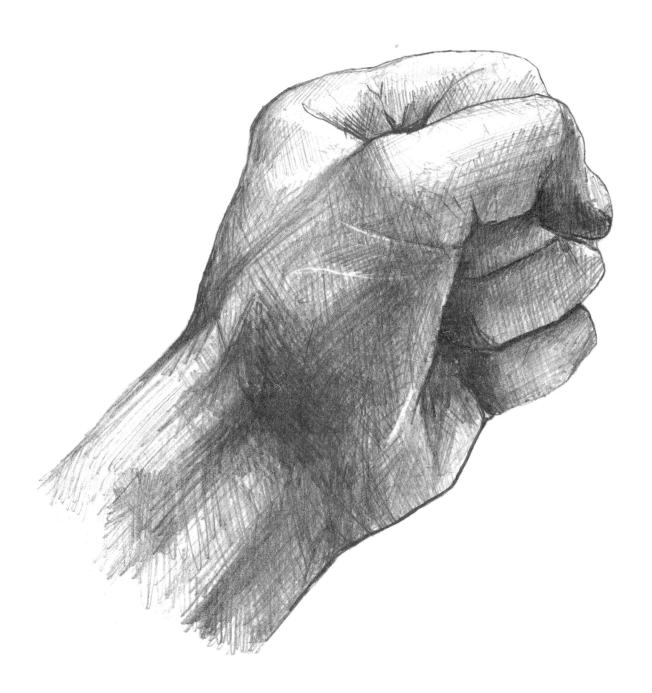

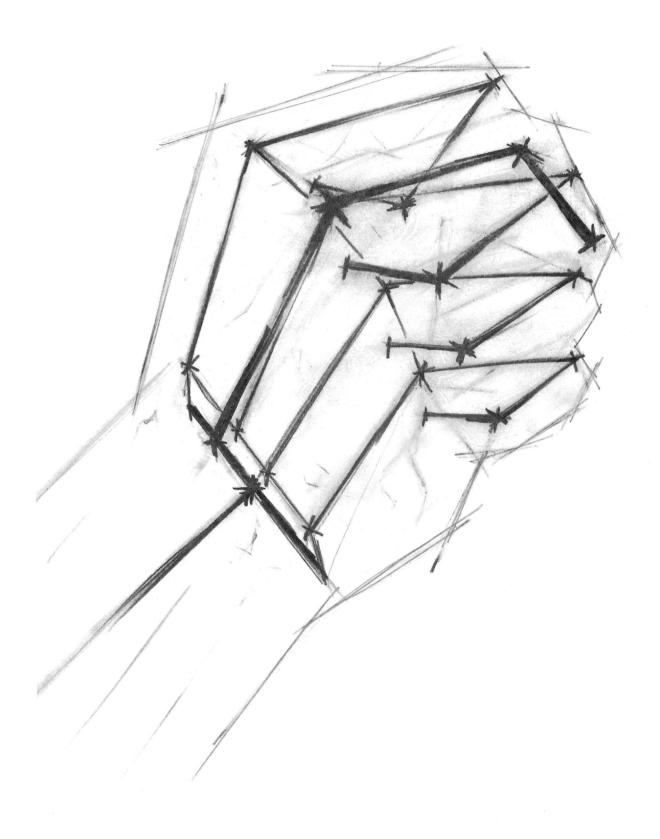

Revised band from Eve Listening to the Voice by Edward Hodges Baily, 1842

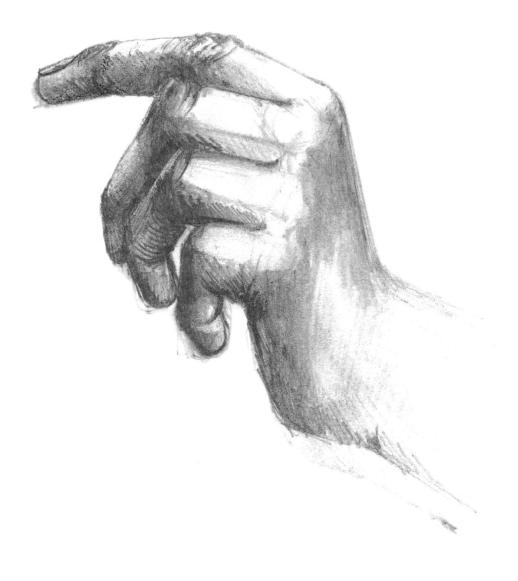

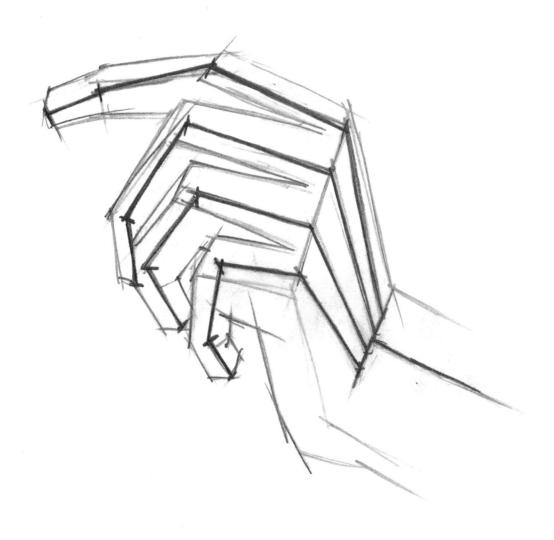

After a detail from Samson and the Philistines by Vincenzo Foggini, inscribed 1749

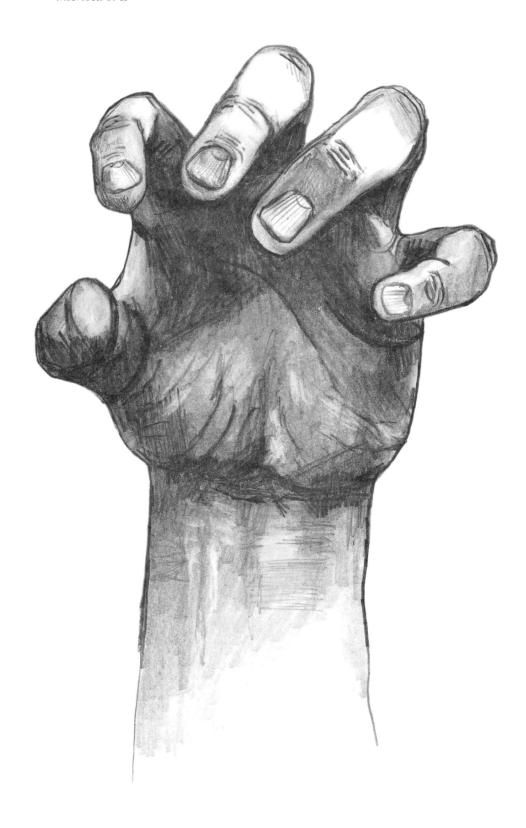

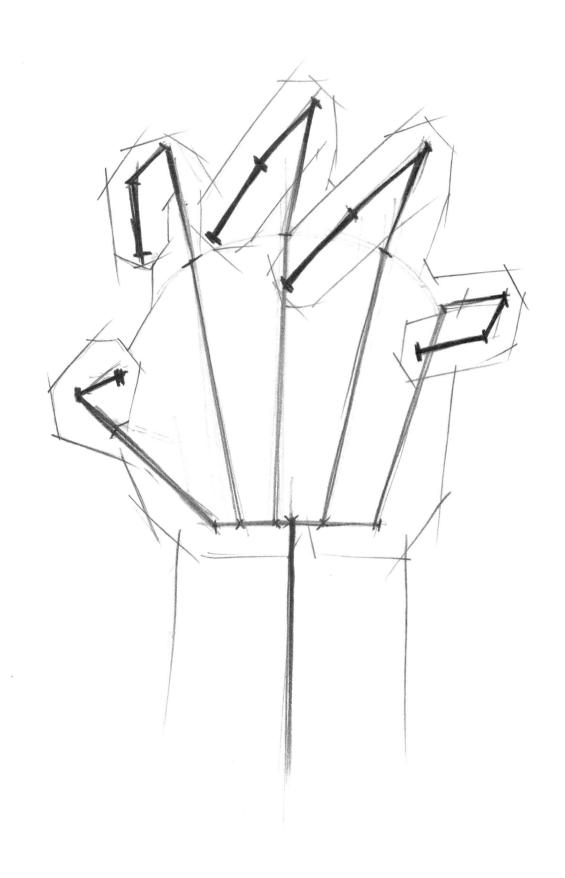

After Samson's right foot from Foggini's Samson and the Philistines, inscribed 1749

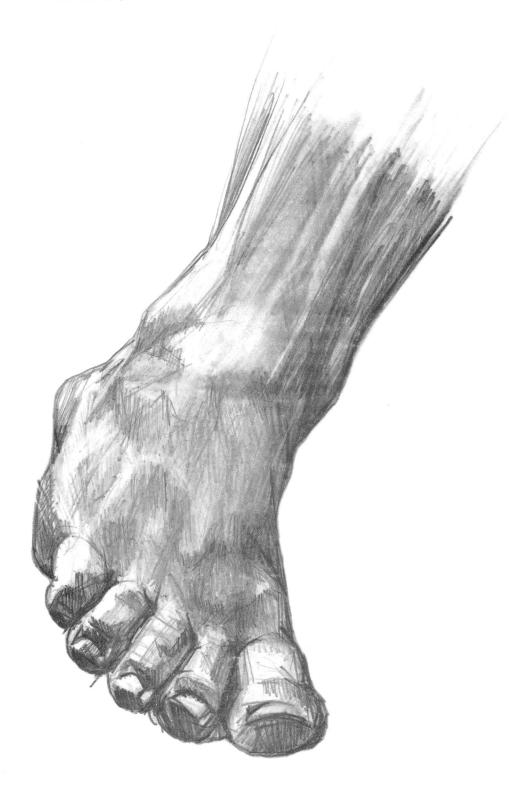

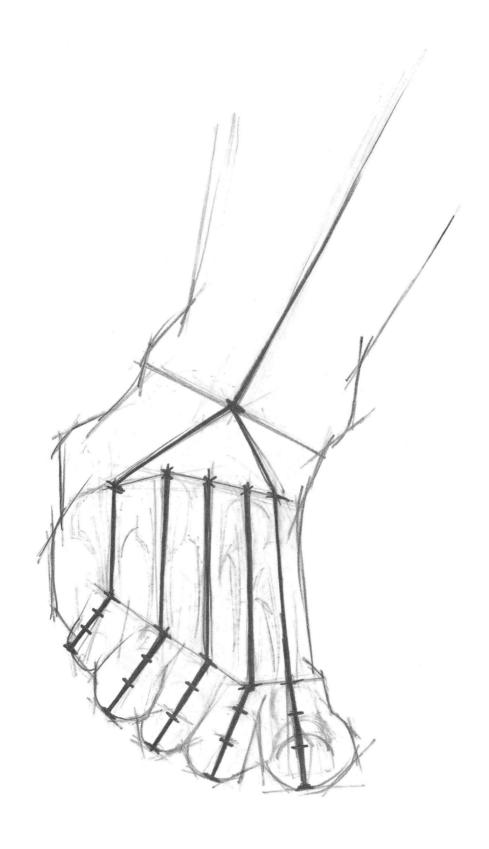

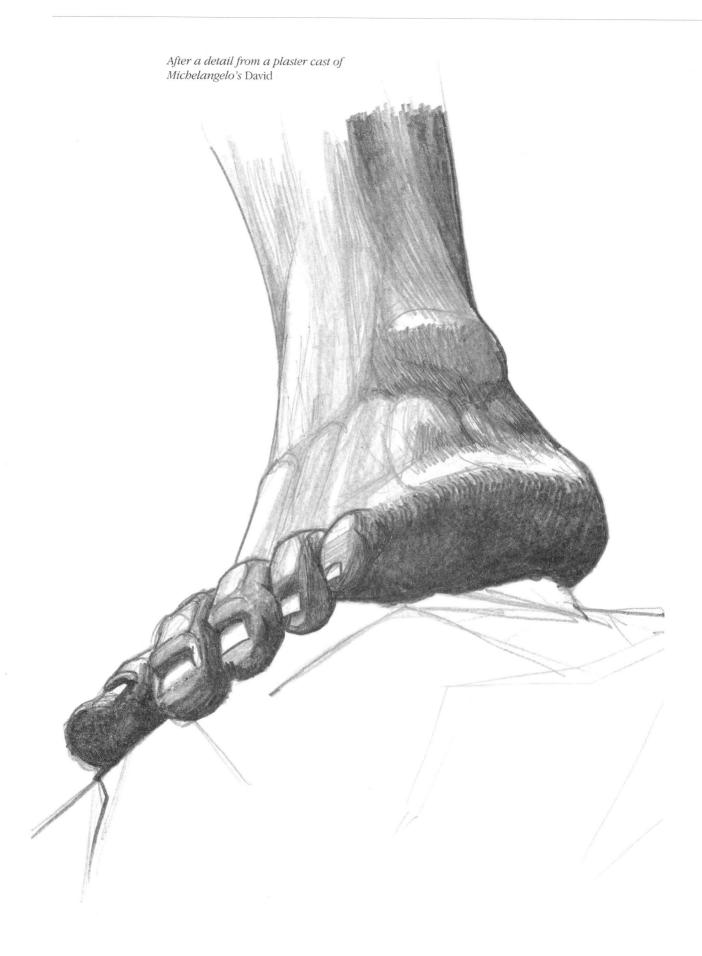

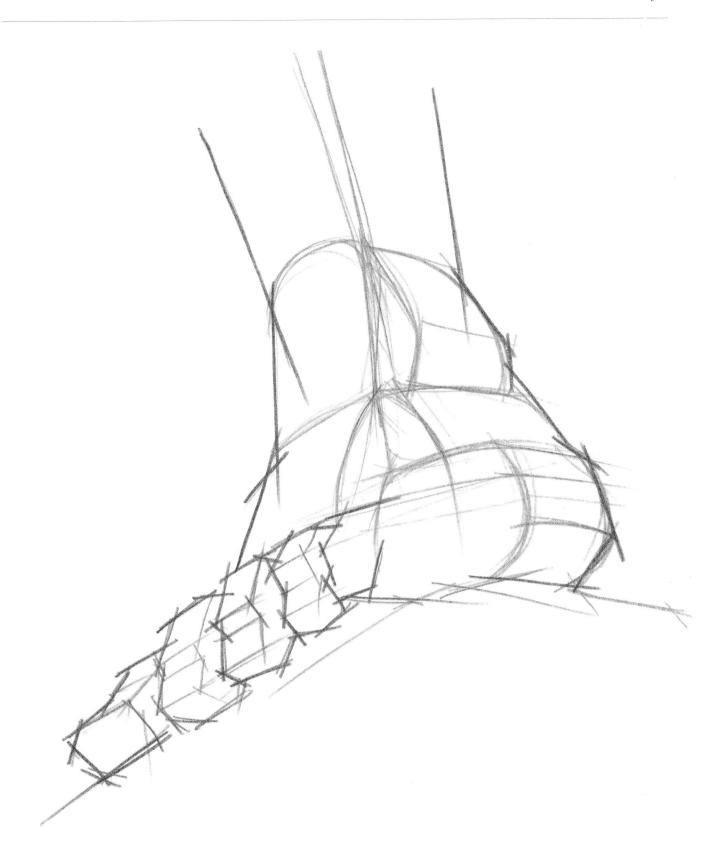

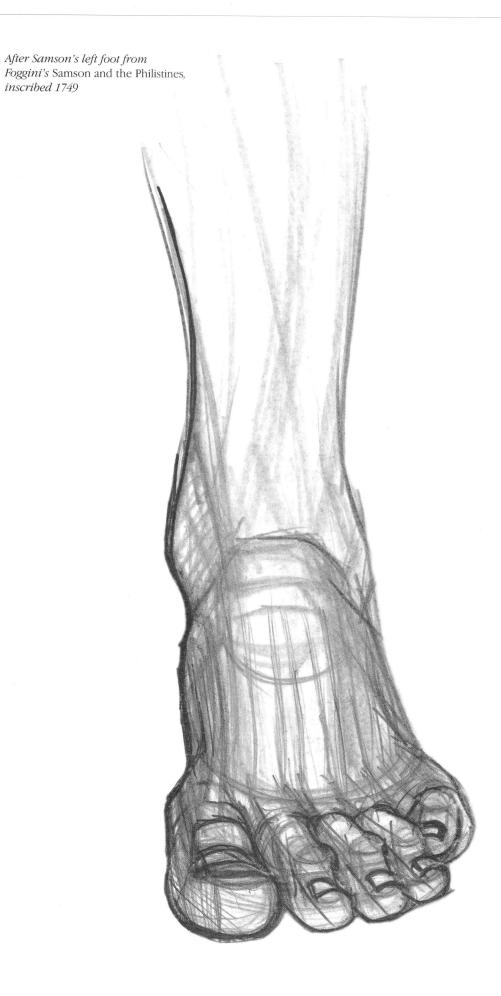

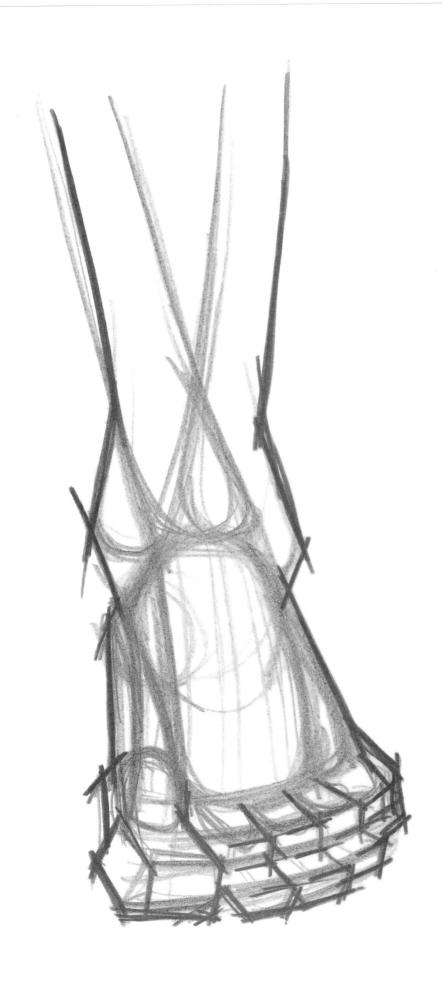

After a detail from Thetis Dipping Achilles in the River Styx by Thomas Banks, 1789

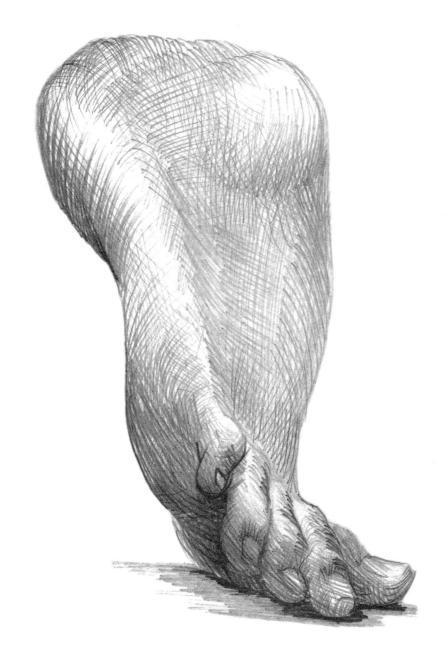

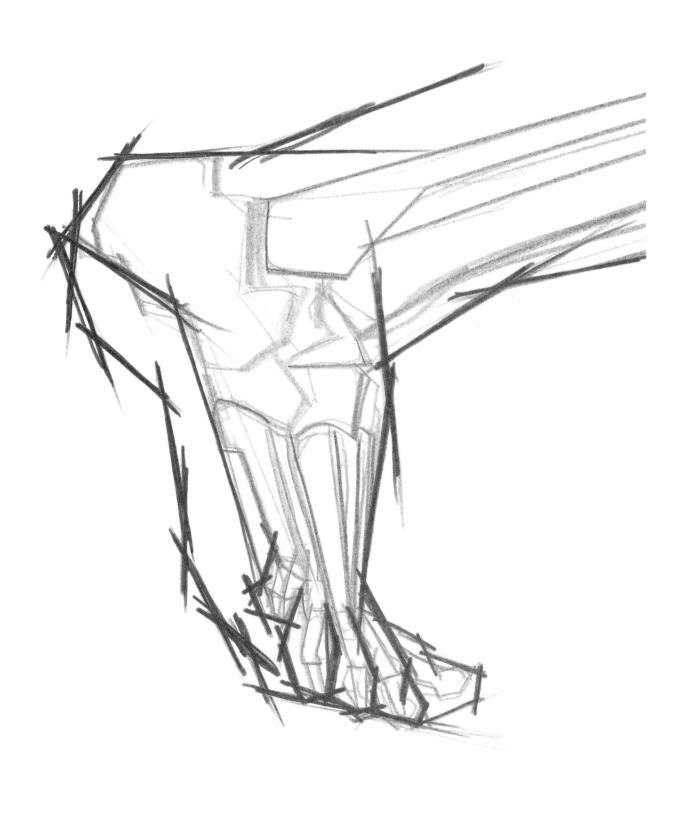

*			

FUNDAMENTAL FORM

For a drawing of a figure to come to life it must have the illusion of volume both above and below the surface. Fundamental form may be described as the volume or composition that lies below the surface of the skin, and should be seen as the foundation of a successful drawing.

Various visual languages have been devised by artists such as Leonardo and Dürer to illustrate fundamental form, from cubes and oblongs to ovoids and cylinders. In this book we use a combination of cylinders and variations on ovoids and boxes to describe fundamental form.

One of the main references used by artists to establish a knowledge of fundamental form has been the mannequin manufactured for this type of study. Using a mannequin enables the artist to gain a basic formal knowledge of a particular pose before employing a model. The mannequin is best used when the pose is too difficult to hold for a long time.

The ability to generate the illusion of mass and volume as they exist in the context of space is the test of the true artist, and comes only with a developed understanding of how the anatomy relates to the underlying fundamental form. Later in the book you will see how fundamental form provides a base to which the superficial muscle is attached, enabling the drawing to become more realistic and expressive.

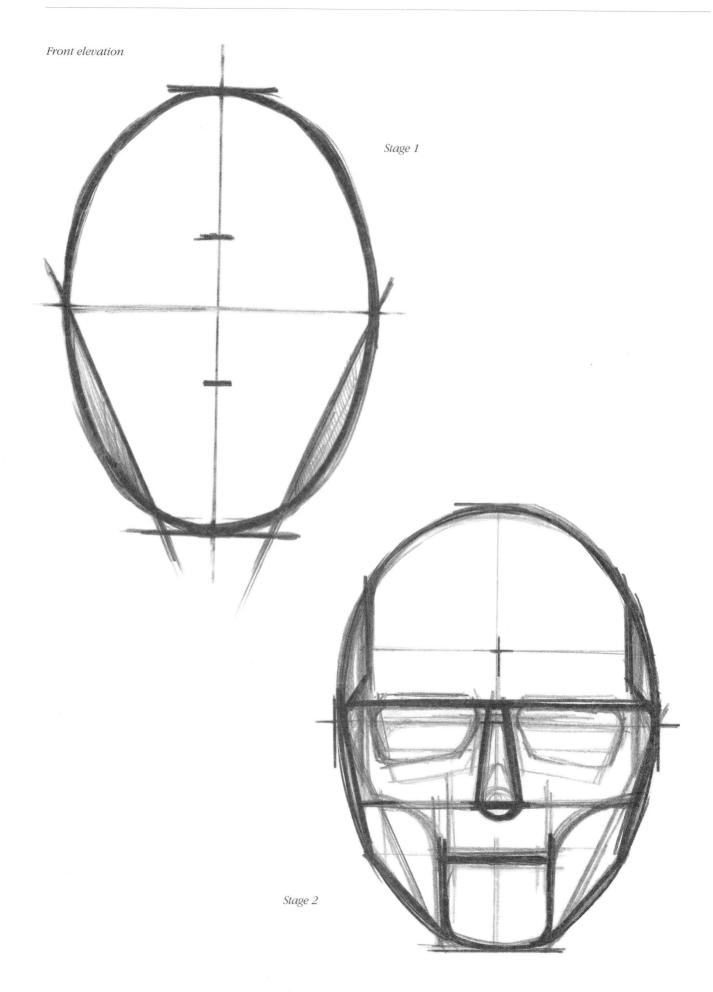

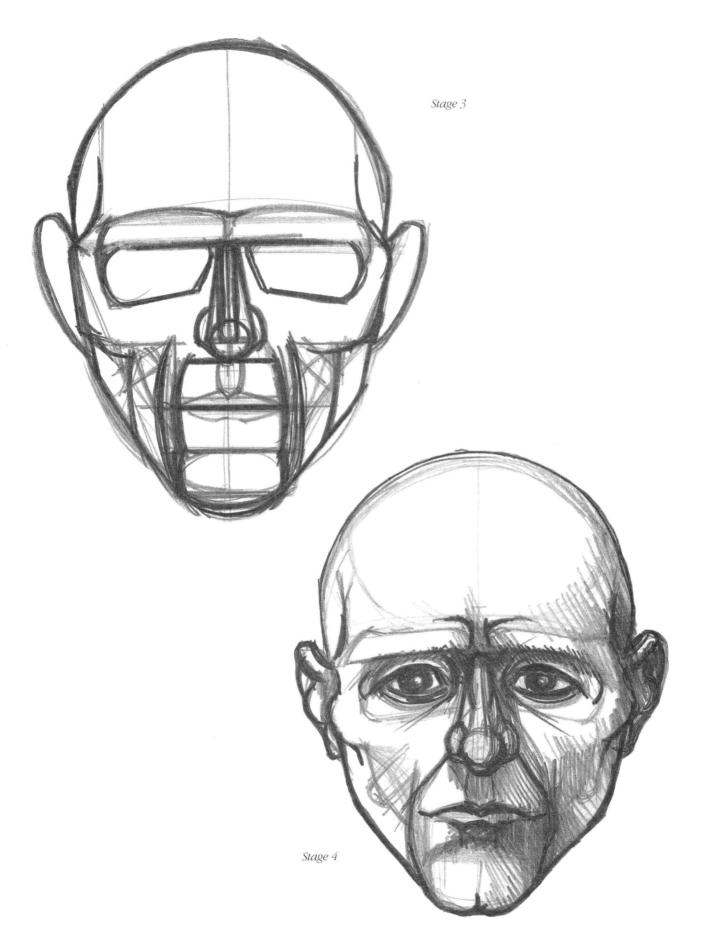

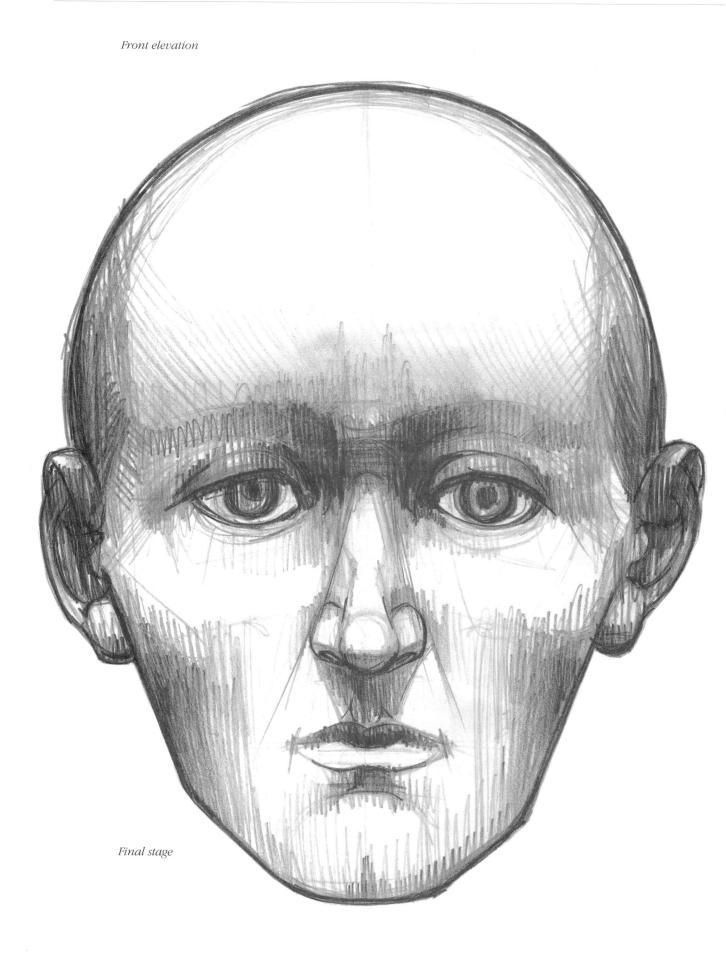

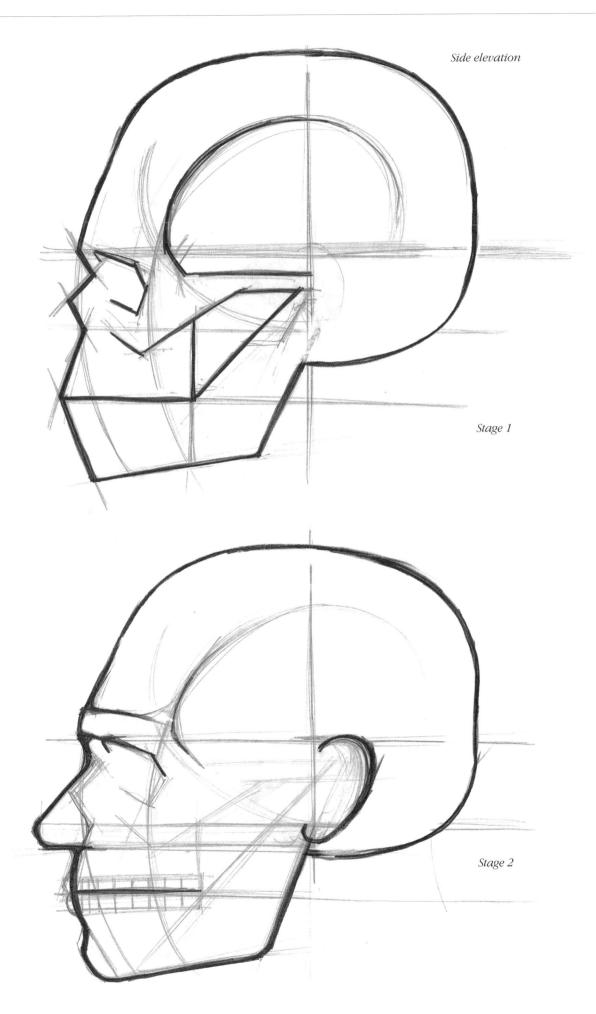

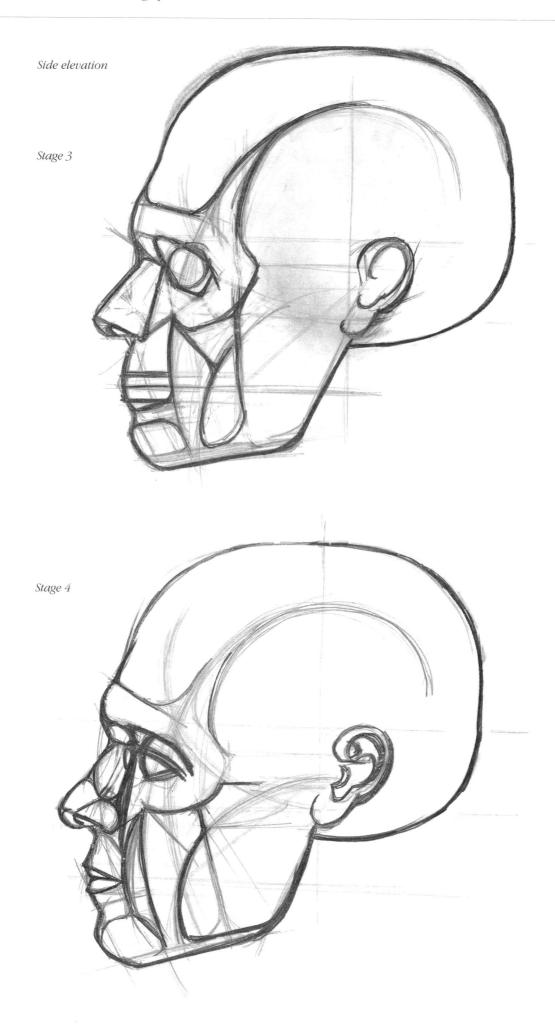

Side elevation

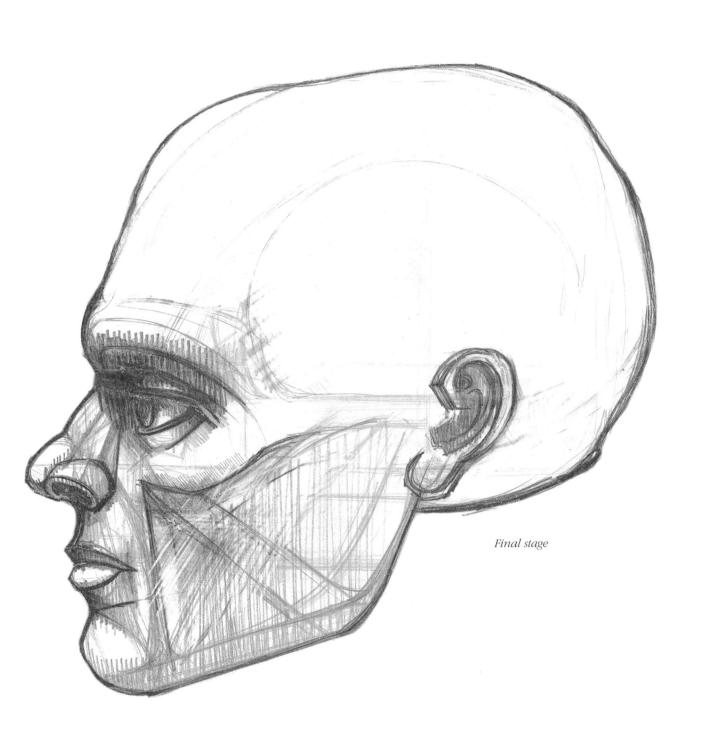

 $Front\ view$

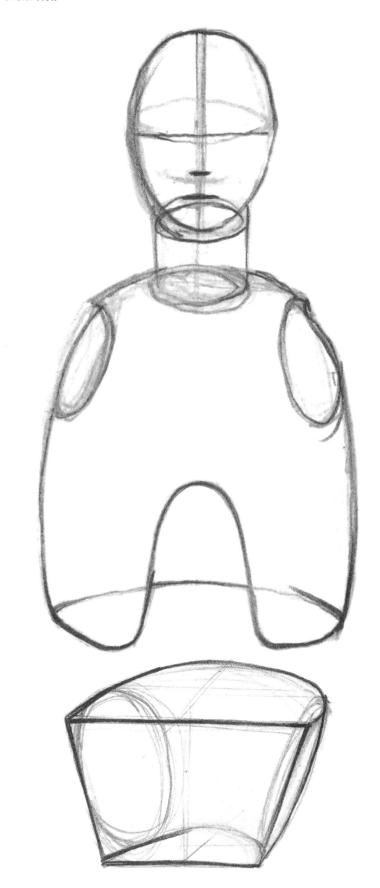

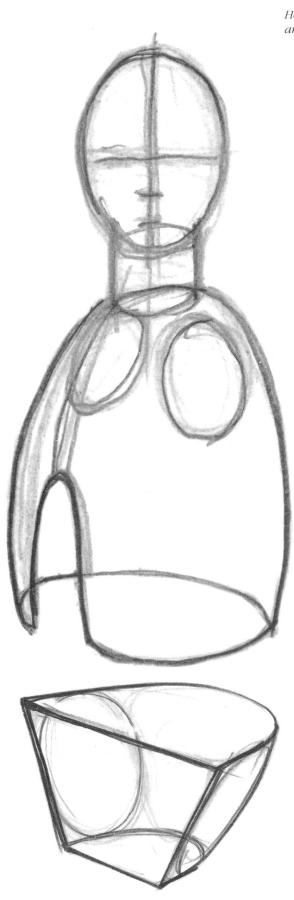

Head looking to front, thorax and pelvis viewed from side

Threequarter view

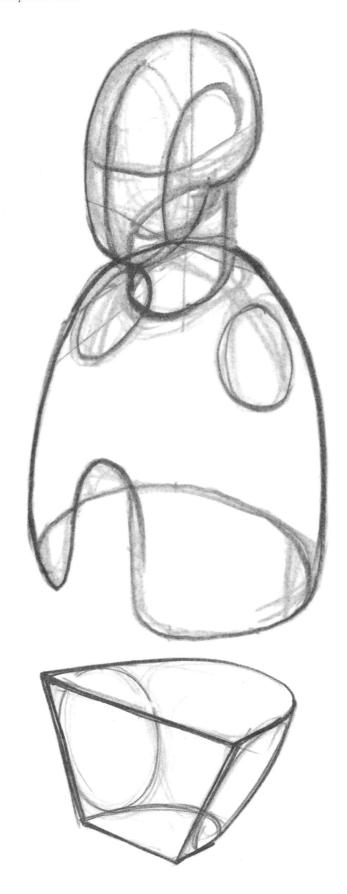

Head turned to left

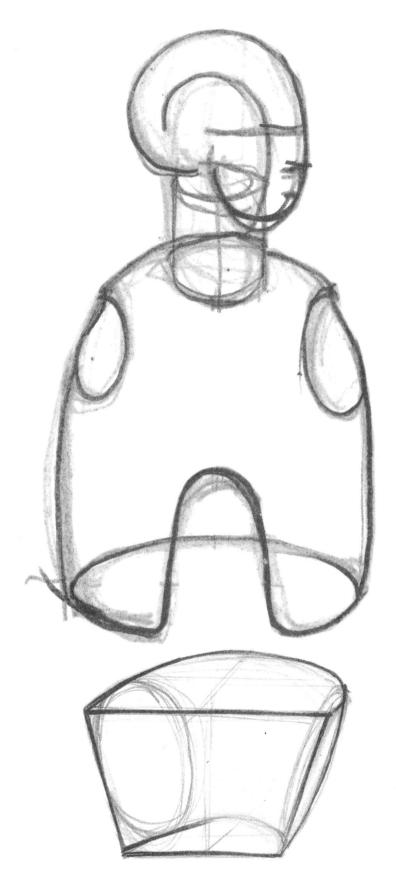

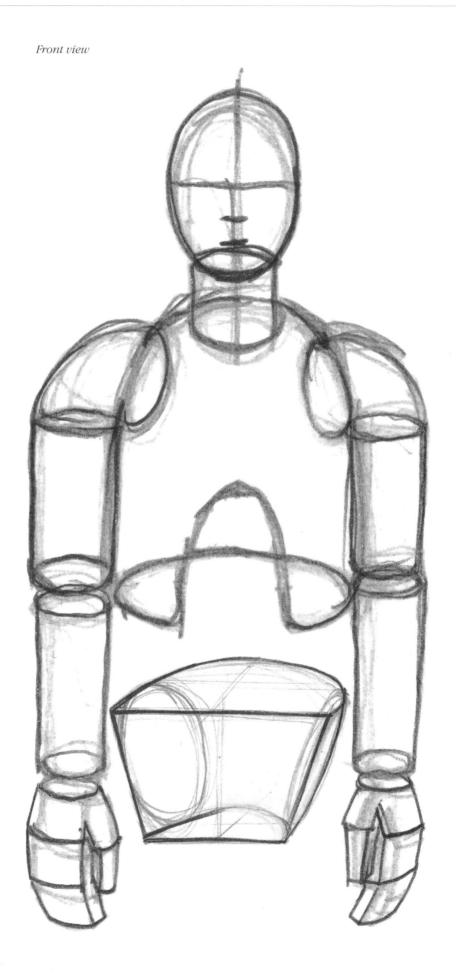

Threequarter view

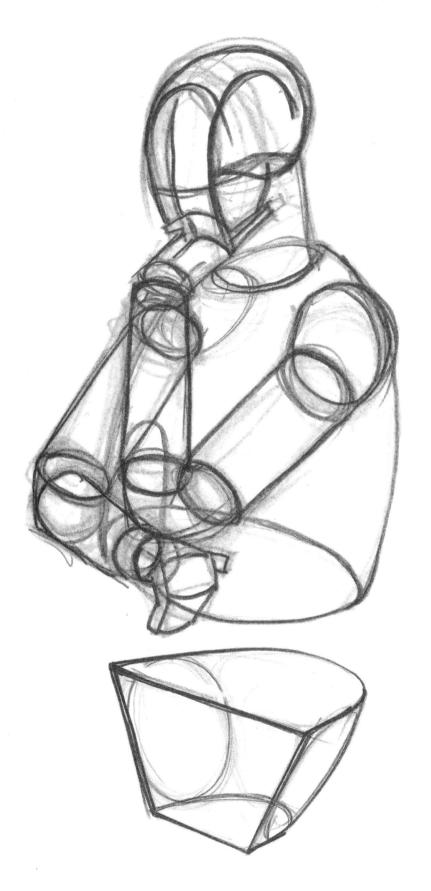

Front view

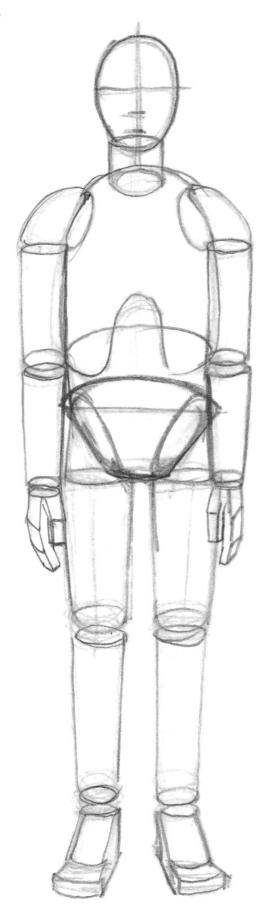

Side view

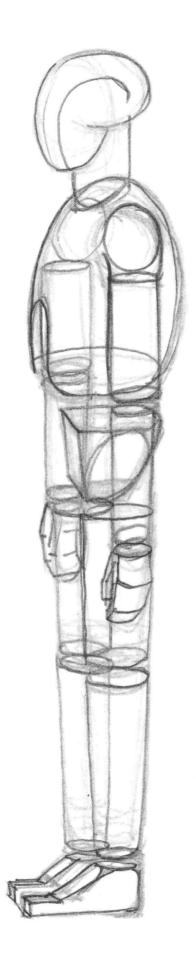

Back view

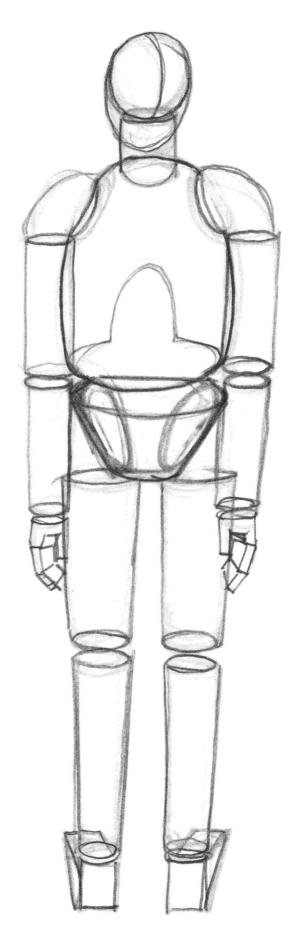

Prone position

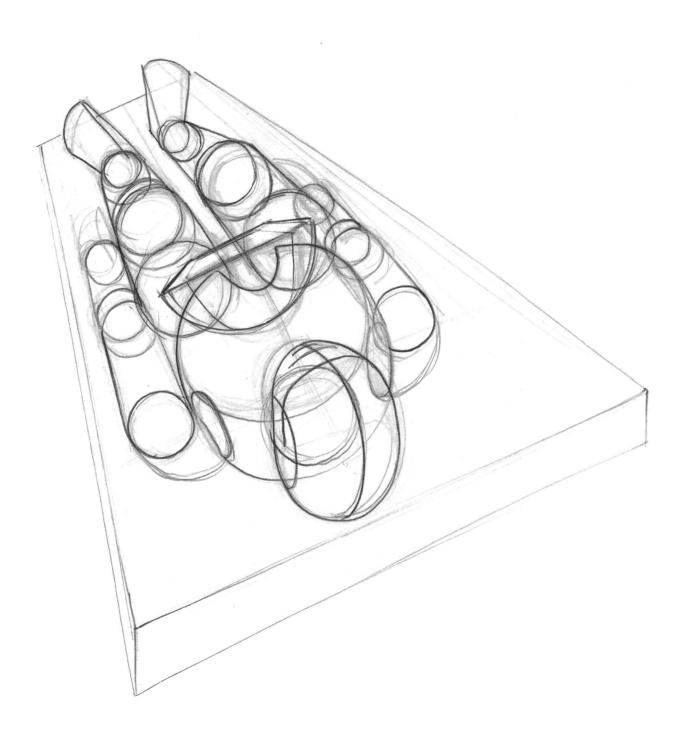

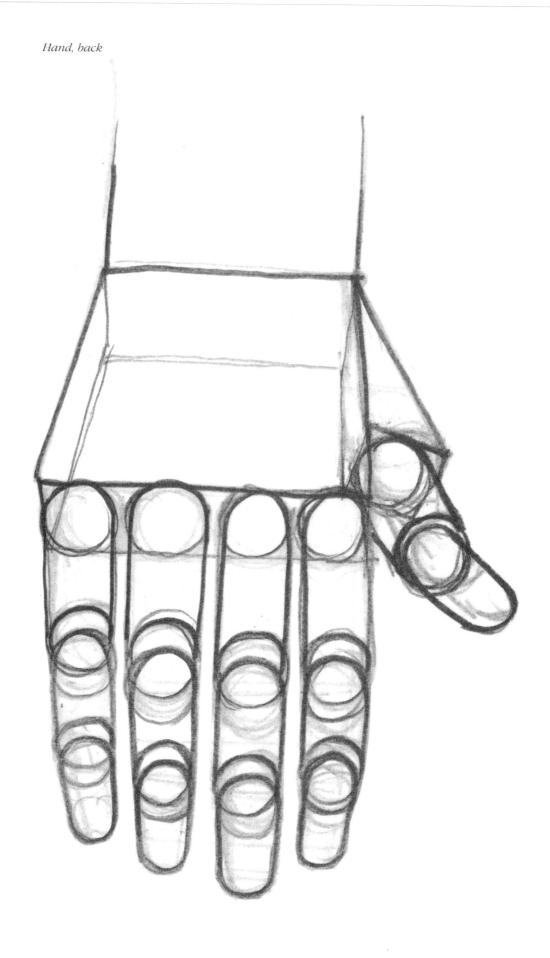

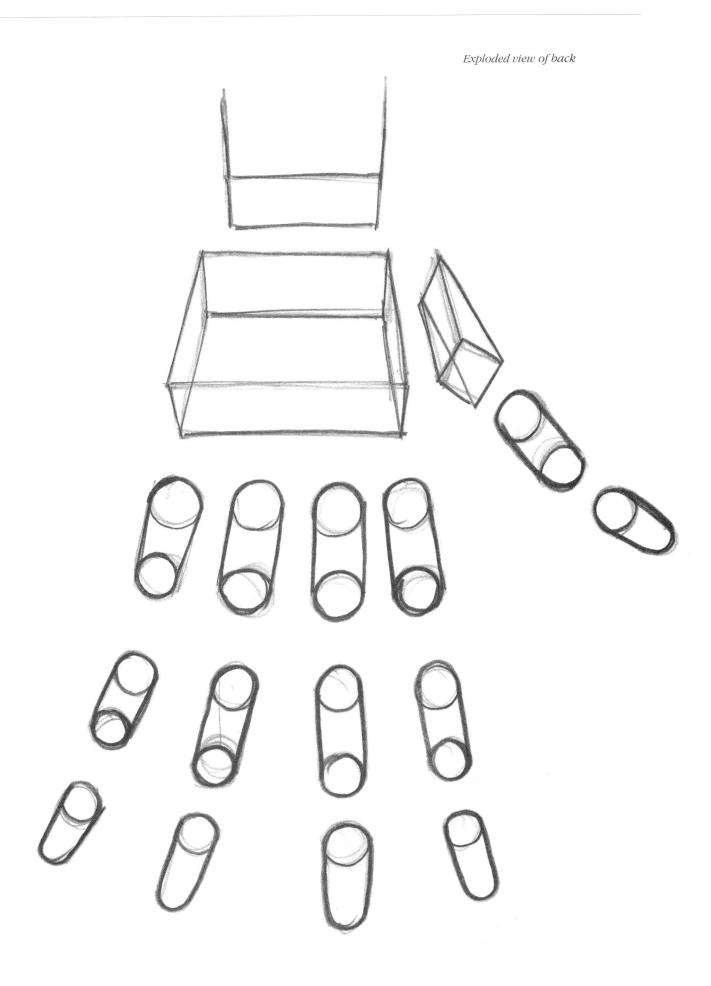

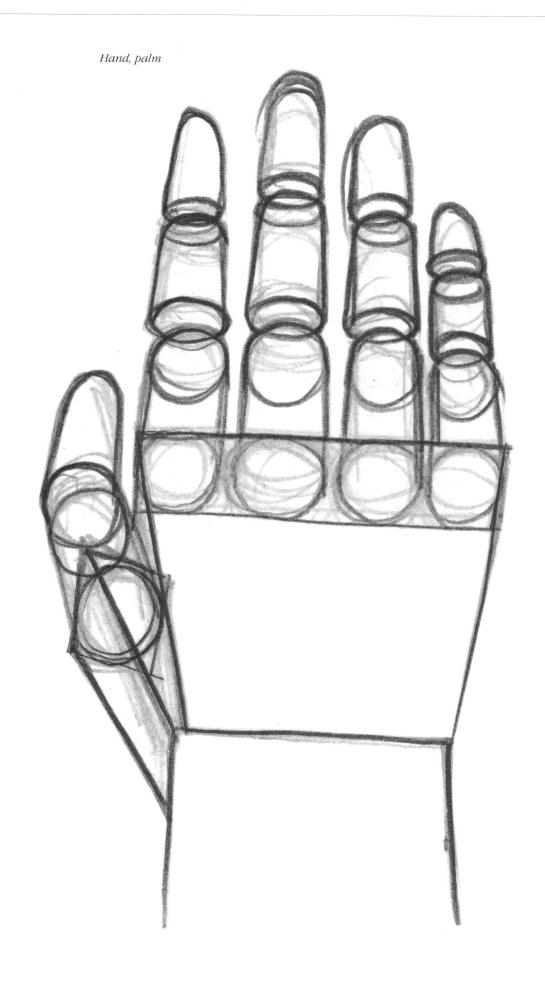

Exploded view of palm

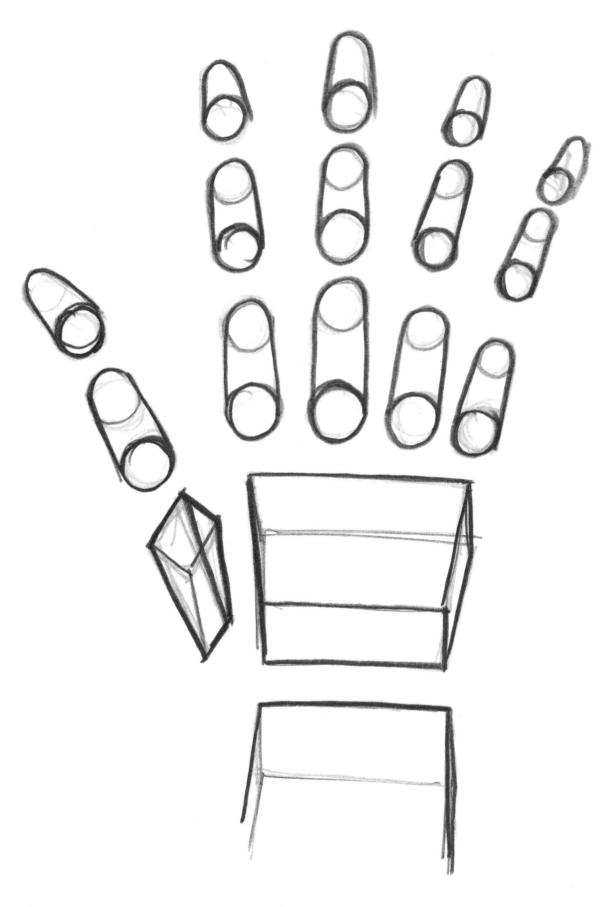

Different angles and attitudes of the hand

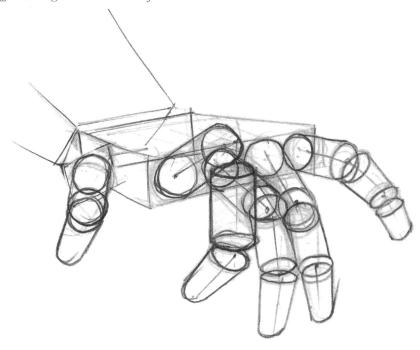

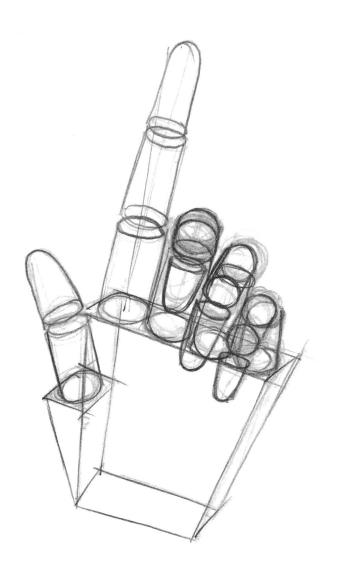

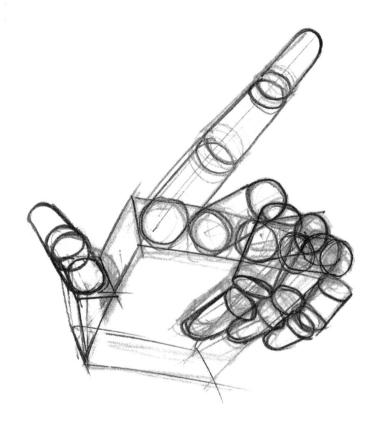

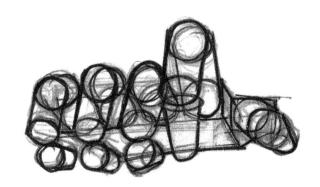

Foot, front

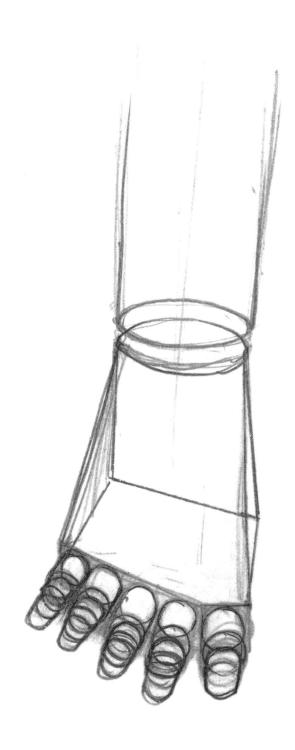

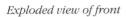

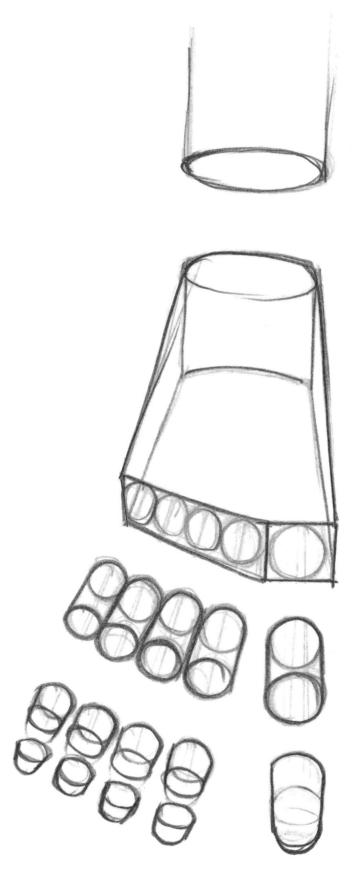

Foot, side

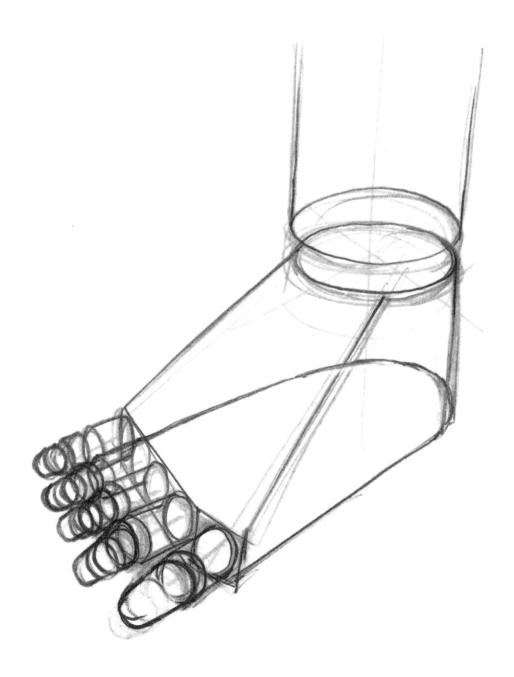

Exploded view of side

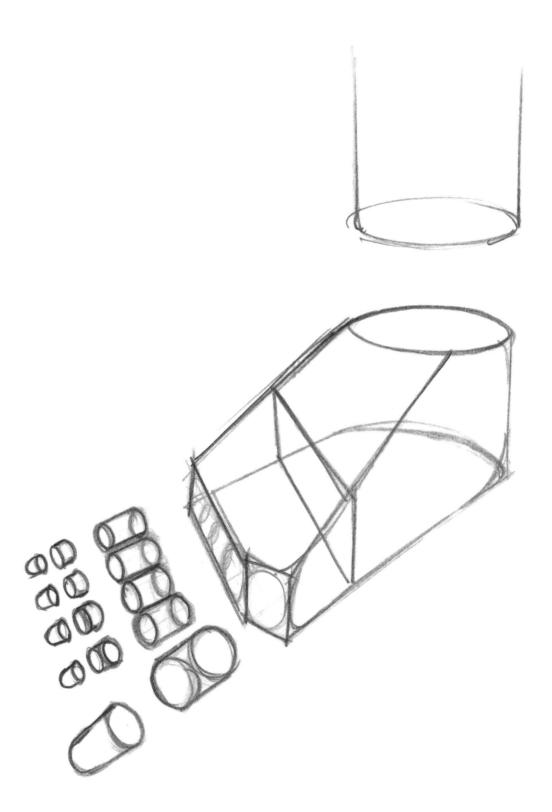

Different angles and attitudes of the foot

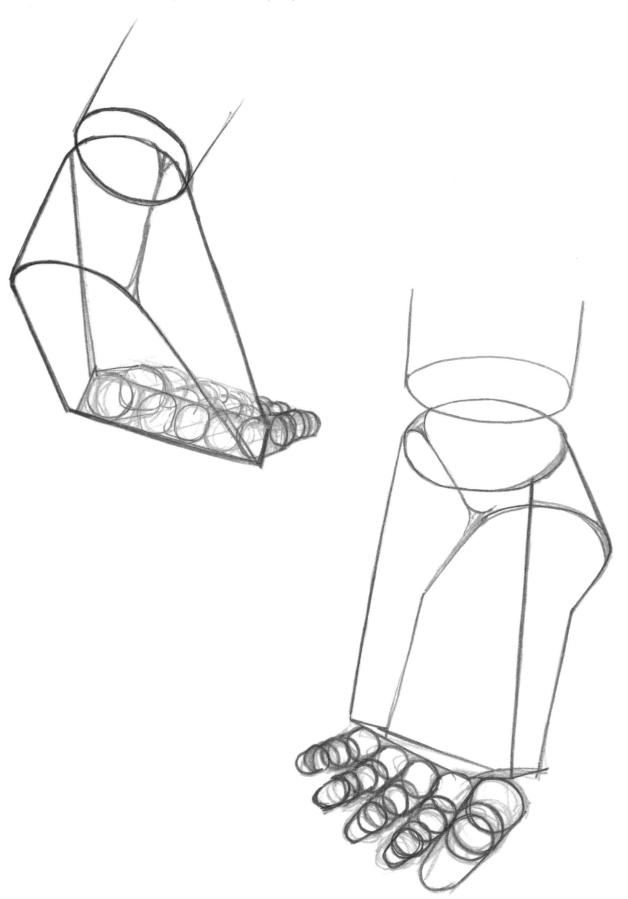

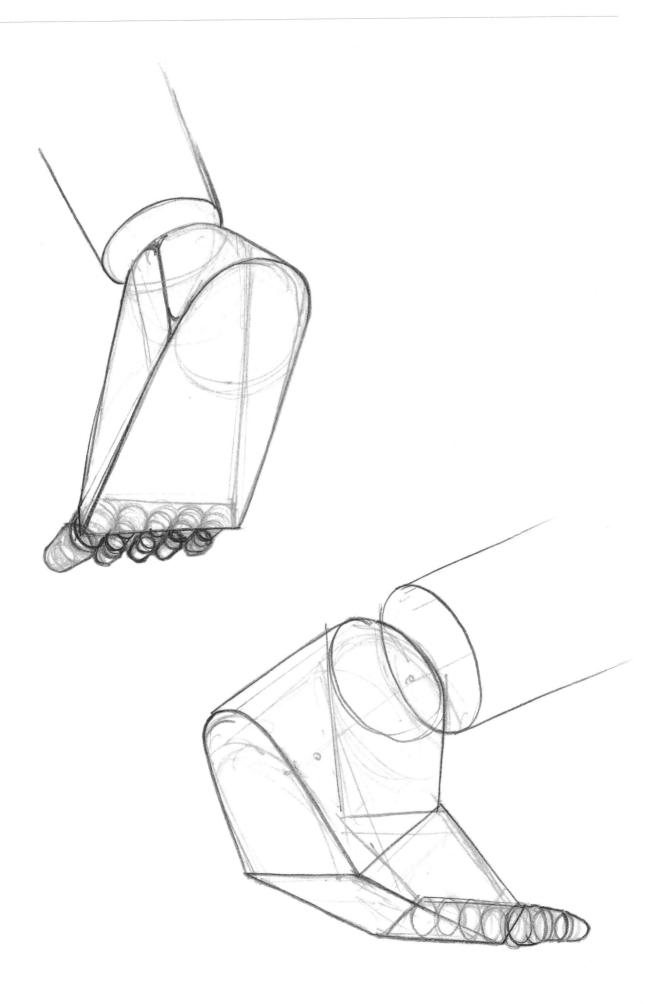

WORKING DRAWINGS

In this final section we bring together all the aspects of anatomy covered so far to produce finished drawings. We begin with a series of step-by-step illustrations in which each of the elements you have learnt about is added in turn and on top of the element it follows. Each drawing builds on what goes before, layer upon layer, so you can see the relationship of the structures and the illusion of forms as they develop.

The integration of these essential components within a single drawing can be expressed in any number of ways, depending on the individual character and build of the model. Models that conform to classical ideals of the human form express the anatomy most clearly and are therefore good subjects for inexperienced artists.

It is advised that you use the template we have established to produce your own drawings or to imitate the series of poses that comes after it. Drawing from a live model can be very daunting for the inexperienced artist. If you fall into this category, take your drawing materials to a museum and work from the casts of nude classical figures you'll find there. Art students used to be encouraged to do this to help them learn. A cast doesn't move, and it is already imbued with the language and visual metaphor that the novice finds so difficult to create from scratch when standing in front of a live model.

Once you are confident about your ability to use effectively the methods we have explored, then you can begin to draw from life and devise your own poses.

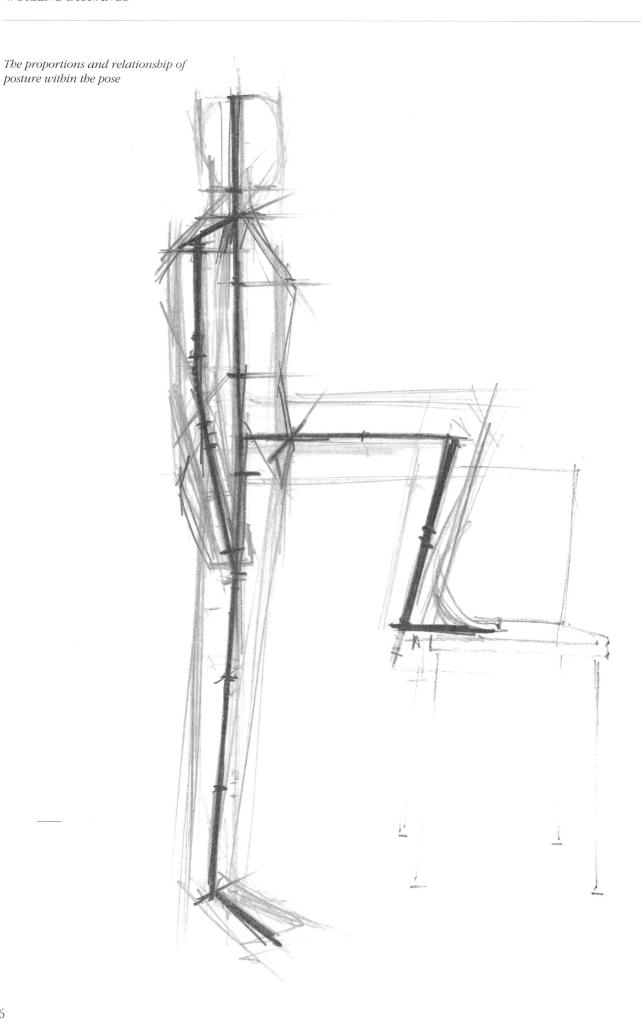

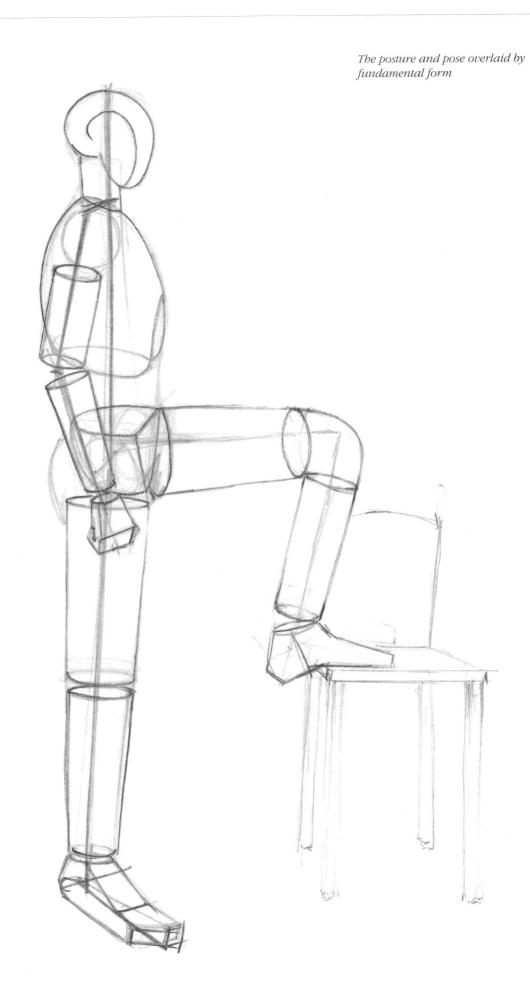

The posture, pose and fundamental form with the underlying skeletal structure

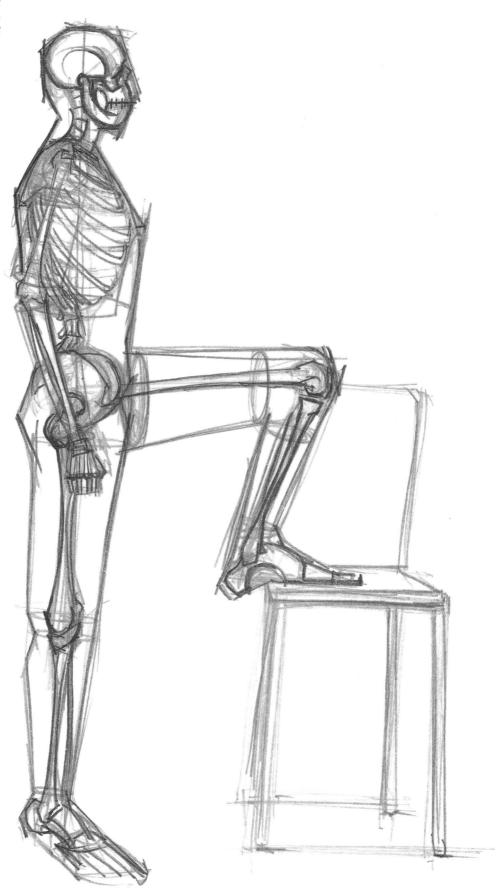

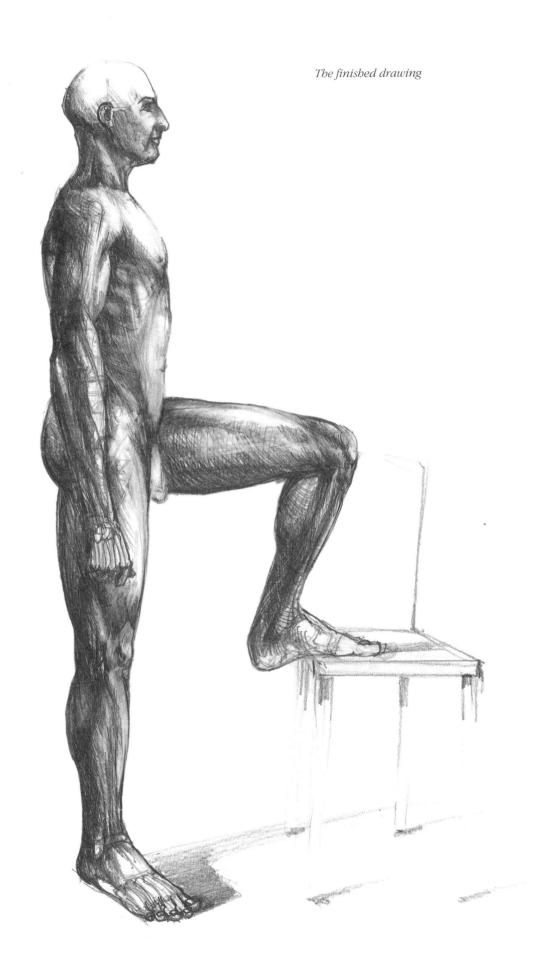

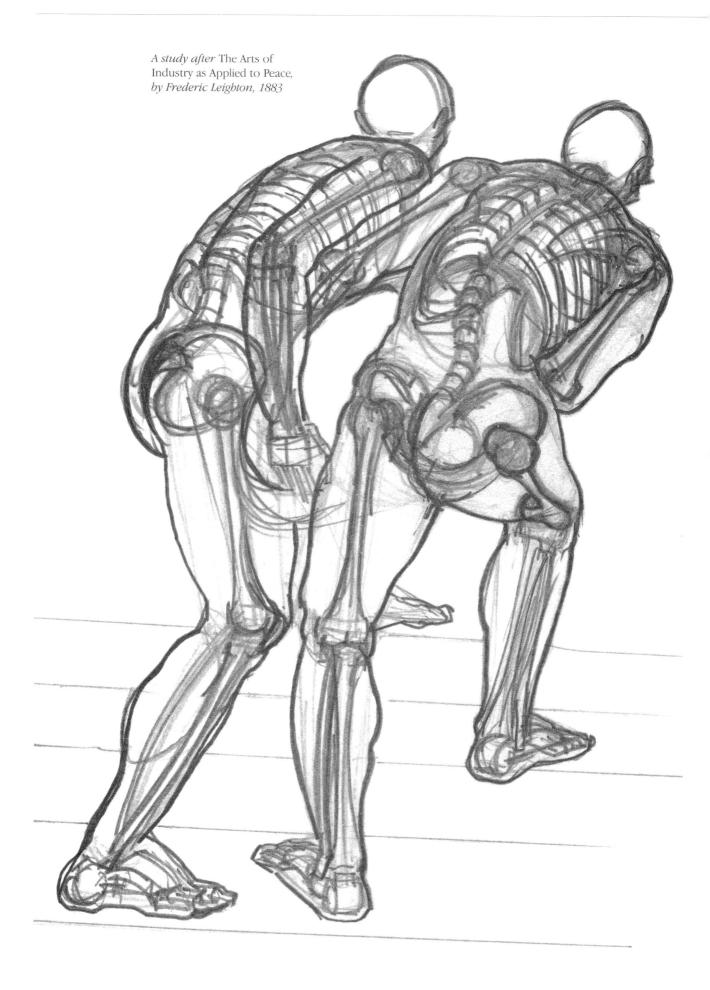

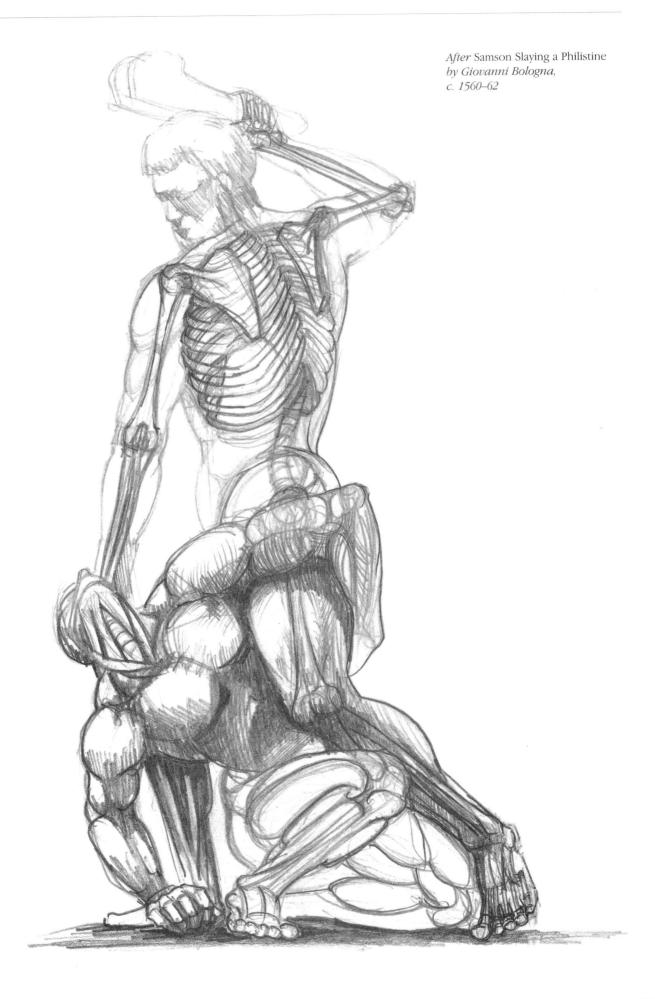

After Samson and the Philistines by Vincenzo Foggini, inscribed 1749

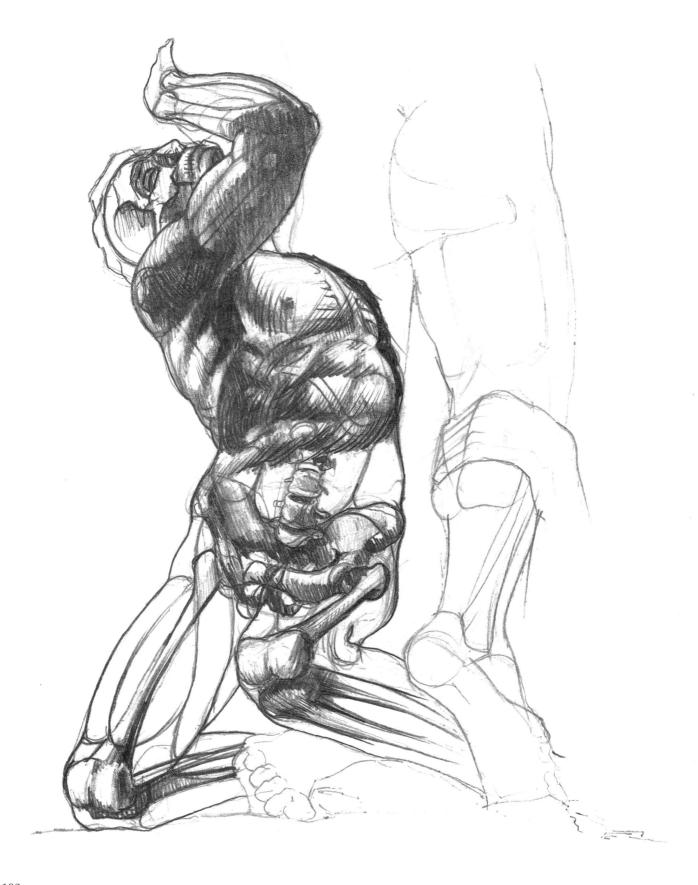

After Theseus and the Minotaur by Antonio Canova

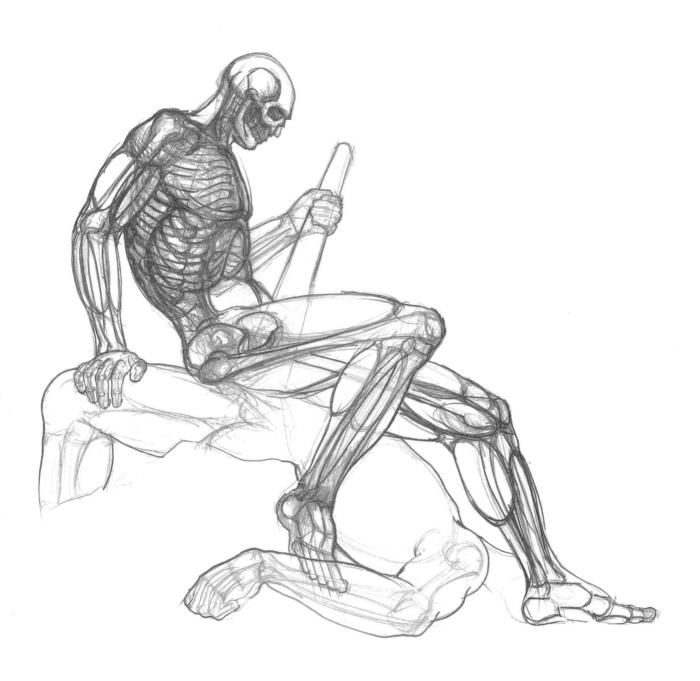

After A Crouching Boy by Michelangelo, c. 1524

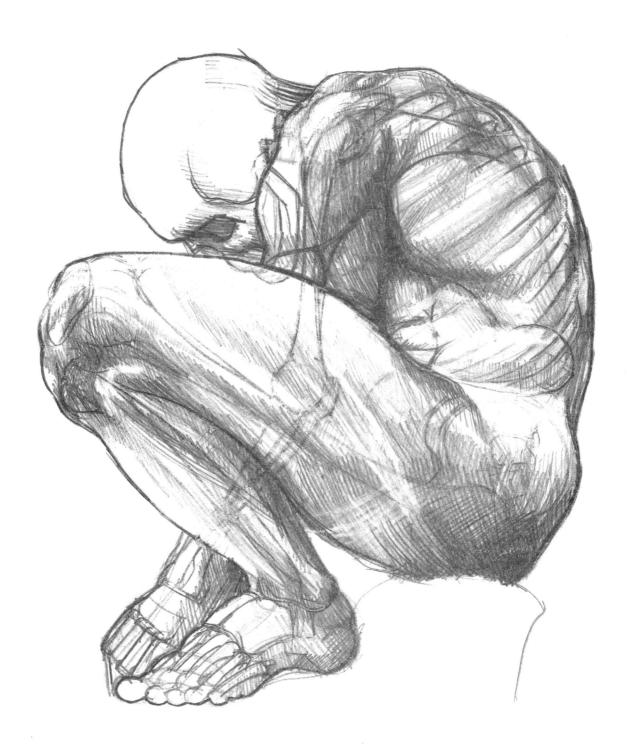

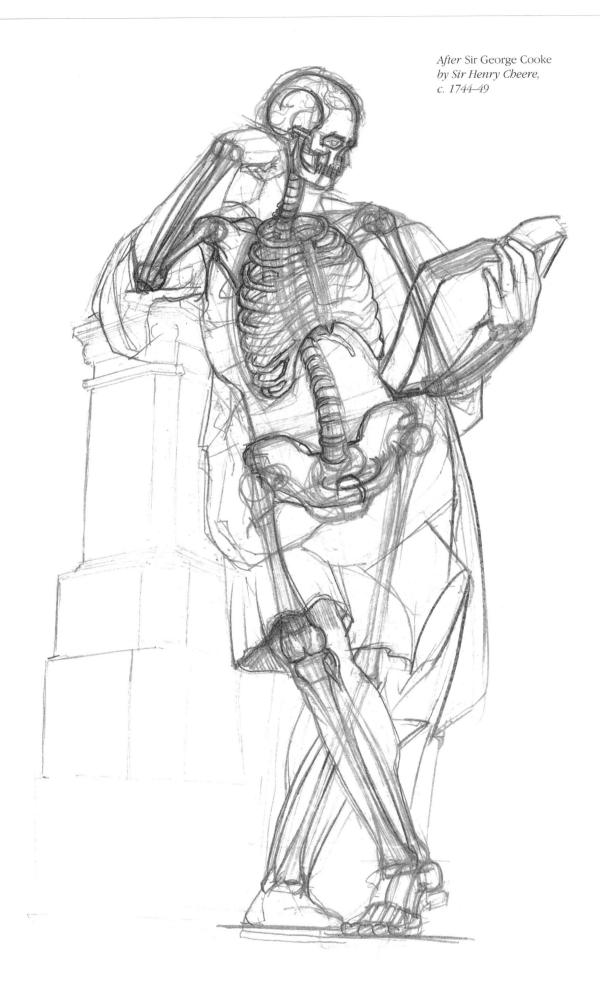

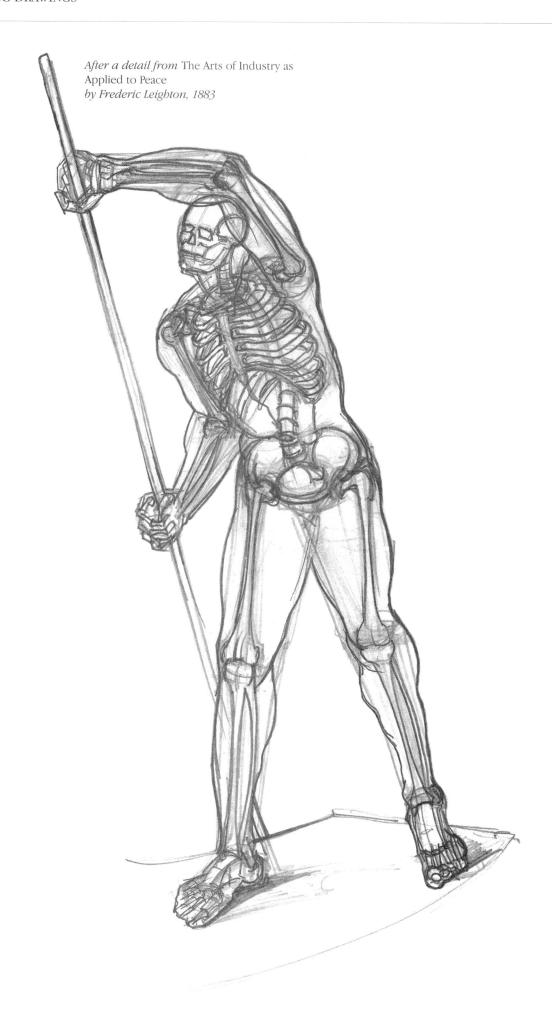

After a detail from The Arts of Industry as Applied to Peace by Frederic Leighton, 1883

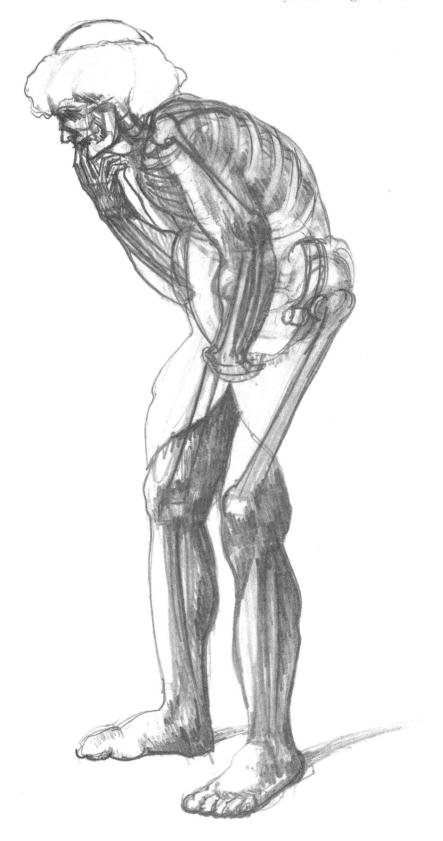

After A Sleeping Nymph by Antonio Canova, 1820–24

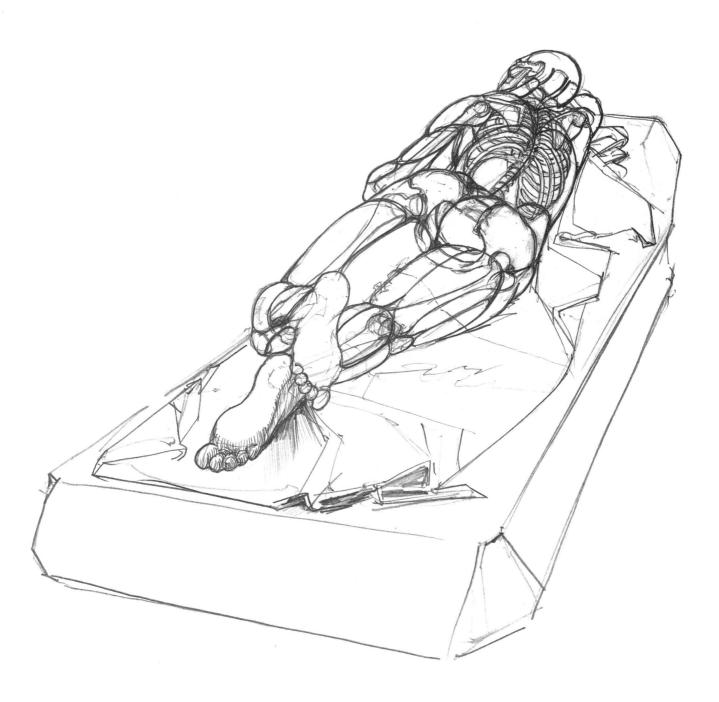

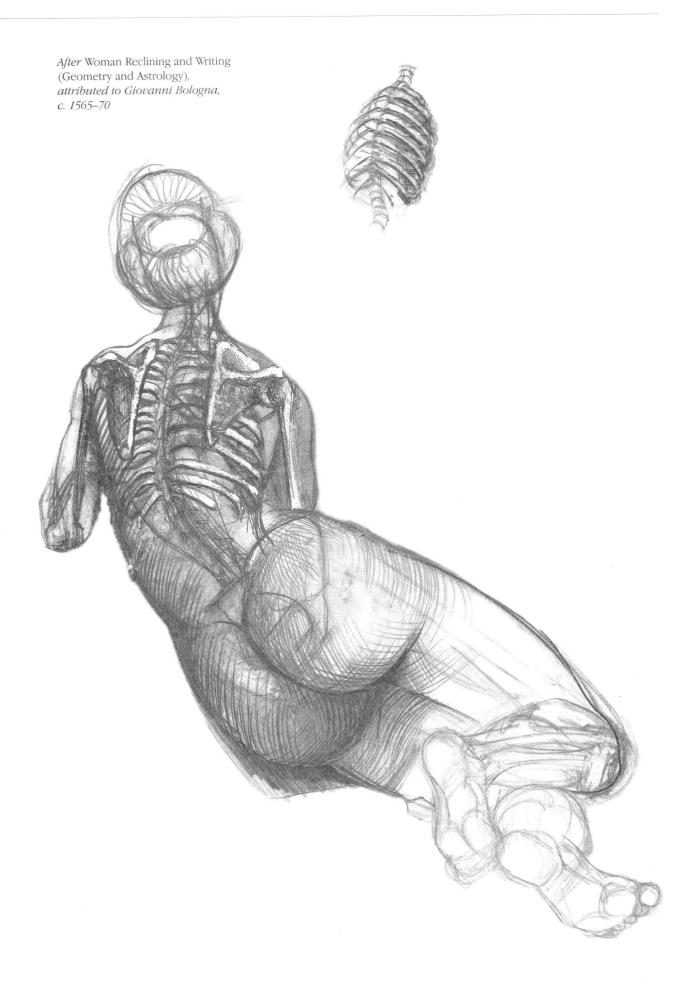

After a detail from The Judgement of Solomon by Simon Troyer, 1741

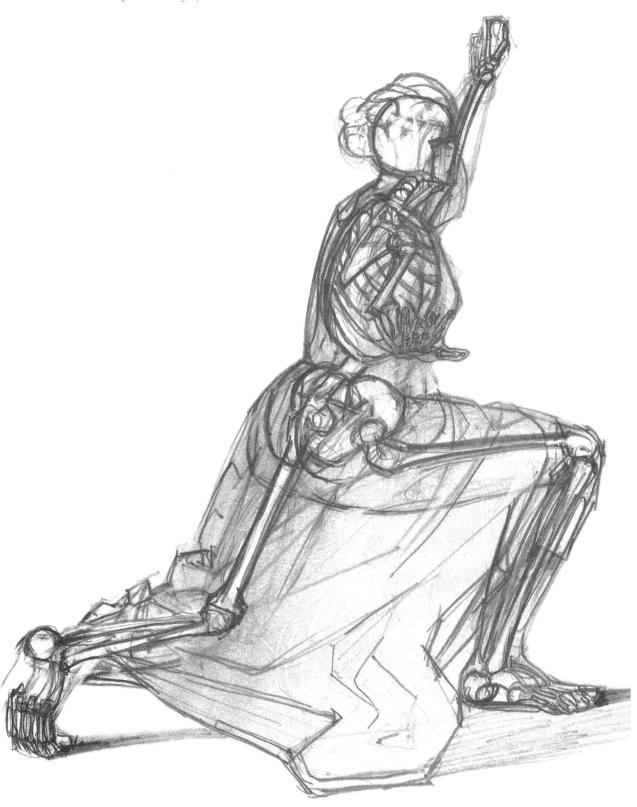

After Henri IV Destroying the Enemy by Hubert Le Sueur, c. 1615–20

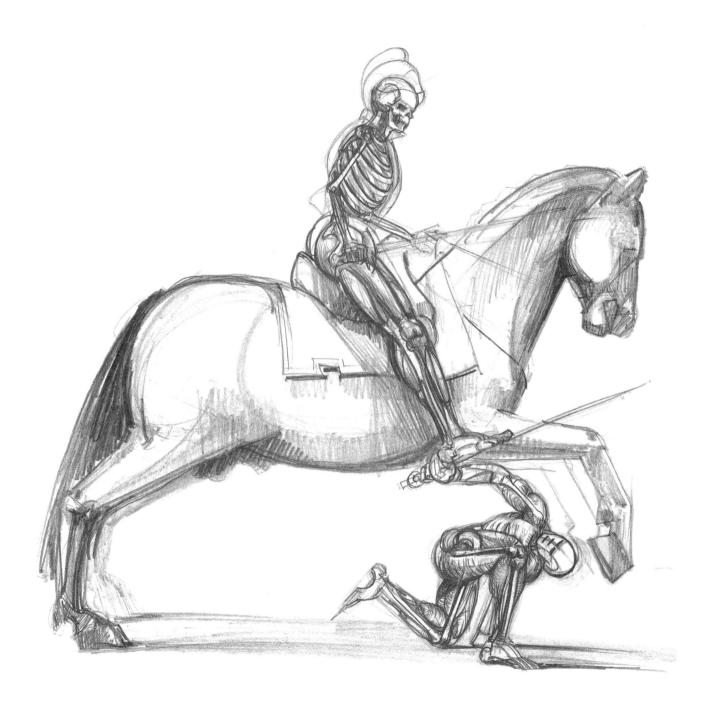

After Woman Reclining and Writing (Geometry and Astrology), attributed to Giovanni Bologna, c. 1565–70

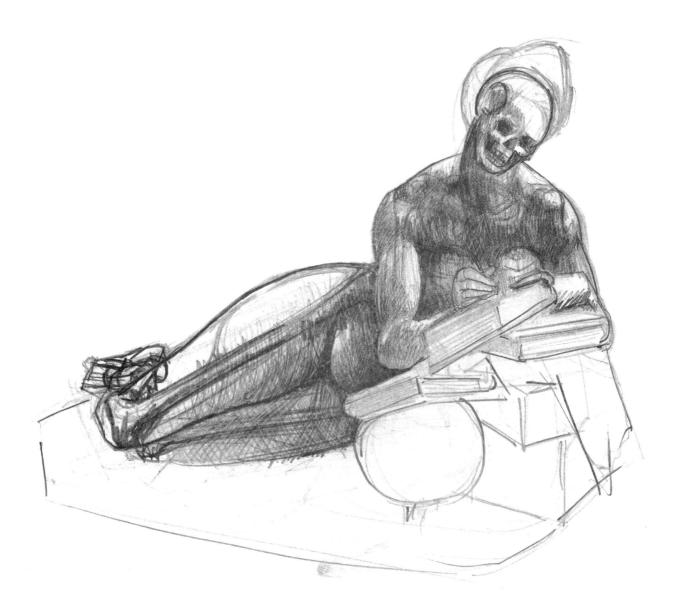

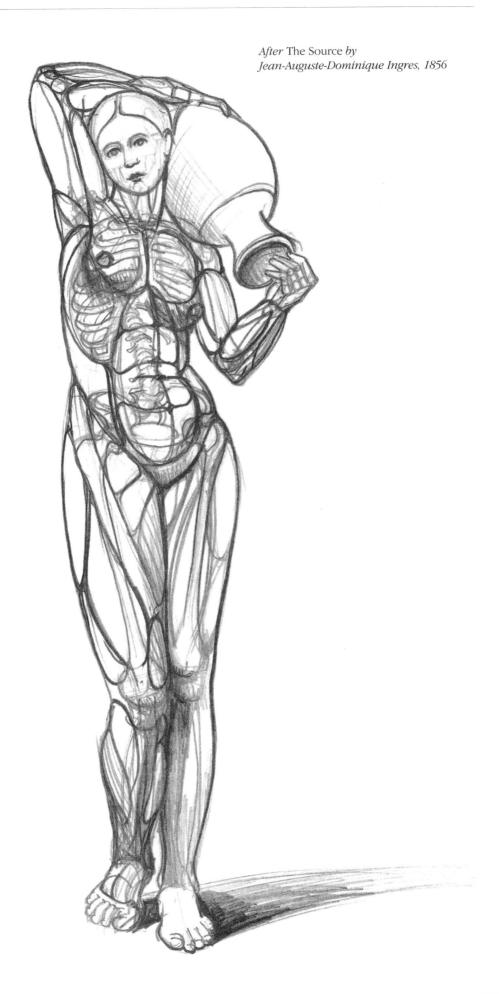

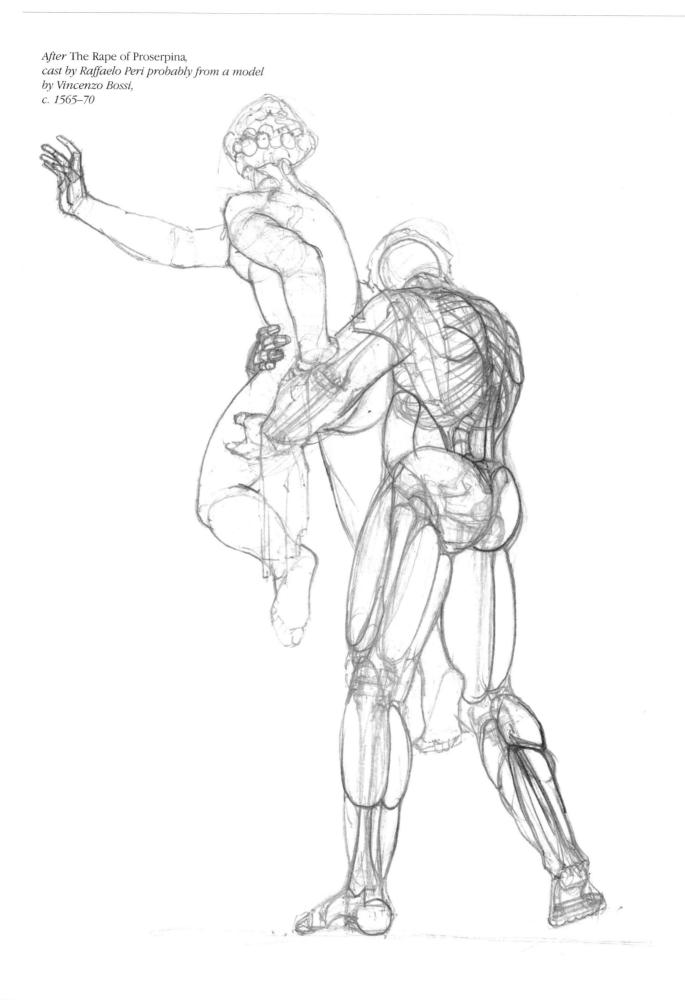

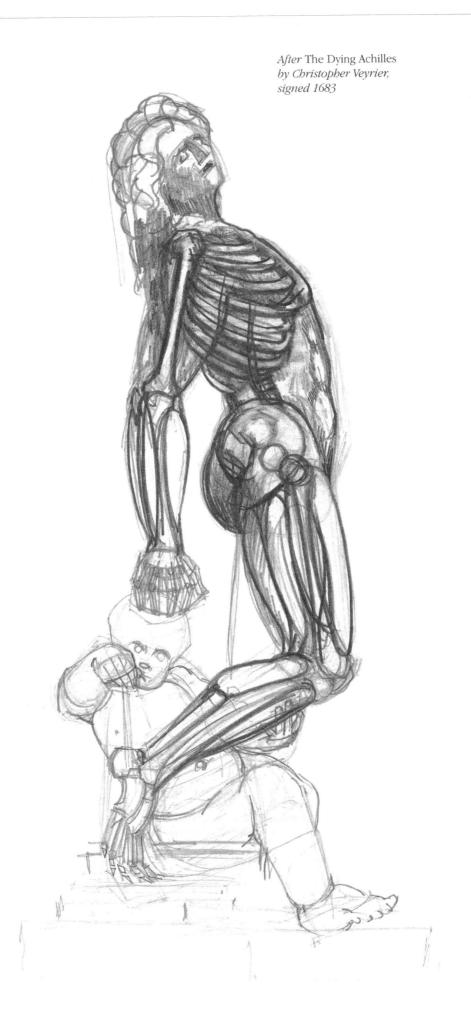

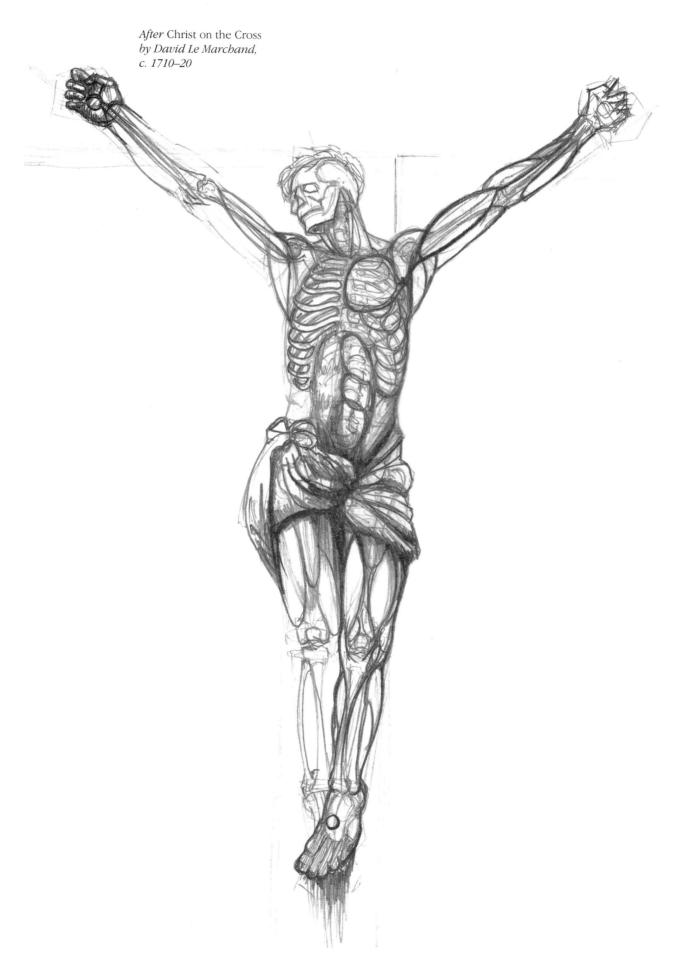

After Campaspe by Walter Pompe, 1763

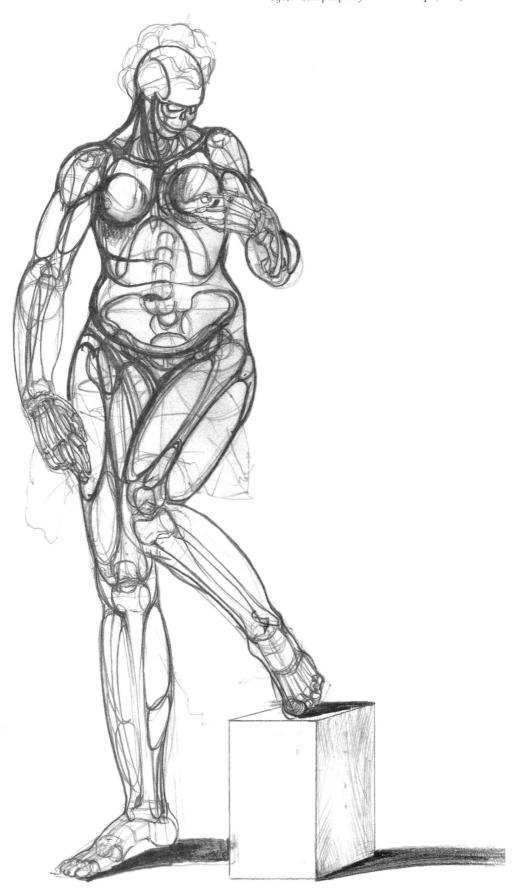

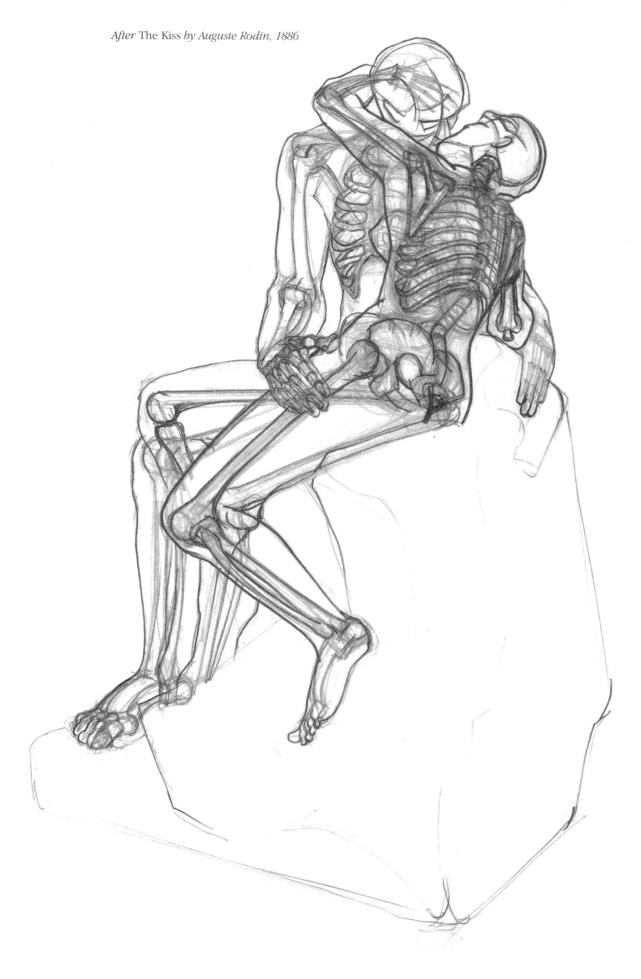